THE

END *of* AR⁻

In *The End of Art* Donald Kuspit argues that art is over because it has lost its aesthetic import. Art has been replaced by "postart," a term invented by Alan Kaprow, as a new visual category that elevates the banal over the enigmatic, the scatological over the sacred, cleverness over creativity. Tracing the demise of aesthetic experience to the works and theory of Marcel Duchamp and Barnett Newman, Kuspit argues that devaluation is inseparable from the entropic character of modern art, and that anti-aesthetic postmodern art is its final state. In contrast to modern art, which expressed the universal human unconscious, postmodern art degenerates into an expression of narrow ideological interests. In reaction to the emptiness and stagnancy of postart, Kuspit signals the aesthetic and human future that lies with the New Old Masters. A sweeping and incisive overview of the development of art throughout the twentieth century, *The End of Art* points the way to the future for the visual arts.

Donald Kuspit is one of America's most distinguished art critics. Winner of the prestigious Frank Jewett Mather Award for Distinction in Art Criticism, given by the College Art Association, he is a Contributing Editor to *Artforum, Sculpture, New Art Examiner*, and *Tema Celeste* magazines, as well as Editor of *Art Criticism*. Professor of Art History and Philosophy at the State University of New York, Stony Brook, he also holds honorary degrees from Davidson College, the San Francisco Institute of Arts, and the University of Illinois at Urbana-Champaign, and he has been the A. D. White Professor-at-Large at Cornell University. Dr. Kuspit has received fellowships from the Ford Foundation, Fulbright Commission, the National Endowment for the Humanities, and the Guggenheim Foundation. He is the author and editor of hundreds of articles and books, most recently *The Rebirth of Painting in the Late 20th Century* and *Psychostrategies of Avant-Garde Art*.

THE
END *of* ART

—

DONALD KUSPIT

State University of New York, Stony Brook

CAMBRIDGE
UNIVERSITY PRESS

CAMBRIDGE UNIVERSITY PRESS
Cambridge, New York, Melbourne, Madrid, Cape Town, Singapore, São Paulo

Cambridge University Press
40 West 20th Street, New York, NY 10011–4211, USA
www.cambridge.org
Information on this title:www.cambridge.org/9780521832526

First published 2004
Reprinted 2004, 2005 (twice)
First paperback edition 2005
Reprinted 2005 (twice)

Printed in the United States of America

A catalogue record for this book is available from the British Library.

Library of Congress Cataloguing in Publication Data
Kuspit, Donald B. (Donald Burton), 1935
The end of art / Donald Kuspit.
p. cm.
Includes bibliographical references and index.
ISBN 0-521-83252-7
1. Art, Modern – 20th century. 2. Art – Philosophy. I. Title.
N6490.K864 2004
701'.17' 09045 – dc21 2003055123

ISBN-13 978-0-521-83252-6 hardback
ISBN-10 0-521-83252-7 hardback

ISBN-13 978-0-521-54016-2 paperback
ISBN-10 0-521-54016-X paperback

For

JUDITH

———

CONTENTS

ILLUSTRATIONS

ACKNOWLEDGMENTS

———

As always, in intellectual gratitude to Beatrice Rehl.

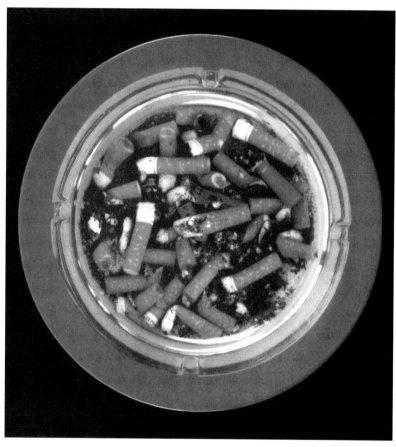

1. Damien Hirst, *Home Sweet Home*, executed 1996. Porcelain, 8.3 inches round. Private collection. Courtesy of Mark Borghi Fine Art Inc.

The unprecedented proliferation of art, the ease with which formerly esoteric or repellent art-forms are accepted, the fascinating conjunction of popular and commercial art with what used to be called advanced art – these circumstances do not support the old belief that art fosters a personal autonomy.

<div align="right">Lionel Trilling, Sincerity and Authenticity[1]</div>

Whoever produces kitsch . . . is not to be evaluated by aesthetic measures but is ethically depraved; he is a criminal who wills radical evil.

<div align="right">Hermann Broch, "Evil in the Value System of Art"[2]</div>

Some of the same people who profess to be repelled by the monotonous rows of identical human dwellings in so-called subdivisions, seem to admire rows of identical boxes in art galleries.

<div align="right">Rudolf Amheim, Entropy and Art[3]</div>

An installation that the popular and pricey British artist Damien Hirst assembled in the window of a Mayfair gallery on Tuesday was dismantled and discarded the same night by a cleaning man who said he thought it was garbage.

The work – a collection of half-full coffee cups, ashtrays with cigarette butts, empty beer bottles, a paint-smeared palette, an easel, a ladder, paintbrushes, candy wrappers and newspaper pages strewn about the floor – was the centerpiece of an exhibition of limited-edition art that the Eyestorm Gallery showed off at a V.I.P. preopening party. . . .

Mr. Hirst, 35, the best known member of a generation of conceptual artists known as the Young British Artists, had put it together and signed off on it, and Heidi Reitmaier, head of special projects for

the gallery, put its sales value at "six figures" or hundreds of thousands of dollars. "It's an original Damien Hirst," she explained.

...The cleaning man, Emmanuel Asare, 54, told *The Evening Standard*: "As soon as I clapped eyes on it, I sighed because there was so much mess. It didn't look much like art to me. So I cleared it all in bin bags, and I dumped it."

...Far from being upset by the mix-up, Mr. Hirst greeted the news as "hysterically funny," Ms. Reitmaier said. . . . "since his art is all about the relationship between art and the everyday, he laughed harder than anyone else."

Warren Hoge, "Art Imitates Life, Perhaps Too Closely"[4]

How many of us would seriously place Rauschenberg besides Rembrandt, Cage besides Bach? Stepping into a museum or a concert hall we enter an aesthetic church, a sublime and rather chilly necropolis, stretching back across time, where Leonardo and Van Gogh, Palestrina and Beethoven join frozen hands. Part of this attitude is an often almost religious reverence and respect, but also a certain indifference. We sense that what truly matters lies elsewhere. What needs preserving does so precisely because it has lost its place in our world and must therefore be given a special place – often at great expense.

Karsten Harries, "Hegel on the Future of Art"[5]

I don't believe in cinema as a means of expression. It could be, later perhaps; but, like photography, it doesn't go much further than a mechanical way of making something. It can't compete with art. If art continues to exist. . . .

Marcel Duchamp, "I Live the Life of a Waiter"[6]

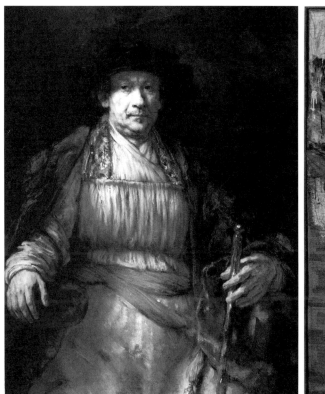

2 (LEFT). Rembrandt Harmensz. van Rijn, *Self-Portrait*, 1658. Oil on canvas, 129 × 101 cm. The Frick Collection, New York. 3 (RIGHT). Robert Rauschenberg, *Bed*, 1955. Combine painting: oil and pencil on pillow, quilt and sheet on wood supports, $6'3\frac{3}{4}'' \times 31\frac{1}{2}'' \times 8''$. Gift of Leo Castelli in honor of Alfred H. Barr, Jr. The Museum of Modern Art. VAGA, NY.

I

THE CHANGING OF THE ART GUARD

———

In May 2001, Frank Stella, one of the luminaries of American abstract art, told Glenn Lowry, the Director of the Museum of Modern Art, "that 'Modern starts' might just as well have been called 'Masturbatory insights'."[7] "Modern starts" was the Museum of Modern Art's way of revisiting, through an exhibition of select works from its collection, the history of twentieth century art. More important, it was a critique of Alfred Barr's famous conceptualization of twentieth century art. Although it first appeared in 1935 as a diagram on the jacket of the catalogue for *Cubism and Abstract Art* – an exhibition that Barr, the first Director of the Museum of Modern Art, organized – Barr's hierarchical scheme, which gave pride of place to Cubism as the most innovative and influential movement of the twentieth century, had remained gospel, not to say dogma. Instead of organizing their exhibition in terms of movements, which is the prevailing way of classifying art, Barr's curatorial successors organized "Modern starts" in terms of "People, places and things." "A more apt subtitle," Stella declared, "would have been 'Pointless, clueless and soulless'." Certainly, compared to "The Age of Modernism" exhibition held in Berlin in 1997, another attempt to re-think twentieth century art, which also dispensed with movements (four broad categories or leading ideas, "Reality – Distortion," "Abstraction – Spirituality," "Language – Material," and

"Dream – Myth," replaced them[8]) "people, places and things" seem banal, not to say conceptually shallow.

Why did Stella angrily condemn the exhibition as "bad ... disgraceful ... disagreeable?" Why did he say that "there are no temperate words to describe the way 'Modern starts' manhandles the collection of the Museum of Modern Art?" He is worth quoting at some length, for the attitude to art he attacks suggests, no doubt unintentionally, that what used to be called high art no longer exists, perhaps not even in name. Indeed, to use the term "high art" these days is to suggest some elitist, exclusive, inaccessible phenomenon, different in kind from everyday phenomena, and as such self-privileging and beside the point of everyday life, which is to survive it, and, if one can, flourish in it, disregarding the fact that it is inherently tragic, just because it is everyday.

High art may speak to the happy few, but it doesn't speak to the unhappy many. It certainly seems too obscure to help them understand the people, places, and things they encounter in their everyday lives. Lacking the common touch, it lacks what seems most human. What's the everyday point, after all, of the aesthetic experience – a so-called higher experience (an altered state of consciousness, as it were, and thus an abnormal or at least non-normal and unconventional consciousness of reality), in contrast to everyday experience (with its convention-respecting, and thus supposedly normal, "realistic" consciousness) – high art professes to offer? What's the use of high art's subtleties and refinements in the low, practical, demanding world of everyday life? It lays claim to all of one's being, as though there was no alternative to it, which might offer a measure of detachment – a certain uncanny aloofness and serenity, giving one the illusion that one is above it and can hold one's own against it, without denying its implacable givenness – and thus a different kind of sanity than the kind of sanity necessary to live in it.

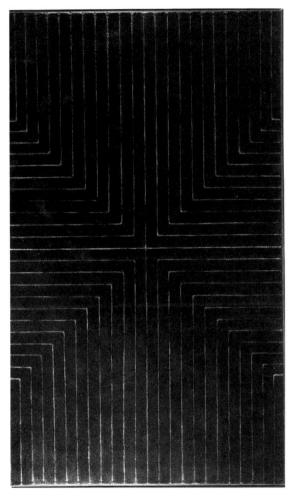

4. Frank Stella, *Die Fahne Hoch*, 1959. Enamel on canvas. $12\frac{1}{2}'' \times 73''$. Whitney Museum of American Art. Gift of Mr. and Mrs. Eugene H. Schwartz and purchase, with funds from the John I. H. Baur Purchase Fund; the Charles and Anita Blatt Fund; Peter H. Brant; B. H. Friedman; the Gilman Foundation, Inc.; Susan Morse Hilles; The Lauder Foundation; Frances and Sydney Lewis; the Albert A. List Fund; Philip Morris Inc.; Sandra Peyson; Mr. and Mrs. Albrecht Saalfield; Mrs. Percy Uris; Warner Communications Inc., and the National Endowment for the Arts. © 2004 Frank Stella/Artists Rights Society (ARS), New York. Photograph by Geoffrey Clements.

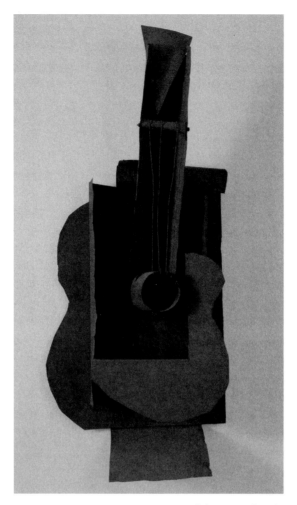

5. Pablo Picasso, *Guitar*, 1912–13. Construction of sheet metal and wire, $30\frac{1}{2}''$ × $13\frac{3}{4}''$ × $7\frac{5}{8}''$. Gift of the artist. © The Museum of Modern Art/Licensed by SCALA/Art Resource, NY. © 2004 Estate of Pablo Picasso/Artists Rights Society (ARS), New York.

"This exhibition," Stella asserts, "neither re-evaluates nor re-interprets; it simply plays around with the collection in the spirit . . . of some fashionable act of de-legitimisation of the ideas of greatness, genius, and uniqueness that the collection embodies. What the

curators, [John] Elderfield & Co., seem to have in mind is a lev-
elling out of quality, the replacement of judgement with the non-
judgemental." Examining the installation in detail, Stella sardonically
observes that

> random placement would have been better, certainly more
> interesting and more beautiful than this flip trivialisation.
> The arbitrariness of the whole affair challenges the viewer to
> find a worse place for Picasso's "Guitar" of 1912–13 than the
> one Mr. Elderfield has hit upon. Even a toilet stall would
> do more for Picasso's "Guitar." Of course, the door might
> not be as spatially "privileged" as a commissioned mural
> animated by a "urinal" motif [Stella is referring to a work
> in the exhibition], but I'll bet that the "Guitar" would look
> better on the door. Trapped in a wall-mounted plexiglass
> cover, his "Guitar" cannot escape being the ugliest display
> of a masterpiece in 21st-century museum history.

Continuing his complaint and lament, Stella argues that "Elderfield's
merciless churning of the collection in order to shake out questionable
benefits, such as the ability 'to avoid the definitive and the comprehen-
sive' and 'to shun a consensus'," is a "debasement of the collection and
the . . . demeaning of Alfred Barr, Jr, as well as three of his most beloved
artists, Cézanne, Picasso and Malevich, is a soulless act – and shame-
ful. Under the guise of academic inquiry, 'Modern starts' attacks Barr's
heroic accomplishments. His pioneering historical . . . study of Mod-
ernism, *Cubism and abstraction* (1935) is summarily dismissed. . . . Barr
is further belittled for failing to see how important it was 'to attempt
a non-historical study of early modernism.' This attack on a great and
ground-breaking figure is relentless. Barr is criticised for creating a
diagram of modern art that 'far too much has been written about'."
Noting that the Museum of Modern Art has "completely obscure[d]

its accomplishment, its original identity and its original and admirable purpose," Stella quotes Lowry's remark that "art is entertainment," suggesting that he should be replaced by Michael Eisner, who "knows how to make entertainment pay. He would not even have to change the logo: MoMA would simply become the Museum of Mickey's Art."

Stella goes on and on, seemingly ranting at will. With biting irony he notes that Elderfield "had solved the problem of what to do with the museum's dated collection. Rather than give it to un-hip historical museums like the Met or the National Gallery, MoMA would give its collection to today's new ecology-conscious generation of artists who really know how to use the art of the past, who recycle it directly into their own work. I wonder if it is really going to be 'all right' when Craig-Martin decides if he wants to take his Picasso and Malevich home, if only to be able to work on them a bit more comfortably in his studio." Turning on the museum rather than the hip postmodern artists it invited to participate in "Modern starts" – a show of trendiness intended to demonstrate that it is not outdated (similar to its merging with the hip P.S. 1) – Stella delivers the coup de grace: "a department store of modern art has emerged to replace a museum of modern art." "'Modern starts' rivals the weekly promotions at Macy's," Stella nastily remarks, emphasizing the commercial degradation of modern art – the confusion of commercial and artistic values, which is an ethical failure, however unwitting – that is a sign of its death throes. Moving in for the kill, Stella writes: "A wall of Cézanne landscapes is totally convincing as a display of framed reproductions ready to be charged to your Visa card and taken home. Rodchenko's 'Spatial Construction no. 12' could be a new colander borrowed from the Williams Sonoma Collection. And poor Picasso is trivialised again as his 'Glass of absinthe' (1914), one of the most original sculptures of the 20th century, second only, perhaps, to his own 'Guitar' of 1912–13, is humiliated in a tableware display."

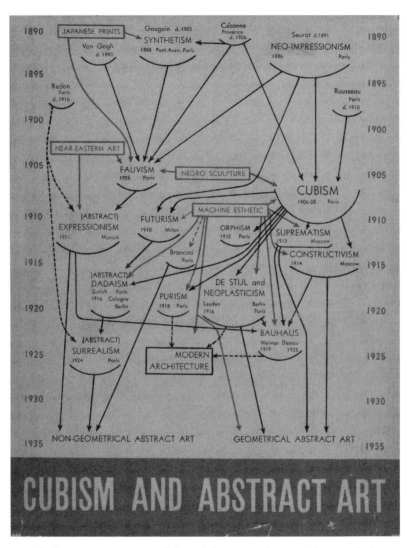

6. Alfred H. Barr, Jr. Cover of the exhibition catalogue *Cubism and Abstract Art*, New York, The Museum of Modern Art, 1936. © The Museum of Modern Art/Licensed by SCALA/Art Resource, NY.

In a final caustic outburst, Stella remarks that "'Modern starts' has a good start toward becoming the most philistine, most anti-art exhibition of the new millennium," and concludes by remarking, in a last statement of despair, that "MoMA has become a Center of Cultural Studies." Lowry, with a "benign smile," agrees. From Stella's perspective, which no doubt seems quaint from Lowry's, this pseudo-Mona Lisa smile is the handwriting on the wall of art, the catastrophic whimper that signals its end. Art has been subtly poisoned by social appropriation, that is, the emphasis on its commercial value and its treatment as upscale entertainment, turning it into a species of social capital. Co-opted by the commonplace, it loses its uncommonness. It has also been undermined by the belief that all one has to do is have a "concept" to be an artist, which suggests that the concept of artist, as well as of art, has lost clear meaning. This is why so many people think of themselves as artists, for everyone, after all, has a favorite "concept," especially about some person, place, and thing they know.

For Stella the Museum of Modern Art has become a hip, fashionable venue of commercial entertainment, although modern art hardly seems as slick, ingratiating, and instantly comprehensible. But "Modern starts" tries to make it as popular and succeeds in doing so by making it seem as trivial – an amusing diversion rather than an aesthetic revelation. "Modern starts" makes modern art seem postmodern in spirit, as Trilling suggests, for it makes advanced, esoteric art seem popular and obvious and popular commercial art seem advanced and innovative, blurring their difference – to the extent that there seems to be no reason or need for it – which makes all art seem "significant" and leads to an unprecedented (and uncritical) proliferation of art. Anyone can become a "serious artist," for there are no longer serious critieria for determining seriousness in art.

For Stella modern art loses its seriousness in "Modern starts," becoming indistinguishable from non-art. This is the point of his cynical observation that Cézanne's landscapes are more tolerable and palatable

as reproductions than as paintings. As reproduction, the painting enters the domain of the everyday. It is almost impossible to escape. The painting can be liberated from the prison of everyday consciousness its reproduction imposes on it only by a defiant act of aesthetic perception. The serious spectator's aesthetic re-affirmation of the painting is a kind of re-creation of it, serving the same spiritual purpose as the artist's creation of it: creativity is the means of escaping from – even decisively breaking with – everyday consciousness of the life-world. The artist keeps one foot in the everyday through his subject matter – Cézanne's landscape – but transcends it by re-creating it in aesthetic terms.

In postmodernity we no longer see the painting, only the reproduction, or, at best, the painting through the reproduction, so that painting and reproduction become identified and seem virtually the same to the popular(izing) eye. Tamed by being reproduced, the reproduction seems more real than the real thing and more acceptable, that is, more comprehensible and familiar: the viewer seems in charge, not the artist. The reproduced Cézanne is reassuring and appealing because it seems everyday – confirms that everyday consciousness is the only legitimate consciousness – where the real Cézanne is intimidating and discomforting because it disrupts everyday consciousness. We become sentimental about normalizing reproductions but not the de-normalizing real thing, which grates on our nerves and unsettles our consciousness. Thus, reproduction is a double castration: it castrates the work of art and consciousness of it – consciousness in general.

Rodchenko's and Picasso's abstract sculptures have also been reduced to familiarity by being presented as household products, however malfunctional. They are made to seem more everyday and commonplace than they are, thus stripping them of their aesthetic aura and strangeness, indeed, estranged state, aesthetically coded. They become material artifacts like any other, no longer different in kind but only in appearance, and that by not very much, at least to the everyday eye that has grown accustomed to them. For Stella the whole point of

"Modern starts" is to habituate the public to modern art, suggesting that it is not as bizarre and disturbing as it has often been thought to be, but continuous with everyday life, if a bit more entertaining and exciting, perhaps only because it has no clear use.

Lowry's comfortable smile suggests that modern art has surrendered to its fate – accommodated itself to inevitable assimilation into everyday life, as though that was its wish all along – as though, from the first, all it wanted to do was to be understood in everyday terms and loved, however unlovable it looked. Modern art was an ugly frog waiting to be kissed by the princess of public acceptance, magically changing it into a charming prince – a social star. Thus prettified – its act cleaned up by showing that, after all, it is just about such familiar everyday things as people, places, and things – it is no longer what Trilling called "serious art, by which we mean such art as stands, overtly or by implication, in an adversary relationship to the dominant culture," and thus signals the "alienated condition" of "social reality" itself.[9] In "Modern starts" it seems to jump at the chance to be institutionalized, forfeiting its adversarial alienation – the source of critical autonomy – even if the only institution willing to have it is the museum. But of course it has an important place in the marketplace, which is the decisive institution – the deus ex machina – in capitalist society. For Stella, Lowry's attitude is the signature symptom of art's death. It is proof that high art – traditional as well as modern – is over and done with. High art has become simply another sample of visual and material culture, losing its privileged position as a source of aesthetic experience, which, from the perspective of cultural studies, is beside the ideological point.

Indeed, it is socially and politically incorrect just because it seems to be a unique, "higher" experience, not available for the asking by everyone – not for sale in the store of cultural entertainment and as such priceless, indeed, inherently unmarketable. It is not a common experience, and thus not democratic; popular and commercial art do

not even pretend to offer it, although they have sometimes been under-stood to offer a simulation of it, that is, a corrupt version of it. Aesthetic experience is in fact discarded as a rhetorical, idiosyncratic effect – an aspect of the illusion of personal autonomy that Trilling refers to – of a socially conditioned, even culturally mandated, impersonal construc-tion. The artist becomes, without irony, the willing representative of so-ciety's everyday values, losing the integrity of his alienation, and art be-comes an instrument of social integration – a sign of social belonging – losing aesthetic purpose and power.

No longer the privileged domain of aesthetic experience, as crit-ical aesthetes and modernist prophets as diverse as Walter Pater, Roger Fry, and Clement Greenberg argued, art is no longer the hard-won "scrap of critical freedom of thought against external pressure to con-form and internal fear," to use Alexander Mitscherlich's words.[10] I submit that aesthetic experience is the momentary, personal, exhilarat-ing – to use Greenberg's word – form of this nonconformist, fearless scrap. It is a delicious, if brief, taste of critical freedom not unlike what D. W. Winnicott called an "ego orgasm" – a eureka-like experience of restorative "creative apperception" involving the conscious feeling of being intensely alive. It transforms alienation into freedom and adver-sariness into criticality. This is a "fragile achievement of the ego," to use Mitscherlich's words, that nonetheless strengthens it, allowing it to transcend its social identity and conformity. Socially, reality is seen in a standard, "schematic" way, as Mitscherlich says, and thus loses complexity. It becomes one-dimensional, losing dialectical intricacy. It seems foreordained and fixed rather than a changing, ongoing pro-cess. Aesthetically, reality is seen spontaneously and dialectically – as a problematic, disjointed, interminable process full of tensions and con-tradictions, some resolved, some unresolved – which opens the way to insight into it, and the self-transformation and re-equilibration that come with insight. The real becomes as lively, fresh, and "moving" – re-ally real – as it was in childhood, which is why many proto-modern and

modern poets and artists, Wordsworth, Baudelaire, Gauguin, Kandinsky, Klee, and Dubuffet among them, have cherished the child as the greatest imaginer, and "primitive," childlike, "outsider" art as the most imaginative, vital art. They have tried to stay in touch with the child in themselves, often by using primitive art as a touchstone (not to say whetstone), keeping it alive in defiance of the adult social world which demands that one play a prescribed role and identify oneself completely with that role.

For Stella, to reduce modern art to a modern take on people, places, and things – the banal substance of everyday life – is to deny its creative vitality and uniqueness. It is to deny its aesthetic transcendence of the people, places, and things that are sometimes its point of departure. It is to banalize modern art, missing its point. Instead of tending to pure art, with its uplifting effect – a kind of healing, however incomplete and temporary that is, however much the wounds inflicted by life start to fester again once the aesthetic effect fades (although it shrinks their significance, making them more tolerable) – modern art is seen as a novel representation of banal reality, that is, the everyday people, places, and things of modern times. It is in effect old wine in a glistening new bottle. Seeing modern art entirely in the everyday terms of people, places, and things undermines it completely, for it denies that it is pure art. It subverts its major thrust, the will to purify art of any reference to everyday reality, or else to transform the appearance of everyday reality so that it becomes purely aesthetic reality, thus losing its matter-of-factness to become consummately real (if only in the "visionary" work of art). Instead of symbolizing the will to hold one's own against society and banality – instead of modern art serving as the special space in which one can be true to oneself in a society that encourages one to be false to oneself, a space that is only nominally social however institutionalized it is – "Modern starts" suggests that modern art was never more than social space. It is not a seriously "other space," but familiar social space in whatever strange disguise. (One paradox of

art is that it has to be socially appropriated to be preserved, but its institutionalization – in effect complete socialization – is unconsciously an attempt to neutralize its aesthetic effect. Putting it into a procrustean cultural bed – the museum is an intellectual sarcophagus as much as a physical mausoleum – undermines its nonconformist, even anti-social character. The point is that the indifference to social role that aesthetic nonconformity brings with it invites social deterioration, that is, the breakdown of social functioning, which to be effective requires submission to social role. Mitscherlich notes that "individuality is extremely rare" however much it is yeasayed, for it brings with it the threat of disruptive nonconformity and thus undermines social order.)

In short, aesthetic experience leads to the realization that social identity is not ingrained – not destiny – nor the be-all and end-all of existence. It is not the source of individuality, but rather precludes individuality. Aesthetic experience allows one to recover the sense of individuality and authenticity lost to "obligatory behavior" – no doubt necessary for social survival – because it allows one to live in society with a measure of what can only be described as sublime if unrealistic happiness while, paradoxically, spearheading "the critical testing of [social] reality." This is no doubt a heroic idea of the human potential of aesthetic experience, but the heroism is entirely private, for it involves insight into the needs of what Winnicott calls the incommunicado core of the self.

2

THE AESTHETIC MALIGNED: DUCHAMP AND NEWMAN

———

S tella has articulated, with uncanny accuracy and discomforting ridicule, the post-aesthetic character of art. He implies that it is the end of art, which does not mean works of art will not be made, but that they will have no important human use: they will no longer further personal autonomy and critical freedom, strengthening the ego against the social superego as well as the instincts, both of which stifle individuality with conformity. When works of art become consummately commercial – when commodity identity overtakes and subsumes aesthetic identity, so that an expensive work is uncritically accorded aesthetic significance, not to say spiritual value – they become everyday artifacts, thus reversing the "esthetic osmosis" that Duchamp thought was the essence of "the creative act."[11] Aesthetic osmosis makes works of art evocative and engaging and even creates them, for it transforms "inert matter" into a phenomenon the spectator is willing to call a work of art – a "phenomenon which prompts the spectator to react critically," that is, to take seriously.

For Stella, "Modern starts" undoes aesthetic osmosis, even reverses it, signalling the regression from high art to non-art that is the end of art – the postmodern end of art, one might add, for in postmodernity art becomes entertainment, as Lowry says, and thus loses the aesthetic consequence that makes it art, not just another

object performing some social service in the guise of art. Duchamp described aesthetic osmosis as "a transference from the artist to the spectator . . . taking place through the inert matter, such as pigment, piano, or marble." This transference is "the subjective mechanism which produces art in a raw state – *à l'état brut* – bad, good, or indifferent." Art in the raw state is informed by the artist's "personal 'art coefficient'," which Duchamp regards as "an arithmetical relation between the unexpressed but intended and the unintentionally expressed."

It is worth noting, as Duchamp undoubtedly knew, that transference is a psychoanalytic term referring to the analysand's tendency to transfer the often intense, even painful feelings he experienced in his childhood relationships into his relationship with the analyst. Duchamp suggests that in the creative act the artist transfers his primitive feelings into his material, which becomes the medium through which they are transferred to the spectator. Transference is in effect the basic creative act – one might say necessary emotional work – that makes the material into art. The first creative step is to make the material into a medium, which is what transference accomplishes. In other words, the material medium replaces the analyst, so that creating a work of art becomes a kind of self-analysis for the artist. Each particular work of art represents a self-encounter, as it were, that is, an analytic session in which the artist re-experiences and re-orders his feelings through the medium of his material. The studio becomes a clinic in which the artist pursues self-cure, although all that he may end up with is self-expression – self-mirroring (self-mimicking?) in artistic disguise.

In other words, the question is whether he gains as much insight into them as he would with a human analyst, whose attentive presence and interpretive remarks offer a more responsive context than the blank slate of the inert material. The artist reflexively invests his feelings in the dead material, bringing it to artistic life, but that does not mean he understands their raison d'etre, which would indicate preliminary

7. Marcel Duchamp, *The Bride Stripped Bare by Her Bachelors, Even (The Large Glass)*, 1915–23. $109\frac{1}{4}''\times 69\frac{1}{8}''$. Oil and lead wire on glass. Philadelphia Museum of Art: Bequest of Katherine S. Dreier. Photograph by Graydon Wood, 1992.

mastery of them. Simply put, it does not mean that making art gives the artist insight into what he makes art about – into his feelings about his subject matter. He may be acting them out – repeating or rehearsing them – through the material rather than reflecting on them. It is not

8. Marcel Duchamp, *Étant Donnés: 1e La Chute d'Eau, 2e Le Gaz d'Eclairage,*
1946–66. H: 95½″ × W: 70″. Mixed media assemblage. Philadelphia Museum
of Art: Gift of the Cassandra Foundation. Photograph by Graydon Wood, 1996.

clear to what extent the act of making is an act of reflecting, how-
ever much reflection – about how to make a particular work of art –
may go into it. The work of art may be their materialized expres-
sion, but it is not necessarily a demonstration or proof of insight into

them. Duchamp's repeated materialization of his sexual feelings – most conspicuously in *The Bride Stripped Bare by Her Bachelors, Even (The Large Glass)*, 1915–23 and *Étant Donnés*, 1944–66 – suggests that he was more interested in expressing them than understanding them. He never worked them through but rather mined them for all they were artistically worth. If he had understood them, he might not have bothered to make art, for he would have had no need to, at least according to his understanding of the personal function of art. As Robert Stoller suggests, art's "purpose is to blur or avoid reality by simulating some aspect of reality, including psychic reality, such as emotions."[12] If Duchamp analyzed his sexual feelings, understanding their rationale, he might not have blurred or avoided them by simulating them.

The artist is not the end of the creative story for Duchamp. The artist's "personal expression of art *à l'état brut* . . . must be 'refined' as pure sugar from molasses, by the spectator. . . . the role of the spectator is to determine the weight of the work on the esthetic scale. . . . the spectator brings the work in contact with the external world by deciphering and interpreting its inner qualifications and thus adds his contribution to the creative act." It is as though the spectator is the analyst, telling the artist the meaning of his artistic dreams. If the first creative "transmutation" or "transubstantiation" – Duchamp's alchemical and religious terms, acknowledging the deep, powerful effect and meaning of the transference – is from inert matter to subjectively raw art, the second creative transmutation is the intellectual refinement of subjectively raw art into a social and cultural object. But this refinement, which is a kind of judgment passed on the art, as Duchamp says, is always subject to revision, suggesting that the work of art is never finished or finalized but always remains peculiarly raw and as such beyond cognition. As Duchamp writes, even "posterity . . . sometimes rehabilitates forgotten artists," a creative re-thinking suggesting that no "final verdict" is absolutely binding.

The engaged spectator can pass no final judgment on art because he may have a new critical reaction to it – a new creative transference to it, bringing with it a new experience and interpretation of it and a new sense of the personality that informs it, as well as a new sense of his own personality and depth – making it seem fresher than when he initially reacted to it. It may even seem fresher than it ever was when it was in a raw state, that is, when it seemed the artist's creation entirely, as though only he had the right and power to create. Thus, the critical spectator's personal art coefficient plays an inescapable role in the deciphering and interpreting of raw art. The spectator, like the artist, plays a "mediumistic role," which means that his aesthetic judgments tend to be rationalizations of his subjective feelings, like "the rationalized explanations" the artist makes with the hope of being approved and even "consecrated by posterity."

Duchamp rebels against the aesthetic weighing and analysis of art – against passing any kind of social judgment on it. "An everyday scientist like me," he writes, "looks in a work of art for vibrations which will put his mind in synchrony with those of the artist."[13] He does not want to refine the personal expression of art *à l'état brut* but understand the artist's personal art coefficient, that is, the "difference between the [artist's] intention and its realization, a difference which the artist is not aware of." He wants to attune to the artist – indeed, identify with the artist – through the work of art, rather than decipher and interpret it for the world. For Duchamp it is a medium of communication with the artist, and through communication the communion which makes him magically one with the artist and his creative act. In a sense, it is the creative act that interests him, more than the work of art that results from it. The artist's "struggle toward the realization is a series of efforts, pains, satisfactions, refusals, decisions, which also cannot and must not be fully self-conscious, at least on the esthetic plane." To stay on the aesthetic plane is to be blind to this unconscious struggle – this

deeply personal creative process. It is simultaneously cognitive, emotional, and volitional – a complete overhaul of the artist's person, that is, a radical transformation and mastery of seemingly intractable and unbearable feelings. For Duchamp aesthetic judgment ignores the artist's creative personality, more particularly, the relationship between the artist's all too human personality and his seemingly superhuman creativity – the way he uses his creativity to transcend his personality by transmuting it into art. Duchamp quotes, with approval, T. S. Eliot's essay "Tradition and Individual Talent": "The more perfect the artist, the more completely separate in him will be the man who suffers and the mind which creates; the more perfectly will the mind digest and translate the passions which are its material." (It is Eliot's way of making the best of the "dissociation of sensibility" – the separation of feeling and thinking, passion and intellect – that he thought was endemic to modernity.) Aesthetic judgment obscures this complex metabolic process, which for Duchamp is the be-all and end-all of art. It is beyond the ken of "the spectator who later becomes [its] posterity" by giving it "social [and intellectual] value." It may be a creative act to do so, but it has little or nothing to do with the artist's creative act, and in fact obscures its purpose.

While Duchamp recognizes the inevitability of aesthetic judgment, he wants to dispense with it, for the posterity it promises is beside the immediate subjective point of creativity. It is too much a matter of consciousness, which invariably uses currently fashionable ideas to cut the subjective work of art down to social size, thus forcing it into a procrustean bed of conventional objective consciousness. Only when one approaches the work of art nonjudgmentally does it begin to reveal the artist's personality and creativity and their relationship. Duchamp goes further: the work of art should have no aesthetic appeal. It should not pitch itself to win the applause of posterity. It should not try to be tasteful, for taste always changes. It should not try to be good, only to be. It should try to translate the passions and suffering which are

its material as best it can, and let it go at that. It should be the "objective correlative" of a mental phenomenon, to use Eliot's term, and as such be indiscreet and esoteric at once – a provocative dream that can be interpreted, as said, but with no interpretation definitive, suggesting the unfathomable character of the artistic personality. The artist may be "a man like any other," as Duchamp says,[14] but unlike other men he "acts like a mediumistic being who, from the labyrinth beyond time and space, seeks his way out of a clearing." The "Large Glass," as he says, was "a renunciation of all aesthetics, in the ordinary sense of the word." That is, it was not "another manifesto of new painting"[15] and thus, implicitly, a new criterion of aesthetic judgment and taste, but an attempt to translate certain feelings in complete indifference to the spectator's aesthetic experience and evaluation of it. The spectator only gets it if he treats it as a medium through which the artist's intention, however unrealized – the "Large Glass" completed itself only when it broke and Duchamp pieced the fragments back together, confirming that its intention will never be perfectly realized – rather than a new, particularly modern kind of aesthetic phenomenon.

Without aesthetics, what does the work of art become? Something like the mechanical drawing Duchamp used "to escape taste. . . . It upholds no taste, since it is outside all pictorial convention"[16] (even though his appropriation of it turned it into another – a modern – pictorial convention). Or else it becomes like an African wooden spoon, that is, an aesthetically neutral or indifferent cultural artifact, at least before it became art. "African wooden spoons were nothing at the time when they were made, they were simply functional; later they became beautiful things, 'works of art'."[17] To see works of art in a non-aesthetic way is to return them to the state in which they existed before they were "recognized" or "real-ized" as works of art – an even more raw state, it seems, than when they were art in a raw state. It is as though Duchamp is asking us to move the Michael Rockefeller Collection of Primitive Art from the Metropolitan Museum of Art to a museum

of anthropology. There the objects in the collection will no longer be artistic masterpieces, but simply cultural artifacts. They will no longer be beautiful works of art – indeed, even works of art – but what they were when they were first found: symptomatic relics of a certain remote society with a particular function in that society.

Can one see such objects both ways – as everyday artifacts and elegant works of art simultaneously? That is exactly how Duchamp would like us to see his readymades. They have a double identity. They are socially functional artifacts that have been changed into sublime artistic masterpieces by the creative act of Duchamp's psyche. But they retain their everyday functionality; they revert to it in the blink of a creative eye, or rather in the mind. In short, they embody aesthetic osmosis while remaining inert matter. Supremely ambiguous, they are supremely perverse, that is, they blur the difference between art and non-art, an act of dedifferentiation all too often regarded as the gist of modern creativity. The tantalizing ambiguity that is the readymade precludes aesthetic idealization. When the *Fountain*, 1917, was praised as beautiful and tasteful, as occurred when it entered the museum, Duchamp became angry, for it was understood exclusively on the aesthetic plane, which destroyed its confused identity as art/non-art, that is, mentally art, physically non-art. Any decision to regard the readymade unequivocally as art downgrades it as a creative act, however necessary its aesthetic elevation is to preserve it for posterity. Duchamp in fact didn't care to preserve his works for posterity – perhaps the ultimate sign of his indifference to the aesthetic.

As he said, "I had to beware of [the] 'look' of the object. . . . You have to approach something with an indifference, as if you had no aesthetic emotion. The choice of readymades is always based on visual indifference and, at the same time, on the total absence of good or bad taste."[18] But it inevitably arouses aesthetic emotion once it is accorded the "dignity and status of art," to use the phrase with which André Breton characterized the result of the mental act that created the

readymade. Breton suggests that Duchamp knighted the ordinary object by declaring it to be a work of art, instantly making the proletariat object into an aristocratic one, a change from lower to upper (indeed, the highest) class. The opposite may also be true. The conception of the readymade as subversive anti-art suggests as much: the readymade is a kind of egalitarian leveling of the handmade – indeed, custommade – art object, turning it into just another everyday manufactured object. The high is brought low, the extraordinary is made ordinary, the different is made the same. This reversal of value is all the more ironical because the readymade is made by mental work alone, while the art object is made by physical as well as mental work.

Clearly the readymade has a double meaning. It is a conundrum, a Gordian knot that no intellectual sword can cut. Simultaneously an art and non-art object, the readymade has no fixed identity. Regarded as art, it spontaneously reverts to non-art. It collapses into banality the moment the spectator takes it seriously as art, and becomes serious art the moment the spectator dismisses it as a banal object. Just as the spectator critically reacts to it, thinking about and looking at it in a more creative way than he thinks about and looks at non-art objects, it becomes one of those non-art objects. The readymade always outsmarts the spectator, outwitting his interpretation of it, suggesting that it has no social value. Indeed, it resists socialization and remains indecipherable. It is absurd and tasteless – beyond good and bad taste because it is absurd. To perceive art through taste, as the aestheticizing spectator does, is to misapprehend it. In short, Duchamp's readymade exists to mock and defeat the spectator. Indeed, for all his yeasaying of "the pole of the spectator" – for all the honor he accords the spectator's creative act of interpretation – it seems "made" only to undermine the spectator's expectations. It exists to ridicule posterity, symbolized by the critical and aesthetic judgment the spectator passes on the work of art. It defeats every attempt to bring it into contact with the external world, remaining the medium and symbol of the artist's inner world.

The readymade is usually regarded as tongue-in-cheek and iron-ical, but its import is clearly nihilistic, for both the spectator and the artist. It not only illustrates Duchamp's belief in the absurdity and futility of the judgment of posterity – his belief that no final verdict can be passed on the artist, which is what the spectator believes he does when he experiences and judges art aesthetically – but his belief that art itself is absurd and futile, for it never adequately realizes the artist's intention and may even misrepresent it. The work of art remains trapped in the psychological limbo between the artist's intention and his failed attempt to realize it. Duchamp implies that it is futile to make art – he in fact gave it up to play chess (although he made a version of art in secret) – for no work of art can ever be a perfect trans-lation of the artist's passions, which suggests that it can do nothing to alleviate his suffering. For Duchamp the work of art is doomed to fail because the translation from one language to another always misses something – it is impossibly hard work in general – especially in the case of the translation of emotional language into artistic language. Similarly, the spectator's aesthetic translation of the work is doomed to fail, for the passionate emotions involved in the work elude it. In-deed, for Duchamp the aesthetic is designed to deny them: aesthetic emotion is aborted emotion. In short, the force of the original as well as nuances of meaning are invariably lost. Duchamp's translation of the work of art into the readymade – ultimately a pathetic mockery of a work of art and of the creative act – is the definitive statement of his nihilistic pessimism. It informs his view of the artist, the work of art, and the spectator, suggesting that there is something tragicomic, if not farcical, about all three.

For Duchamp the aesthetic act is always a social act. It stands in ironical relationship to the artist's creative act, falsifying its intention by interpreting and socializing – that is, intellectualizing and deper-sonalizing – the work of art that realizes it, however poorly. In con-trast, for Barnett Newman "the aesthetic act always precedes the social

one."[19] It is primal, as he says, and there is nothing ironical about it. It pre-dates the work of art – which at best suggests it – rather than arises after the work's creation, as it does for Duchamp. For Newman the aesthetic is a primal existential phenomenon, and as such ahistorical and asocial, in contrast to works of art, which are not only historical and social but also, because they are, seem far from primal and thus beside the existential point. What Newman calls "the primal aesthetic root"[20] is inseparable from "original man, shouting his consonants... in yells of awe and anger at his tragic state, at his own self-awareness and at his own helplessness before the void."[21] "Man's first expression, like his first dream, was an aesthetic one. Speech was a poetic outcry rather than a demand for communication." That is, it was a "totemic act of wonder" by a vulnerable individual rather than a social communication. It was a primal act, full of the futility of self-recognition, acknowledging human isolation in an inhuman universe. It was "an address to the unknowable."[22] "The dog, alone, howls at the moon," and the aesthetic is like this primal howling, at once "a cry of power and solemn weakness," "a futile attempt at poetry" and "an ecstatic outburst of... power," like the "cock's crow" and the sound the loon makes "gliding lonesome over the lake." (Thoreau describes a similar loon in *Walden Pond*, suggesting Newman's link to American Transcendentalism.)

For Newman the aesthetic is tragic and defiant at once, an acknowledgment of trauma but also an assertion of autonomy. Anguished and ecstatic at once, aesthetic awareness of being suggests that man has an "artistic nature," that "the artistic act is man's personal birthright," that "the artists are the first men,"[23] that "the meaning of the world cannot be found in the social act," that it is "inconceivable... that original man, that Adam, was put on earth to be a toiler, to be a social animal." "Man's origin was that of an artist." The "archaic writer... of the first chapter of Genesis... set him up in a Garden of Eden close to the Tree of Knowledge, of right and wrong, in the highest sense of

divine revelation. The fall of man was . . . that Adam, by eating from the Tree of Knowledge, sought the creative life to be, like God, 'a creator of worlds,' to use Rashi's phrase, and was reduced to the life of [social] toil as a result of a jealous punishment. In our inability to live the life of a creator can be found the meaning of the fall of man. . . . What is the raison d'etre; what is the explanation of the seemingly insane drive of man to be painter and poet if it is not an act of defiance against man's fall and an assertion that he return to the Adam of the Garden of Eden?" To make art is to recover the sacred prelapsarian state of God-like creativity, in mad defiance of the fall of man into social life. It is to recover the primal aesthetic root which makes human existence "original."

Newman and Duchamp may differ about the aesthetic – Newman romantically regards it as primal and as such existentially ultimate, while for Duchamp it reconceives irrational art as a rational social phenomenon, thus ironically stablizing what is inherently unstable – but they agree that it has nothing to do with the actual work of art. For them the aesthetic does not exist in and through its materiality. Instead, the aesthetic is its conceptual aura – a dawn for Newman, a dusk for Duchamp. Newman locates the primal aesthetic in nature – not human nature, but animal nature. Human experience of it is regressive – a return to origins, to original life, and above all to the primal creativity that makes life original. The material work of art is a mute relic of this return, which is the all-important point, for only creativity gives life meaning and substance. For Newman one must regress to the unsocial core of one's being to experience the originality of one's existence, that is, to realize that one is a unique creation, which gives one the courage to live creatively in an uncreative society. Newman's famous "zip" – a vivid grand gesture the vertical length of the canvas, a kind of punctuation mark of existence, signifying primal howling in the cosmic void, anguished recognition of the originality of being – is the crude but firm trace of this powerful animal feeling. The work of art is a kind

26

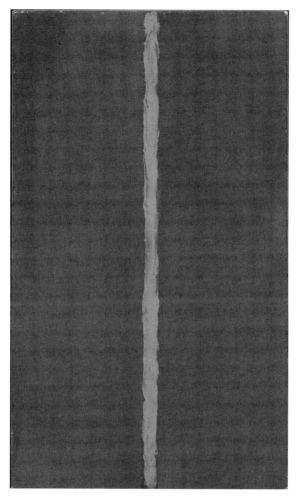

9. Barnett Newman, *Onement I*, 1948. Oil on canvas, $27\frac{1}{4}''\times16\frac{1}{4}''$. The Museum of Modern Art: Gift of Annalee Newman. © The Museum of Modern Art/Licensed by SCALA/Art Resource, NY. © Barnett Newman Foundation/Artists Rights Society (ARS), New York.

of afterthought of the primal aesthetic experience, which is a kind of mystical encounter with the elemental creativity of the cosmos – a mystical embrace of the creativity through which being originates and which sustains it. One can have the experience without actually

making a work of art, unless the dog's howling is a work of art. Similarly, for Duchamp aesthetic experience has nothing to do with making an actual work of art, which involves a kind of self-encounter, and to that extent resembles Newman's existential conception of aesthetic experience. But Duchamp's artist is a kind of mental toiler – a version of Adam after the Fall (Adam easing his unhappy lot by his cleverness) – while Newman's artist is Adam before the Fall, Adam with a fresh memory of God's creation and able to communicate with God, which was his creativity.

Whatever the differences in their conceptions of aesthetic experience, or, as I would prefer to say, aesthetic transformation or re-creation, both conceive it apart from the physical and mental work of actually making a work of art. They do not locate it in the work of art, but before and after its production. They do not realize that the process of making a work of art – even an abortive non-aesthetic work of art such as the readymade – is itself a transformative aesthetic experience. They do not realize that the creative process is an aesthetic process, and that the work of art that results from it is the result of the aesthetic transformation of everyday experience of reality, thus affording a fresh new experience of it, which makes it seem fresh and new, that is, to use Newman's term, original – as though seen for the first time, and thus, implicitly re-created. (This does not necessarily mean, as Newman seems to think it does, that one sees it as though in paradise, and that the artist can talk to God and is even on a par with him, but rather that one's consciousness of it has been radically altered, so that reality seems phenomenologically authentic, not simply routinely given. That is, one seems to own it rather than be owned by it, all the more so, paradoxically, because one wants and expects nothing from it.)

For them, the work of art becomes "anti-aesthetic," to use the fashionable term, or, as I would rather say, post-aesthetic, that is, altogether stripped and emptied of aesthetic value. Art is no longer fine art, that is, the expression and mediation of aesthetic experience – both

Duchamp and Newman, in their different ways, signal the end of fine art, although vestiges of it survive and perhaps will continue to – but rather a psychosocial construction defined by its institutional identity, entertainment value, and commercial panache. No effort will be required to understand it, for there will not be much to understand, or rather it will be comprehensible in everyday terms. The post-aesthetic is not simply ironically opposed to the aesthetic or an alternative ironical aesthetic, as the anti-aesthetic has been understood to be, but, to use Duchamp's words, willfully indifferent to the aesthetic, which is almost to deny its reality. Duchamp clearly wants to deny the finality of aesthetic judgment – the kind of aesthetic objectivity that Kant spoke of – but in doing so he denies that there is any such thing as aesthetic experience. The closest he comes to acknowledging it is his reference to aesthetic emotion, a term which remains unqualified in his writing, apart from its association with taste – and thus judgment. I am sympathetic to Duchamp's non-judgmental approach to the work of art – psychoanalysis has taught us that when the analysand experiences the analyst as non-judgmental he feels safe enough to reveal his feelings, suggesting that when we approach a work of art non-judgmentally we are more likely to fathom the subjectivity implicit in it – but it misses the point that what he lamely calls aesthetic osmosis is aesthetic experience manqué, that is, an abortive aesthetic transformation of the given (like the readymade).

It does not matter that Duchamp's post-aesthetic art is the result of a negative countertransference to the aesthetic – rebellious hatred of it, symbolizing ironical hatred of the spectator, in turn symbolizing absolute hatred of posterity, with its delusion of survival after death (Duchamp's works of art conceived as the skeletal remains of his mind, or cryptic tea leaves left in the empty cup of his life) – or that Newman's post-aesthetic art is the result of his elevation of the aesthetic to the seventh heaven of transcendental creativity, which the work of art can never adequately convey, just as it is never adequate to the artist's

intention, according to Duchamp. What matters is that for both of them art is not inherently aesthetic, but the record of a non-art process, be it personal, as in Duchamp's case, or existentially universal, as in Newman's case. To put this another way, for both Duchamp and Newman art is a translation – pretending to be a transcription – of a primary non-art experience that cannot help but misrepresent and miscommunicate it, rather than an aesthetic transformation of it that represents and communicates the otherwise incommunicado truth about it.

What does it mean to speak of the work of art as quintessentially aesthetic – as the consummate embodiment of aesthetic experience, indeed, the very substance and thus privileged site of aesthetic experience? The British aesthete Walter Pater famously stated: "It is the art of music which most completely realises this artistic ideal, this perfect identification of matter and form. In its consummate moments, the end is not distinct from the means, the form from the matter, the subject from the expression; they inhere in and completely saturate each other; and to it, therefore, to the condition of its perfect moments, all the arts may be supposed constantly to tend and aspire. In music, then, rather than in poetry, is to be found the true type or measure of perfected art."[24] This remains a radical idea, because of its insistence that there is such a thing as artistic perfection – a notion that has fallen by the wayside in the post-aesthetic condition of art, all the more so because perfection seems elitist in an imperfect world.

All art can do is protest it, as so-called Protest Art – a major phenomenon of post-aesthetic art – suggests, by regurgitating its ugly reality back to it, as though to highlight the world's ugliness was a revolutionary artistic act – an artistic call to arms – changing it for the better, if not exactly making it beautiful. Leon Golub's so-called brutal realism, with its fetishization of ugliness, emotional and physical, is an example of such protest, which in fact takes on the character of – deliberately embraces – the reality it protests. If, as Hanna Segal writes, "classical tragedy" is the "paradigm of beauty," then Golub's

unrepentant ugliness – his celebration of the social and "emotional ugly" in all its grotesqueness and "the forces of destruction" in all their relentlessness – and his indifference to the "counterbalancing of the violence by its opposite in the form," indeed, his inability to create the harmonious rhythmic form that makes for beauty able to withstand and "contain feelings which might otherwise be uncontainable"[25] shows the tragic failure of his art as art, as well as his failure to understand the dialectic inherent to the tragic. Neither art nor the tragic are as one-dimensional as he shows them to be, suggesting that he has missed their point. Protest artists fail to realize that beauty is the ultimate protest against ugliness, which is why the absence of beauty in their works shows that they are not critical. They are in fact creative failures. Indeed, the inability to imagine beauty is a sign of the creative inadequacy of post-aesthetic modern art.

The resentment and repudiation of beauty, resulting in a one-sided, aesthetically inadequate art – art that can hardly be called fine art – is a central feature of post-aesthetic art. As Newman said, "the impulse of modern art was this desire to destroy beauty."[26] I would qualify this by saying post-aesthetic modern art, for there is aesthetic modern art, indeed, a subtly tragic aesthetic modern art, whether it be Abstract Expressionism or the figural representations of Egon Schiele, Pablo Picasso, Hans Bellmer, and Lucian Freud. There is in fact a stand-off, not to say futile war, in which victory is invariably Pyrrhic, between unequivocally and uncompromisingly aesthetic art and unequivocally and uncompromisingly post-aesthetic art in modernity, that is, between absolutely beautiful art (sometimes with no trace of the ugly, and so creatively incomplete and inadequate) and art so aesthetically indifferent that it is hard to know why it is called art, or for that matter socially critical art, rather than a simplistic reprise of life which is blind to its complexity. It is worth noting, incidentally, that Newman, however different his paintings are from Duchamp's readymades, agrees with Duchamp that painting should be "at the service of the mind,"[27]

that is, "an intellectual expression."[28] "Modern art is abstract, intellectual," Newman writes. "Modernism brought the artist back to first principles. It taught that art is an expression of thought, of important truths, not of a sentimental and artificial 'beauty'."[29] Pater couldn't agree less: the first principle of art is aesthetic beauty, which transcends the distinction between the abstract and concrete, the intellectual and the sensuous, and which is not sentimental. Sentimentality about art follows from maintaining the distinction – which is what popular or crowd art, or light art, as Theodor Adorno calls it, does. Art doesn't express thought, but rather resolves the difference between an idea and its expression, seamlessly integrating them in aesthetic experience.

"The sensuous material of each art brings with it a special phase or quality of beauty, untranslatable into the forms of any other, an order of impressions distinct in kind," Pater notes,[30] adding that "painting is the art in the criticism of which this truth most needs enforcing, for it is in popular judgments on pictures that the false generalisation of all art into forms of poetry is most prevalent."[31] "In its primary aspect, a great picture has no more definite message for us than an accidental play of sunlight and shadow for a few moments on the wall or floor: is itself, in truth, a space of such fallen light, caught as the colors are in an Eastern carpet, but refined upon, and dealt with more exquisitely and subtly than by nature itself."[32] Pater's example of a great picture – "painting quite independent of anything definitely poetical in the subject it accompanies" – is Titian's *Lace-girl*: "it is the *coloring* – that weaving of light, as of just perceptible gold threads, through the dress, the flesh, the atmosphere, in Titian's *Lace-girl*, that straining of the whole fabric of the thing with a new, delightful physical quality."[33]

Building on Pater's remarks – and influenced by them, as he acknowledges in a footnote on abstract musical painting[34] – the later American aesthete Clement Greenberg writes: "Just as Schönberg makes every element, every voice and note in the composition of equal importance – different but equivalent – so these [American aesthetic]

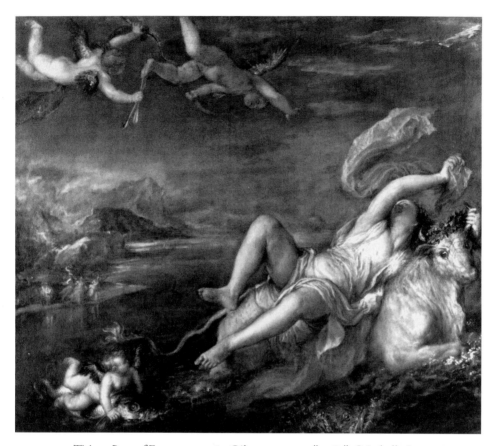

10. Titian, *Rape of Europa*, 1559–62. Oil on canvas, 73″ × 81″. © Isabella Stewart Gardner Museum, Boston.

painters render every element, every part of the canvas equivalent; and they likewise weave the work of art into a tight mesh whose principle of formal unity is contained and recapitulated in each thread, so that we find the essence of the whole work in every one of its parts."[35] Interestingly enough, in what seems like an emulation of Pater, Greenberg celebrates Titian as "the central and perhaps supreme master of ... five centuries,"[36] observing that "Titian's color has a substantiality of texture that makes it hard to conceive that it is the product of thin layers of paint spread on a sheet of canvas; one has the impression of

configurations that well up out of infinite real space – as if the reverse as well as the obverse of the canvas had been transformed by paint. Or as if the very threads of the fabric had been dissolved into pigment so that the picture consisted entirely of paint without a supporting surface. And yet – this is the contradiction essential to art – the supporting surface that we know to be actually there is not denied as flatness, and we feel this without feeling any the less the illusion that it is not there."[37]

According to Pater and Greenberg, aesthetic experience is heightened sense experience, separated from all other experience. It is inherently beautiful and affords pure pleasure. This was also the view of antiquity. In Plato's *Philebus* Socrates states: "True pleasures are those which arise from the colors we call beautiful and from shapes; and most of the pleasures of smell and sound. . . . such sounds as are pure and smooth and yield a single pure tone are not beautiful relatively to anything else but in their own proper nature, and produce their proper pleasures." In the *Tusculan Discussions*, Cicero writes: "There is a certain apt disposition of bodily parts which, when combined with a certain agreeable color, is called beauty." St. Augustine agrees, using almost exactly the same words in *On the Kingdom of God* (xxii, xix). The idea survives in modern philosophy. Thus, for Schopenhauer, in *The World as Will and Idea* (1818), the pleasure of beauty arises from "disinterested . . . sensuous contemplation." As the phenomenologist Mikel Dufrenne writes, "the being of the work of art yields itself only through its sensuous presence, which allows us to apprehend it as an aesthetic object."[38] Meaning is "immanent in the sensuous, being its very organization."[39] More complexly, but in a related way, Hegel, in his *Aesthetics* (1835), writes: "art has the function of revealing truth in the form of sensuous artistic shapes and of presenting to us the reconciliation of the contradiction [between sense and reason, between what is and what ought to be, between desire and duty]. Consequently it contains its end in itself, in this very revelation and presentation."

The beautiful work is one in which this aesthetic reconciliation seems inevitable. As Hegel says, "the greatness and excellence of art . . . will depend upon the degree of intimacy with which . . . form and subject-matter are fused and united."

This dialectical point of view continues virtually unchanged in Pater and Greenberg. They differ in privileging music as the greatest art, and in the visual arts, musical painting, that is, painting which takes music as its model. It is in music and musical painting that form and subject matter are most clearly reconciled. They seamlessly fuse and unite – dialectically merge, as it were – to the extent that they can no longer be differentiated. Greenberg carries this one step further: in the great musical painting the paint and canvas seem one and the same, however much one knows them not to be. For Greenberg this illusion is the supreme aesthetic triumph. If, as Hegel writes, "it is the function of art to present ultimate reality to our immediate perception in sensuous shape," then in great music and great musical painting the sensuously immediate *is* ultimate reality. Revelation and presentation are reconciled. They are inseparable in aesthetic experience. Thus, great music and great musical painting are the most realized arts. They are artistic consciousness at its most unconditional, that is, unconditioned by worldly concerns.

Hegel writes: "the interest in art is distinguished from the practical interest of desire by the fact that it leaves its objects alone in their independence, while desire adapts them, or even destroys them, for its own purposes. Conversely, artistic contemplation differs from the theoretical contemplation of the scientific intelligence in cherishing an interest for the objects in their individuality; it does not busy itself in reducing them to universal thoughts and conceptions." For Pater and Greenberg, the connoisseur of art – the person seriously interested in art – enjoys music and musical painting more than any other art. He looks at art with an eye to finding the music in it. He feels its music in his senses, and if his senses are contemplatively attuned to it,

and there is no music to be heard, he knows that it is not great art, however interesting from a worldly point of view – from a practical and theoretical point of view. For Pater and Greenberg, music and musical painting are the most aesthetically consummate arts, and as such the arts most removed from exploitive practicality and scientific reductionism, both of which manhandle reality. They murder it to dissect it, as has been said, and also to use it, both of which are a kind of merciless abuse, at least from an aesthetic point of view. They betray reality in the act of knowing it. Desire and science relate to reality in a completely different way than pure art. Pure aesthetic art has a respect for the subtlety and individuality of objects beyond the ken of both. The aesthetic approach to objects sees the beauty in them. As Hegel says, "art does indeed possess this formal character of being able to beautify every possible subject-matter by engaging our contemplation and our feelings."

Post-aesthetic art loses this respect, and with that the age-old concern for beauty, involving the aesthetic attempt to reconcile form and subject matter so as to sensuously reveal the truth of the subject matter. Instead post-aesthetic art regards form as a kind of scaffolding for subject matter or a platform from which it can be proclaimed. Like a politician, the artist has a "position" about his subject matter, and his presentation of it often consists in thrusting it in the spectator's face, so to speak. This does not make it a revelation. In post-aesthetic art subject matter tends to be experienced as in-your-face because it is left more or less aesthetically untransformed; that is, little or no effort is made to give it a satisfying form. Form is minimal, as it were, subject matter is maximum, making for a somewhat unbalanced work of art, at least from an aesthetic point of view. The matter-of-fact form the subject matter has in everyday life is regarded as its "true" form – the form that shows it as it really is. Subject matter *is* form from the post-aesthetic point of view, which means that any effort to aesthetically modify or "re-form" it is regarded as falsifying. The subject matter speaks for

itself, which is "artistic" speech enough for the post-aesthetic artist. He has no realization that aesthetic form represents what Jacques Maritain calls creative intuition into the subject matter. Thus, post-aesthetic art involves a certain failure of creativity.

In a post-aesthetic art world the work of art becomes a bully pulpit, and the artist tries to bully the spectator into believing what the artist believes. He becomes a self-righteous bully preaching to us (or rather at us) about what we already know – the ugliness and injustice of the world – without offering any aesthetic, contemplative alternative to it. Indeed, the aesthetic, the contemplative, and the beautiful are bad words in the artist's "revolutionary" vocabulary. They do not speak to his attempt to make the world a better place to live in, at least according to his idea of a better world. Social criticism is no doubt a noble cause, and changing the world for the better is no doubt a heroic enterprise, but it is far from clear that art is effective at both. The artist is not exactly the best person to educate us to the realities of the world nor the best person to help us endure and even overcome our suffering.

Most disastrously, the supposedly moral use of art as meliorative criticism and social advocacy abandons the civilized idea that art is the privileged space of contemplation, and as such a reprieve and sanctuary from the barbarism of the world – however much that may be its subject matter – and thus a psychic space in which we can own ourselves and survive, that is, realize autonomy, however aware we are of the special and limited conditions in which it is possible. It ignores the ethics inherent in aesthetics and beauty. Artistic contemplation – as distinct from art as a kind of social practice and even theorizing (manqué) about the world – is a way of caring for one's psyche. Art will serve the mental health of whomever turns to it in pursuit of aesthetic experience and beauty. When one looks at Otto Dix's horrific images of trench warfare, his aesthetic transmutation of death and destruction into a weirdly beautiful scene gives us a certain perspective on it that is more critically effective – more consciousness raising, as it were – than any

journalistic rendering of it. It is also more soul-saving, for it has a cathartic effect that no war photograph can have. The photograph may move us, but it will not rescue us from the unpleasant feelings it arouses in us, which is what Dix's aesthetically brilliant images do in the very act of evoking such feelings. The photograph shows us the devastating scene, but Dix's images not only show its devastation, but involve us with it, in a complex dialectic of identification and disidentification – shocked attachment and resolute detachment – similar to the dialectic of subject matter and form. In short, aesthetic autonomy is a prelude to personal autonomy, even a basic part of it. Human beings are not fully human without aesthetic experience.

In a devastating critique of post-aesthetic adversarial art, William Gass eloquently describes the difference between it and aesthetic art, that is, art that is beautiful, for him the only successful art. Pleading for a return to beauty, he in effect argues that socially relevant art – whatever the character of its relevance (which tends to be journalistic, if sometimes editorializing) – is a massive failure as art.

> I think it is one of the artist's obligations to create as perfectly as he or she can, not regardless of all other consequences, but in full awareness, nevertheless, that in pursuing other values – in championing Israel or fighting for the rights of women, or defending the faith, or exposing capitalism, supporting your sexual preferences or speaking for your race – you may simply be putting on a saving scientific, religious, political mask to disguise your failure as an artist. Neither the world's truth nor a god's goodness will win you beauty's prize.
>
> Finally, in a world which does not provide beauty for its own sake, but where the loveliness of flowers, land-scapes, faces, trees, and sky are adventitious and accidental, it is the artist's task to add to the world's objects and ideas

those delineations, carvings, tales, fables, and symphonic spells which ought to be there; to make things whose end is contemplation and appreciation; to give birth to beings whose qualities harm no one, yet reward even the most casual notice, and which therefore deserve to become the focus of a truly disinterested affection.[40]

3

SEMINAL ENTROPY: THE
PARADOX OF MODERN ART

Duchamp and Newman malign the aesthetic by separating it from the work of art and the process of making art. They do not see it as an aesthetic process and experience, but, in Duchamp's case, an irrational psychodynamic process, and in Newman's case, a primal creative process. There is nothing that requires the psychic process and experience to be embodied and expressed in art. It has its own inherent validity, independent of art. It can be expressed, but it remains inexpressible and needs no legitimation by cultural externalization. Every cultural embodiment of it falsifies and misrepresents its narcissistic import. Sensuous presence and pleasure, so essential to the epiphany called the aesthetic, are beside the point of the work of art, which is a kind of memento mori of supposedly deeper processes. There is nothing fundamental about sensuous experience, however pure and intense, for Duchamp and Newman. It is in fact a distraction from psychocreative fundamentals, inevitable – for sensing cannot be suspended, and the work of art presents itself to the senses – but deplorable, for, in their ideal world, the work of art would only present itself to the mind. Implicit to their thinking is the old idea that sensing is deceptive and misleading, a view that can be traced back to Plato, who, in the epistemological metaphor of the divided line in the *Republic*, located art in the realm of sensuous illusion, along with shadow. A stick seems

to bend in a glass of water but we know it doesn't. Art, like that water, is the medium of illusion. It is a natural lie, as it were, which reason can see through.

The division between reason and sense haunts modern art, a split that undermines it from within, eventually destroying it – pulling it apart into factions, each of which proliferate uncontrollably without the check of the other – however initially stimulating it is to creativity, so much so that it leads to great originality, ultimately issuing in an art of seemingly pure reason (so-called conceptual or idea art) and pure sensuousness (what Greenberg called postpainterly abstraction). In other words, this unbalanced situation, which is evident in modern art from the beginning – from Manet, who for all his effort to render a reasonable representation of reality often used unreasonable sensuous means of doing so – is as entropic as it is creative. (We see the same thing in early Chardin, where, up close, the painting is an intricate mass of sensuous details, while from a distance it looks like a completely reasonable, coherent, and convincing representation of reality.) I want to argue that in the history of modern art the entropic becomes dominant, to the extent that modern art increasingly seems like a failure of creative nerve, or rather, more pointedly, creative imagination and creative intuition – imaginative intuition, one might say – come to be beside its point. Creative imagination, eloquently analyzed by Baudelaire and Coleridge, is replaced by pandering to everyday social interests, usually stripped of their affective resonance and existential implications – their human dimension. Art becomes a way of getting an ideological message across (to refer to Lucy Lippard's feminist "Get the Message?") much the way, for Plato, myth was a way of making the truth comprehensible to the simple-minded masses, or at least putting it in a hyperbolic narrative form that turned it into a spectacle that would hypnotize them into believing they in fact were in possession of it.

But post-aesthetic art's ideological message does not come with any mythopoetic sugarcoating. And it is topical and newsworthy, not

necessarily the whole truth and nothing but the disinterested truth. It must be swallowed raw – in post-aesthetic art the idea is raw and intellectually and emotionally undigested, and there is little or no art. Nuance and subtlety are expendable; the message is all, and it is ultimately a self-righteous one, calling for a new conformity and simplicity in its conception of the social truth. Indeed, the simpler the message the better, for a simple message is easier to communicate to the masses than a dialectically complex one. Ideas become slogans – banner headlines – in ideological art, if it can still be called art. For it seems more like a poor cousin of the mass media, lacking both their slickness and outreach. Indeed, the point is to be as "artless" as possible, for art, after all, is a distracting illusion appealing to the senses not the revolutionary-minded.

The imaginative transformation of socially objective reality to bring out its subjective significance all but disappears, along with a sense of the complexity of the subject, however much subjects continue to be presented as case histories and specimens, as in the video performances of Tony Oursler. In their quasi-clinical if comic detachment, they are a long way from Géricault's portraits of the insane, which convey their humanity as well as their suffering – the tragedy of their lives. In other words, the collapse of the sense of what it is to be human, more pointedly, of all feeling for what it is like to be inside another human being – an empathic, humanistic goal of modern art since romanticism (Goethe, echoing Terence, and echoed by Hegel in the *Aesthetics*, famously declared "Nihil humani a me alienum puto" [nothing human is alien to me]) – goes hand in hand with the collapse of creative imagination. If the aesthetic reconciles reason and sense (form and subject matter or message) – in the material work of art, as Pater, Greenberg, and Hegel argue – then modern art is an aesthetic failure, for the split between an art of reason and an art of sense grows greater and greater, each finally purifying itself in complete indifference to the other.

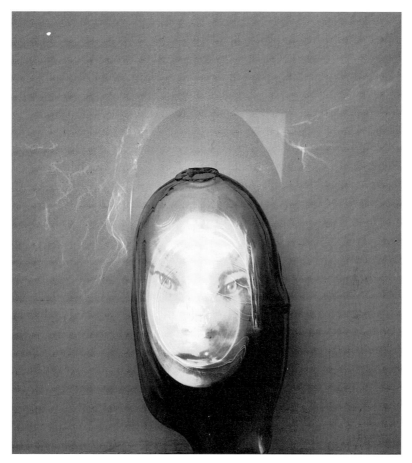

11. Tony Oursler, *Creeping Numbers*, 2001. SONY DPL CS2 projector, DVD player, DVD, glass, fiberglass sphere. Performance by Casson Demmon. $30\frac{1}{2}'' \times 16'' \times 13''$. Courtesy of Metro Pictures.

Duchamp announced the entropic split – the end of aesthetically integrated art, that is, so-called fine or high art (dialectical rather than one-dimensional art) – when he sharply distinguished between "intellectual expression" and "animal expression."[41] He elevated the former at the expense of the latter – which he misrepresented and slandered. In the nineteenth century "the more sensual appeal a painting provided – the more animal it became – the more highly it was regarded."

Before then, "all painting had been literary or religious: it had all been at the service of the mind,"[42] as though there was nothing sensual about it – as though sense and reason were not integrated in the best literary or religious painting. But of course such integration, which is the achievement of the aesthetic, is beside the intellectual point for Duchamp. Clearly he has a rather one-sided view of painting. He also neglects to face the fact that nineteenth century sensual painting, which he acknowledges is a unique development in the history of art – and aesthetically unique – is a greater creative innovation than any literary or religious painting, however imaginatively such a painting may recreate literary or religious themes, arriving at aesthetic perfection in the process of doing so.

"His disdain for sensual painting" was irrational, as Robert Motherwell implies.[43] However much it was informed by "the despair of the aesthetic"[44] – the lack of any reason to prefer one "retinal" sensation, as Duchamp called it, over another, using it in a painting in which all seem pleasurable (this was Duchamp's basic critique of Fauvism) – his hatred of sensual painting clearly had to do with Picasso and Matisse, its masters. They achieved fame when Duchamp was still trying to find his artistic footing. Thus, they had to be annihilated, and the best way to do so was to devalue their medium – deny the significance of painting, which Duchamp repudiates as passé, that is, not modern. He went so far as to declare, in final nihilistic indifference – what rage did his indifference mask? – that painting has been "dead . . . for a good fifty or a hundred years,"[45] which effectively trivializes and demolishes Picasso and Matisse (whose Fauvism he initially emulated, however crudely) as well as Cézanne. Duchamp preferred the more scientific – mock scientific, I would say, like Duchamp himself – Seurat. Fiercely competitive and vengeful, Duchamp established an outsider position for himself, becoming "the asp in the basket of fruit," as Motherwell said. I would add that he spoiled all the fruit and upset the basket of art itself, punching holes in it so that it could no longer hold any fresh

sensual fruit. Duchamp was an envious spoiler, spoiling whatever he touched out of envy – it scoops the goodness out of life, as Melanie Klein said, coveting what it cannot create (the Devil's envy of God is the cardinal sin, and the reason Shakespeare calls envy the green-eyed monster) – especially the innovative art that the father figures of twentieth century painting created. In a sense Duchamp wanted to out-innovate them, but the only way he could do so was to destroy the aesthetic ground on which their art was built, spoiling the spectator's pleasure. Perhaps his greatest achievement is the discrediting and undermining of the aesthetic. It is a triumph of destructiveness that has corrupted twentieth century creativity.

Ironically democratic, no particular painting was better than any other for Duchamp – what matters is the idea it conveys not the sensuous form it gives the idea – apart from the general superiority of intellectual art to animal art. He is grateful "for the beauty . . . provided" by Matisse's work, but "it created a new wave of physical painting in this century or at least fostered the tradition we inherited from the XIXth century masters."[46] It is as though sensual physical painting – beauty itself – was an eccentric deviation in the history of art, which Duchamp was going to put back on the right intellectual track. The old hierarchical way of thinking informs his seemingly novel idea: the sensual is demeaned as animal – conceived as something repulsive – and the intellectual is regarded as uniquely human. His art is an attempt to negate the animal with the intellectual. Using the intellectual destructively, he never discovers any constructive purpose in it.

In 1956, a decade after making his famous – and conventional – distinction, Duchamp declared: "I am interested in the intellectual side, although I don't like the word 'intellect.' For me 'intellect' is too dry a word, too inexpressive. I like the word 'belief.' I think in general that when people say 'I know,' they don't know, they believe. I believe that art is the only form of activity in which man as man shows himself to be a true individual. Only in art is he capable of going beyond the

animal state, because art is an outlet toward regions which are not ruled by time and space."[47] Are these the same regions conceived by religion? It seems so, as the word "belief" suggests. Is Duchamp being ironical, as he usually is? Perhaps they are the hellish regions of the unconscious rather than the heaven of salvation. Whichever, and however probably the former, Duchamp is for once not being ironical: he's revealing his Achilles heel – the animal state. He doesn't realize that what you repress will return with a vengeance, and in fact was never really absent and lost. It always has an unconscious influence on what one consciously creates. For Duchamp woman represents the animal state, and woman is the recurrent theme of his art, implicitly and explicitly. It is an old idea, which Mondrian also believed – as he wrote, he turned to the rational straight line in rebellion against the irrational feminine animal/natural curve (which he also thought of as tragic, in contrast to what he regarded as the joie de vivre of his color-controlling grids) – traceable back to the nineteenth century decadent poets, who preferred artificiality to nature (and their own animal functions), symbolized by woman, and before that, to the Bible. This idea is alive and well in many societies.

Duchamp's major pieces, the Large Glass and *Étants Donnés*, dwell on woman with a contempt and hatred that no amount of irony can conceal. She is mocked and abused in both works, her body maligned and humbled into a mechanical object, a kind of grotesque erotic machine (Motherwell's phrase) in the former work and a ruined mannequin in the latter. In the Large Glass Duchamp attacks and distorts her body, in *Étants Donnés* he attacks and uproots her genitals, the site of her sexuality – a perverse, destructive step further, suggesting the castration of the phallic woman. Woman is the scapegoat of his desire. He resists sexual temptation by destroying its object. Where faith in God helped St. Jerome overcome his sexual temptations, faith in ironical intellectuality helped St. Duchamp do so. Faith in something higher and presumably more dignified than the animal helped them

overcome the gross sexual animal in themselves. Duchamp subsumed and sublimated it into an art of ironical reason, that is, intellectual activity in artistic disguise. Jerome also subsumed and sublimated his sexual drive into intellectual activity, as his Latin translation of the Bible, the Vulgate, and numerous theological writings, indicate.

Does their intellectuality help them escape their sexuality? I don't know in the case of Jerome, but in Duchamp's case it seems clear that he remains obsessed with sexuality. He was not too successful repressing it, except, perhaps, when he was playing chess. He didn't have to worry about the unexpected return of repressed sexuality, for its artistic repression (mechanical treatment) took the excitement out of it, but it was unable to exterminate the body in which it existed – the female body that, however injured, continued to have a sexual identity, indeed, to emanate sexuality even in death. It is worth noting that chess, however intellectually demanding, is sexual in import, however ironically. The queen's job is to protect the king. She is able to do so because she is more powerful than he is – indeed, the most powerful piece in the game. King and queen can make the same moves, and thus resemble each other, but he is allowed to move only one square at a time, while she can move over as many squares as she wants – a crucial difference between them. Nominally the ruler, he remains impotent and passive relative to her. Duchamp, who officially became a chess master, implicitly identified with the queen, even as he used her to protect the king in himself.

The "checkmate" that concludes the game also suggests its perverse sexual character. Chess is an ironical "mating" game; Duchamp probably took to it, like a duck to water, because to mate in chess means the opposite of what it does in life – not sexual fulfillment and intimacy, in which each partner erotically and emotionally wins, but the frustrating end of the game, that is, the checking and defeat of the king that has been mated. One or the other player becomes a frustrated loser in chess. Mating is destructive rather than humanly constructive

in chess. If perversion is the erotic form of hatred, as Robert Stoller argues, then the game of chess is profoundly perverse – a perverse battle in which the players are antagonists rather than lovers. They relate only by being at odds, a dubious intimacy achieved by positioning their pieces – each implicitly a body part, militarized into a weapon – in perverse relationship to one another. Heat may be generated – hatred can be as passionate as love – but there is a tactical coldness to the whole game, which no doubt appealed to Duchamp. Cold detachment rather than warm attachment – although Duchamp could be ironically cordial, misleadingly inviting – is the way to win the game. Sexual mating always incorporates aggressivity (it looks like violence to a child), as Freud reminds us, but checkmating is pure aggression – the murderous climax of a long, patient battle.

Sometimes the relationship ends in a "stalemate," a wonderful term that epitomizes Duchamp's idea of the work of art as well as the ideal relationship with a woman. Both are brilliantly exemplified in the Large Glass. *Étants Donnés* shows that stalemate has become intolerable: Duchamp resorts to violence to win the battle of the sexes, showing that he is deadly serious, and never loses. His works are not simply war games – glorified chess games – but a fight to the finish with woman. For Duchamp a game of chess with the enemy – fully dressed, he perversely played one with a rather voluptuous female nude at the opening of his retrospective in Pasadena – was the perfect antidote to emotional intimacy with her, all the more so because chess is pseudo-sexual (substitute perverse sex). Does Duchamp finally murder the queen in *Étants Donnés*, asserting that he, the artist, is the only royalty allowed in the game of sexual chess? Clearly in turning to chess he gave up neither art nor sex.

Has Duchamp understood the sensual animal? He simplifies it – sensuality is a compound of sensing and feeling, not simply a matter of sensing. (Duchamp spoke of "the 'antisense'" character of the Large Glass.[48]) Sensual woman has always been associated with feeling

rather than reason – as operating on the basis of her irrational feelings rather than her rational mind. In fact, she has often been regarded as too feeble-minded to do any serious thinking. This is an old cliché, and Duchamp has fallen for it – certainly a serious failure of critical consciousness for a self-proclaimed intellectual. He has the same conflict about woman that many men do, and the same emotional need to devalue her, which goes hand in hand with devaluation of his sexuality. He may identify with woman, as his manifestation as Rrose Sélavy indicates, but it is an ironical identification, in which he shows himself as a dowdy, unsensual woman, in effect projecting his rejection of sensuality into his ironical self-representation. The conflict is not only between reason and sense, but also between reason and feeling, sense being the avenue to feeling, which is, conventionally, woman's domain. Duchamp seems blind to the fact that there is no thinking without feeling and sensing, which suggests that woman may be a better thinker than man, for she is not alienated from her own feelings and senses. Feeling is the ultimate enemy for Duchamp, not sensing, and his works seemed imbued with flat affect – feeling deadened.

Matisse's painting is famous for its joie de vivre; Duchamp's art is joyless. If, as Robert Lebel said, that, with *Fresh Widow*, 1920 – a French window with "the little panes covered with black leather" [suggesting sadistic fetishism] that "would have to be shined every morning like a pair of shoes in order to shine like real panes," with the word "fresh" meaning "smart" (and thus a merry widow, according to Lebel, that is, a woman promiscuously dancing on the coffin of her husband) – Duchamp "reached the limit of the unaesthetic, the useless, and the unjustifiable,"[49] then the unaesthetic is joyless, anhedonic, altogether feelingless. Duchamp's ultimate prophylactic goal was to feel nothing, which, unexpectedly turned mind into a joke – although he didn't realize it – for without feeling mind is purposeless play, cleverly competing with and outsmarting other minds, as in chess. Erotic feeling may be

disguised by this mental play, as Duchamp suggested, "not . . . out of shame," as he correctly said, but out of hatred, as he failed to recognize. If, as Freud said, Eros and Thanatos are the forces that polarize life, and if Eros brings people temporarily together and Thanatos separates them forever, then Duchamp comes down squarely for Thanatos however much he is haunted by Eros. His art and attitude epitomize the paradox of modern art – the death drive or entropy that informs its creativity, making it ironically alive and exciting, even when it is inwardly dead, that is, nothing but pure mind. It is what eventually disintegrates the work of art as art, destroying its aesthetic potential by turning it completely toward everyday life without offering any imaginative insights into it, that is, actualizing it as an extension of everyday thinking without offering any new in-depth thinking about its character and effect on the people who live it. Such commitment to banality, with its predatory curiosity and uncritical dependence on everydayness, and sometimes ironical manipulation of it – a perversity which in Duchamp passed for art making – is the kiss of aesthetic death, and artistic death, for it makes art just another everyday phenomenon.

The undertow of entropy in modern art, which is what makes it seem perverse and problematic, as well as paradoxical, and gives its remarkable innovations and wide-ranging creativity a look of desperate futility, a kind of whistling in the dark – Duchamp's harping on the ineffectiveness and irrelevance of the aesthetic says as much – has been brilliantly described by Rudolf Arnheim.

> Disintegration and excessive tension reduction must be attributed to the absence or impotence of articulate structure. It is a pathological condition, on whose causes I can hardly speculate here. Are we dealing with the sort of exhaustion of vital energy that prophets and poets proclaimed and decried in the last century? Is the modern world socially, cognitively, perceptually devoid of the kind of high order needed to

generate similarly organized form in the minds of artists? Or is the order of our world so pernicious as to prevent the artist from responding to it? Whatever the causes, these products [modern works of art], although often standard artistically, reveal strong positive objectives: an almost desperate need to wrest order from a chaotic environment, even at the most elementary level; and the frank exhibition of bankruptcy and sterility wrought by that same environment.[50]

Arnheim observes "that the increase of entropy is due to two quite different orders of effect; on the one hand, a striving toward simplicity, which will promote orderliness and the lowering of the level of order, and on the other disorderly destruction."[51] The former leads to "the emptiness of homogeneity," exemplified by seriality, especially the seriality of the grid, which often seems an end in itself in modern art. The latter leads to the "disintegration" of "organized structure . . . either by corrosion and friction or by the mere incapacity to hold together,"[52] evident, Arnheim argues, in Pollock's paintings and abstract expressionistic paintings in general, which look like the shapeless residue of an explosion, and in "the shapelessness of accidental materials, happenings, or sound" presented as art. (One recalls John Cage's remark that beauty is underfoot, in every chance sound and passing appearance, which is why one doesn't have to look for it in museums.)

I propose that instead of understanding modern art in terms of movements – a telling modern term, aligning modern art with the many social and political movements that help give the modern period its unique dynamic character, that convey the modern sense of always being on the move, always going somewhere (if not always knowing where) – one understand it in terms of the dialectic of entropy and creativity, or, to use Arnheim's terms, the morbid catabolic and healthy anabolic forces that make it self-contradictory. This cuts across

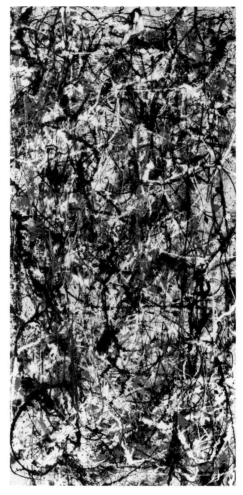

12. Jackson Pollock, *Cathedral*, 1947. Enamel and aluminum paint on canvas. H $71\frac{1}{2}''$ × W: $35\frac{1}{16}''$. Dallas Museum of Art. © 2004 The Pollock-Krasner Foundation/Artists Rights Society (ARS), New York.

stylistic and conceptual differences and honors the fact that virtually all modern movements are short-lived "breakthroughs." They appear abruptly, and they disappear almost as abruptly. They seem to die as soon as they are born, their flowers quickly fading and pressed

between the pages of history, losing their perfume and flavor to become intellectual and cultural artifacts. They may be exciting experiments, as has been said – in recognition of the knowledge gained from scientific experiments (where art once paid homage to religion and its beliefs, much of it now pays homage to science and its methods) – but they are experiments with often inconclusive results. It is not clear that they give us knowledge, at least not knowledge of the same order as scientific knowledge. This is why new artistic experiments are always being made – why modern art has remained in an "experimental" state, according to some thinkers, for example, E. H. Gombrich. (Picasso said he was interested in results not experiments, but he never stopped experimenting, suggesting that he was dissatisfied with the results – not certain of their significance.)

In no time at all, as Leo Steinberg argues – in three to five years at most – an avant-garde enfant terrible becomes an academic elder statesman, his moment of creative glory over and socially assimilated and institutionally categorized almost as soon as it happens. The imminent and perpetual threat of entropy in the modern world – it always seems on the verge of catastrophic disintegration, and in fact readily deteriorates into homogeneity (standardization) and violence (sadistic indifference) – motivates modern creativity. Indeed, the death drive, however immanent in existence, seems to hover above the surface of modern life, which often seems like an updated Triumph of Death. More and more outbursts of life-giving innovation and avant-garde affirmation, each with less and less shelf life – the more pyrotechnical and spectacular the better (and they become more and more attention-grabbing as modern art "progresses," as though to combat the short attention span of the modern spectator, suggesting that entropy has also infected his consciousness, which is even more short-lived and has fewer breakthroughs than avant-garde art) – are necessary to keep the death drive at bay. Perhaps nowhere is the restless

impatience of modern consciousness, growing ever more jaded and bored with every breakthrough, more visible than in art. People may be baffled by scientific and technological breakthroughs, but they never disappoint, and never seem pointless or clever for the sake of cleverness.

The spectator defends himself against novelty with a sense of déjà vu – why, after all, should he struggle to keep up with all the breakthroughs, particularly when they seem to feed off each other, losing their critical edge, and suggesting that they have no larger purpose, while the artist imagines he keeps himself from becoming passé by making his art more and more of a spectacle, which of course is self-defeating, for only what is passé finds its definitive place in the waxworks of public spectacle. (Art about art is prevalent in postmodernism, signalling the narcissistic bankruptcy of art, all the more so because art about art offers no new insights into art, but reproduces old art, with whatever ironical twist, which destroys its import. It becomes a designer look in an encyclopedia of art looks, losing its unfamiliarity by become a familiar visual cliché. So-called decontextualizing appropriation and recontextualizing restoration – the relocation of stale old art to a new artistic site, where it is juxtaposed with other oldies but goodies in the hope that the friction created by the difference between them will generate a sufficiently large sense of meaning that will hide the fact that they both have become experientially meaningless historical artifacts – is the basic method of postmodern art. Philip Johnson's A T& T Building and David Salle's paintings – they're both masters of appropriation – are among the more sophisticated examples. Sherrie Levine's mechanical reproductions of old modern masterworks is a more simplistic example.)

Ironically, the sophisticated feeling of déjà vu and the tragic feeling of being passé – both are variations of indifference (without the irony) – are perversely entropic in import: they signal the exhaustion of creativity, the abandonment of critical consciousness, the replacement

of the "sensation of the new" (Baudelaire) with what might be called fatigue with the new, bringing with it a sense of the purposelessness of art. The sense that one is watching the eternal return of the same, involving ironic apathy – the viewing of every new breakthrough and experiment as the latest coy fashion in the wardrobe of the emperor's new clothes – is the symptom par excellence of postmodern entropy. If modern art was energized by a sense of breakthrough and experiment – if the modern artist thought of his studio as a laboratory, as both Picasso and Duchamp said – postmodern art represents the exhausted aftermath.

The public street has become the studio – not only implicitly, but often explicitly – for many postmodern artists. Indeed, Allan Kaprow's happenings, pitched to the crowd, took place on what might be called a simulated street rather than in the private studio. The artist was no longer centered in the studio, where he was the master of all he surveyed, but decentered in the street, another marginal figure in a social space in which everyone is marginal, for the street has no center. No one can be centered in himself in a crowd, for there is no model of a center in it, which is why it is inherently shapeless, however much it may now and then be ordered according to a certain belief. Like Nicolas Cusanus's universe, the crowd is a circle whose center is everywhere and whose circumference is infinite, which means that it is nowhere and that no one in it is anywhere. Everyone in a crowd is homogeneously marginal, as it were, and thus in principle the same. (This is why panic subliminally pervades the crowd, looking for an occasion to explode and disrupt it, as though the explosion will restore the personal autonomy and precarious individuality lost to the crowd. When men joined the army in the first world war, which was initially welcomed as a cleansing purge, they happily relinquished their individuality for the crowd's higher cause. But they suddenly realized they were individuals when they found themselves facing death in the trenches. This is why many of them, including such major modern artists as Beckmann and

Kirchner, had breakdowns. They lost their sense of self out of fear of death, which the unempathic military did nothing to mitigate – after all, they were dispensable – and their breakdown ironically restored them to selfhood. They experienced their existential reality only when their existence became meaningless. The effect of this was undoubtedly traumatic, but the trauma woke them up to the reality of their lives. For the artists art became *the* way of acknowledging the existential trauma and recovering a sense of self in the process of doing so. This is particularly evident in the case of Beckmann, whose many self-portraits show him in different social situations – all reminiscent of war zones in their emotional difficulty – as though he could endure them all and still be himself.)

Unlike modern artists, postmodern artists are not interested in al-chemical experimentation, however uncertain the result – they are too disillusioned to believe that works of art can be alchemical miracles – but in having an audience that will make them popular, giving them the celebrity and charisma they believe they are entitled to as artists. But they lost their raison d'etre the moment they thought of them-selves as entertainers representing a mass audience's everyday wishes to itself (which is one definition of entertainment) – thus becoming celebrities by celebrating with the crowd – rather than reclusive al-chemists struggling to purify the dross of everyday reality into the gold of high art. The moment they gave up the inner solitude – the real, secret studio – necessary for serious creativity, they became publicists for an anonymous, random audience. They became as conformist and banal as their audience. They received their identity from the crowd, rather than earned it by their nonconformist creativity. The postmod-ern point is to become a media artist, not an avant-garde artist – which today would mean an artist in advance of the media, which very quickly catches up with him, mediaizing him into a transiently topical social phenomenon. The postmodern media artist repeats, in hackneyed, slick form, the alchemical experiments of modern art, turning it into a

caricature of itself by making it seem everyday. This gives his work the touch of magic necessary to transfix the crowd without giving it a new perspective on existence and a new vision of reality – which is what the best modern art does – that would threaten and unsettle the crowd, so that it could never again feel comfortable with and trust itself. Indeed, no one in a crowd can ever again feel at ease in it once his vision of internal and external reality have been shaken by modern art. But the postmodern artist doesn't want to disturb the crowd, but rather affirm it by mirroring it, thus justifying its belief in itself and its everyday view of reality and life, as though it were the only one possible. No artistic earthquakes for him. Instead he fills in the abysses modern art opened, landscaping the terrain of the modern world as though there were no more faults in it.

Postmodern artists are caricatures of artists, for they make the artist part of the crowd, an everyday person with an everyday job to do like everybody else. They do not create panic by making everything familiar seem unfamiliar, as the best modern artists did – suggesting that there is no firm ground for life as well as art – but offer the crowd a brief reprieve, a facile moment of uplift, as it were, from their normal unhappiness, as Freud called it. Thus, postmodern artists ironically realize the therapeutic intention of modern artists, trivializing it in the act of doing so. Disillusioned about art, they still have illusions about themselves – about what art can do for them (not what they can do for art), namely, make them rich and famous, or at least newsworthy if not exactly noteworthy. With them, art becomes socially redundant – proliferates pointlessly, as Trilling suggests, becoming a lame duck repetition of the "already read, seen, done, experienced," as Roland Barthes says. It inhabits social space without becoming personal space. It becomes fatalistically historicist, or at best Alexandrian – "the imitating of imitating" – as Greenberg said.

Arnheim's distinction between the two orders of entropic effect is tailor-made for modern art: geometrically oriented art tends to empty,

energyless homogeneity, gesturally oriented art to explosive disintegration, in which energy is extravagantly dissipated, resulting in a sense of chaotic disorder, subliminally or overtly. (Both kinds of modern art ironically re-create – one might say sublimate – the entropic conditions that prevail in the crowd.) All modern art, whether abstract or representational, is oriented, formally and expressively, toward the geometrical and the gestural – Cézanne implicitly made this point when he struggled to create a Poussinesque Impressionism, as he suggested – and often tries to combine them, which is what occurs in the work the gesturalist Kandinsky made in the 1920s, when he was at the geometrically oriented Bauhaus, and the work that Paul Klee made throughout his career. Mondrian and Sol LeWitt are the leading exemplars of geometrical abstraction – they are the alpha and omega of its development – and Pollock and Willem de Kooning are the grand climax of gestural abstraction, Pollock's all-over paintings showing it at its purest, de Kooning's paintings conveying its existential import. De Kooning shows the entropy that makes the human body seductive in modern times. It is the death in de Kooning's women that attracts us, not their sexuality, which he mangles. The death drive is as strong in them as sexual libido, and eventually triumphs over it. De Kooning offers us a modern vision of Death and the Maiden. But it is in modern representational art that the entropic character of modern emotions become self-evident. There is nothing like Pop art, with its deadpan rendering of social stereotypes – its stereotyping of success – to convey emotional shallowness, hollowness, and homogeneity. Max Beckmann's allegorical triptychs, which alchemically blend psychosocial images in a more emotionally explosive way than Surrealism, convey with climactic intensity and insight the underlying insanity – emotional decadence, one might say – of the modern world in a way unequaled before or since.

The trick of making entropy seminal, thus sidestepping it while admitting to it, is to make geometry "off," so that it seems absurd and

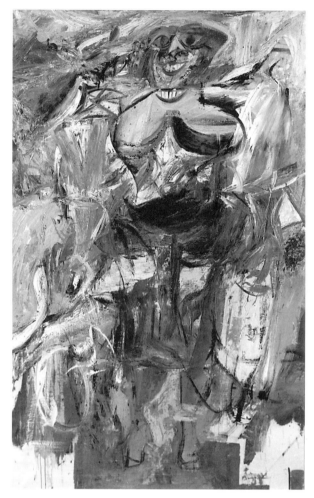

13. Willem de Kooning, *Woman and Bicycle*, 1952–53. Oil on canvas, $76\frac{1}{2}''$ × $49''$. Whitney Museum of American Art, New York. © 2004 The Willem de Kooning Foundation/Artists Rights Society (ARS), New York.

uncanny, which makes the transcendental seem immediate, and to imply that gestures form an enigmatic order, which also makes them uncanny – not simply mindless markings but fraught with unconscious meaning. What Meyer Schapiro calls Mondrian's asymmetry – the occult balance he establishes between his planes, which have

different colors and sizes, and are thus not stillborn and inert – counteract the homogenity of the grid, thus neutralizing its entropic effect. By opening his squares – I am referring to his tour de force arrangements of all the variations of a square – LeWitt does the same. He also uses color to enliven his later geometrical structures, for all his yea-saying of their conceptual or intellectual character. In other works black and white gives them a perceptual edge, creating an expressive effect that counteracts their homogeneity. LeWitt carefully sites his works architecturally, whether they are two-dimensional drawings or three-dimensional structures (the interplay of two and three dimensionality is an essential part of his work). They are in effect architecture within architecture, the interplay between the architecture of the site and that of the square preventing both from settling into geometrical complacency. Thus, LeWitt's squares – which clearly owe something to Malevich's Suprematist square – resonate in physical as well as mental space, their dialectical oscillation keeping them from deteriorating into bland, one-dimensional abstractions. In LeWitt's work static geometry becomes perceptually dynamic, losing its conceptually entropic character.

Pollock's gestures seem to be rhythmic, however elusive the rhythm, suggesting a mysterious, inarticulate order beyond the ken of ordinary eyes. Thus, the artist maintains his privileged "insight," even as his work disintegrates into chaos, suggesting his inner chaos, barely controlled and contained by the rhythm of his gestures, which in the end remain desperately "informal" and erratic if not altogether formless. By his own testimony, Pollock began his all-over paintings by drawing a series of schematic, ghostly figures on the canvas – they become manifest in *Blue Poles*, 1952 – which are then vigorously painted over, in effect eradicating them. But the sense of latent figuration remains, and we expect to experience it, on the basis of Pollock's earlier gestural figuration. The point is that the invocation of some familiar subject matter, however distorted and bizarre – so that it seems mysterious

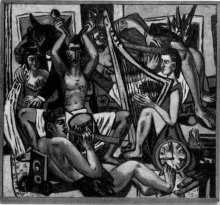

14. Max Beckmann, *Blind Man's Buff*, 1945. Oil on canvas, $81\frac{1}{4}'' \times 173''$ (overall). Left panel: H $73\frac{1}{2}'' \times$ W $40''$. Center panel: H $81\frac{1}{2}'' \times$ W $91\frac{1}{5}''$. Right panel: H $73\frac{7}{8}'' \times$ W $41\frac{3}{4}''$. The Minneapolis Institute of Art: Gift of Mr. and Mrs. Donald Winston. © 2004 Artists Rights Society (ARS), New York/VG Bild-Kunst, Bonn.

and intimidating – keeps entropy at bay. This is the unconscious purpose of de Kooning's use of the female figure, however disintegrated it eventually becomes, so much so that it finally becomes a spiritless, spineless, virtually sexless body – a lamed, leftover landscape, as he himself suggests. In line with his appreciation of the death in life, symbolized by woman, her body eventually loses both its epic and lyric characters, becoming a level playing field of sterile gestures. Where the geometrical artists introduce a disruptive note of non-identity in self-identical geometrical forms, the gestural artists introduce disruptive, unconsciously provocative subject matter, in whatever illusory form, in their abstract paintings. They create a rich sense of emotional latency within the surface of their manifest paint. The result of the contradiction – the dialectic, however awkward and unresolved – is the same: the entropic generates creativity.

But it loses its creative potential when modern art turns to everyday life to revitalize itself, for everyday life – life in the crowd – is

insidiously entropic. It tends to the extremes of homogeneity and explosiveness, as noted. Each seems necessary to counteract the stultifying effects of the other, but they in fact work synergistically together, to devastating psychosocial effect. When modern art openly embraces and identifies with everydayness, it embraces and identifies with the enemy of art, in effect committing suicide. It becomes, at best, Nominal Art – a crowd phenomenon with the honorific identity of art, but without its transcendental ambition and aesthetic substance. It is in effect everyday life in dubious artistic disguise. Thus, the attempt to enliven art with everydayness is self-defeating, although no doubt superficially vitalizing. "Blurring art and life," in Allan Kaprow's telling phrase, is to confirm that both have become entropic. Kaprow doesn't see the irony in the blurring: he doesn't realize that instead of cross-fertilizing to new creative effect, both come to seem meaningless – the major symptom of psychic entropy. Meaninglessness is the mental disease of the age, as Viktor Frankl writes – a sign of the insidious entropy that underlies it – and both art and life have become meaningless in postmodernity.

For Kaprow, art and life are in competition. Art once seemed superior to life, but in modernity it seems inferior to life. Life has clearly won the competition, which is why art joins it – or rather is colonized by it. Art becomes humble and full of self-doubt as a result of its capitulation. The point seems to be that if you can't beat everyday reality you might as well become part of it, with whatever manic-depressive results – a Whitmanesque approach that dispenses with poetry without even pretending to be poetry, or to see the poetry in prosaic life, as Whitman did. (Kaprow's ideas have in fact been said to derive from Whitman and John Dewey's idea of "art as experience.") Here are some quotations that make the point. In "The Education of the Un-Artist, Part I" – or "postartist," as I prefer to call the new social personage – Kaprow writes, without irony, or with just enough to add a sardonic lilt to his remarks, which compare modern art unfavorably to modern technology and the modern environment in general:

Sophistication of consciousness in the arts today (1969) is so great that it is hard not to assert as matters of fact;

that the LM mooncraft is patently superior to all contemporary sculptural efforts;

that the broadcast verbal exchange between Houston's Manned Spacecraft Center and the Apollo 11 astronauts was better than contemporary poetry;

that with their sound distortions, beeps, static, and communication breaks, such exchanges also surpassed the electronic music of the concert halls;

that certain remote-control videotapes of the lives of ghetto families recorded (with their permission) by anthropologists are more fascinating than the celebrated slice-of-life underground films;

that not a few of those brightly lit plastic and stainless steel gas stations of, say, Las Vegas, are the most extraordinary architecture to date;

that the random trancelike movements of shoppers in supermarket are richer than anything done in modern dance;

that lint under beds and the debris of industrial dumps are more engaging than the recent rash of exhibitions of scattered waste master;

that the vapor trails left by rocket tests – motionless, rainbow-colored, sky-filling scribbles – are unequaled by artists exploring gaseous media;

that the Southeast Asia theater of war in Vietnam, or the trial of the "Chicago Eight," while indefensible, is better theater than any play;

that . . . etc., etc., nonart is more art than Art art.[52]

Kaprow seems to be mocking Ad Reinhardt's quasi-mystical art of art-as-art (and nothing else), that is, his belief that pure art is beside the point of life, indeed, transcends it in sublime indifference (which is what Reinhardt's famous black paintings seem to embody). But Kaprow goes further, dismissing all as-if artists – particularly conceptual artists – as self-aggrandizing, socially ingratiating farces, all theory and little or no practice.

> Those wishing to be called artists, in order to have some or all of theirs acts and ideas considered art, only have to drop an artistic thought around them, announce the fact and persuade others to believe it. That's advertising. As Marshall McLuhan wrote, "Art is what you can get away with."[53]

Declaring, in a quiet crescendo, that "critics will be as irrelevant as artists"[54] in the future – which is in the endless technological now of software and television, as Kaprow suggests (he has a prescient fantasy of a woman making "electronic love to a particular man she saw on a monitor" in a TV Arcade "open to the public twenty-four hours a day, like any washerette," and surveyed by "automatically moving cameras... prominently displayed"[55]) – Kaprow declares:

> During the recent "age of analysis" when human activity was seen as a symbolic smoke screen that had to be dispelled, explanations and interpretations were in order. But nowadays the modern arts themselves have become commentaries and may forecast the postartistic age. They comment on their respective pasts, in which, for instance, the medium of television comments on the film; a live sound played alongside its taped version comments on which is

"real"; one artist comments on another's latest moves; some artists comment on the state of their health or the world; others comment on not commenting (while critics comment on all commentaries as I'm commenting here).[56]

Concluding, Kaprow argues that art will disappear, particularly art as a spectator sport. "The actual, probably global, environment will engage us in an increasingly participational way. . . . we'll act in response to the given natural and urban environments such as the sky, the ocean floor, winter resorts, motels, the movements of cars, public services, and the communication media."[57] Our participatory responses will not be art, and in fact anything "sponsored by art galleries" will instantly become passé. It will not be art "because it will be available to too many people,"[58] while art depends on exclusiveness, difficulty, and contemplation – all of which make it seductive – for its cachet. But they will no longer give cachet, but be a disadvantage, for they preclude global participation and everyday responsiveness, which needs no seductive foreplay to occur. Art is no longer for the happy few, eager for something new to sharpen their perceptions and change their conceptions, but for the unhappy many, who no matter how unhappy are happy with technology, which alone they allow to change their lives, for it doesn't change the emotional status quo. (Is it the case that Kaprow's electronic sex is the ultimate participatory art (or rather non-art), because it is completely simulated, entirely in the mind, and available to all? If art entertainment, like all entertainment, offers instant vicarious gratification of ostensibly forbidden wishes – dares express in safe make-believe form what has become forbidden and tantalizing by reason of its social and self-repression – then electronic sex is the most entertaining conceptual art of all.)

While elated by the new open system that replaces the closed system of art – Kaprow makes frequent references to systems theory –

Kaprow is also depressed. In "Manifesto" (1966), he writes:

> Once, the task of the artist was to make good art; now it
> is to avoid making art of any kind. Once, the public and
> critics had to be shown; now they are full of authority and
> the artists are full of doubt.
>
> The history of art and esthetics is all on bookshelves.
> To its pluralism of values, add the current blurring of
> boundaries dividing the arts, and dividing art from life, and
> it is clear that the old questions of definition and standards
> of excellence are not only futile but naive. Even yesterday's
> distinctions between art, antiart, and nonart are pseudo-
> distinctions that simply waste our time: the side of an old
> building recalls Clyfford Still's canvases, the guts of a wash-
> ing machine double as Duchamp's *Bottle Rack*, the voices
> in a train station are Jackson MacLow's poems, the sounds
> of eating in a luncheonette are by John Cage, and all may
> be part of a Happening. Moreover, as the "found object"
> implies the found word, noise, or action, it also demands
> the the found environment. Not only does art become life,
> but life refuses to be itself. . . .
>
> This makes identifying oneself as an artist ironic, an
> attestation not to talent for a specialized skill, but to a philo-
> sophical stance before elusive alternatives of not-quite-art
> and not-quite-life. *Artist* refers to a person willfully en-
> meshed in the dilemma of categories who performs as if
> none of them existed. If there is no clear difference be-
> tween an Assemblage with sound and a "noise" concert
> with sights, then there is no clear difference between an
> artist and a junkyard dealer.[59]

If only the issue was so eloquently philosophical – a Gordian knot of
irony which grows intellectually tighter whenever one tries to loosen

it. How about saying that when there is no clear difference between an artist and a junkyard dealer it doesn't matter which one is because both have become equally meaningless and valueless? How about saying that both art and life have become meaningless and valueless because both have become essentially the same? Let's go further: how about saying that art has become meaningless and valueless because life has become the source and measure of art? Art may develop "a hyperconsciousness about itself and its everyday surroundings,"[60] but it is the everyday surroundings that decide whether it is art or not, if they bother doing so. "The technological pursuits of today's nonartists and un-artists . . . provide [the] resources" for future art,[61] which means they have more meaning and value than it does. They are more psychosocially expressive and engaging than it can ever be. Art depends completely on them, transforming them – if it can be called that – to little effect, especially since the artistic re-working and re-thinking of them – if it goes as far as that (which is doubtful) – has no aesthetic effect.

Jean Tinguely's *Homage to New York*, 1960, a self-destructing machine – hardly a technological wonder and obviously with no constructive value – is about as far as such technology-dependent art goes toward "aesthetic" excitement. Tinguely has said that "the machine allows me, above anything, to reach poetry," but the poetry he reaches is entirely destructive if it is poetry, whether the poetry of the machine or of art or of destructiveness, and if destructiveness can be regarded as poetic, even ironically. Does Tinguely mean what he says, or is he just putting together two terms that are conventionally regarded as incommensurate – machine and poetry (and thus emulating Duchamp and Picabia, who supposedly saw the poetry in the machine) – to provocative effect? But is there still an ounce of provocation and incongruity in what, after a half century, has become a prosaic idea, not to say boring cliché? Does evoking it still give a work of art credibility and significance? Destruction seems more widespread than constructive

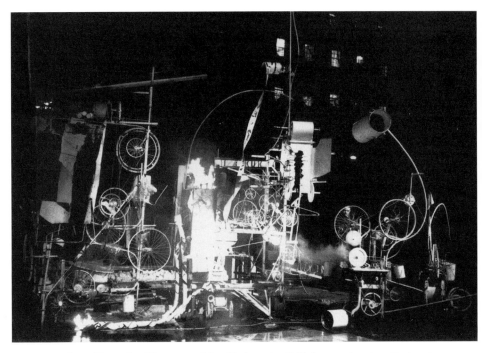

15. Jean Tinguely, *Homage to New York*, 1960. Self-destructing installation in the garden of The Museum of Modern Art. Photograph copyright David Gahr. © Artists Rights Society (ARS), New York/ADAGP, Paris.

innovation in the modern world – so much technological innovation serves the death drive, barely keeping up with it – and Tinguely's piece can be said to be an homage to twentieth century destructiveness, even a suicidal version of a destructive war machine, and as such ironical and perverse in the best modern tradition. Tinguely's self-annihilating machine certainly takes what Duchamp called the nihilism of Dada – which first declared the meaninglessness and valuelessnes of art in the modern world – to a new extreme. Tinguely's machine is a very uncomic relief in a tragic – however technologically advanced – age. (Richard Huelsenbeck, the author of *Memoirs of a Dada Drummer*, gave up Dadaism to become a psychoanalyst, and the other Dadaists drifted away into indifference, while Dadaists such as Max Ernst and Jean Arp,

who became professional artists, saw Dadaism as the latest experiment – a way out of Cubism – indicating that they never viewed it nihilistically as the end of art, but rather as another method for making art.)

But most postart isn't as technologically clever as Tinguely's machine, as Lucy Lippard's chronology of conceptual art – the premier postart – shows. It takes its triviality far too seriously to be self-subversive. It suggests that the conceptual postartist is the most banal entertainer of all, for he "performs" completely banal ideas. (He doesn't have to make them; he finds them – everywhere.) LeWitt has famously said, in his "Sentences on Conceptual Art," that "Banal ideas cannot be rescued by beautiful execution" (sentence 32),[62] but the conceptual postartist is incapable of beautiful execution. He has absolutely no interest in aesthetics and lacks the craft necessary to create beauty. (LeWitt lets the physical execution of his ideas be carried out by others. Sentence 35 states that "When an artist learns his craft too well he makes slick art." LeWitt doesn't have to worry about that problem.) Sentence 33 states that "It is difficult to bungle a good idea," but for the conceptual postartist every banal idea is "good" just because it is banal, which is why the thought that it needs rescuing by good craft and beauty never occurs to him.

Here are some samples of postart that seem to revel in banality. William Wegman's *3 Speeds, 3 Temperatures*, which involved "three faucets running progressively warmer and harder," was performed in the faculty men's room at the University of Wisconsin, Madison, in May 1970.[63] Were any faculty present to confirm that it was performed? It doesn't matter – it's just an idea, credible because it is banal. That same year (clearly a banner one for conceptual postart), beginning on October 1, Billy Apple performed *Vacuuming*, which consisted of vacuum cleaning the second floor front and rear space, landing, stairs, and entrance at 161 West 23rd Street in New York City. The work was still in progress as of December 11.[64] The vacuum bags discarded after each cleaning are proof of its significance. In April 1971, for ten days,

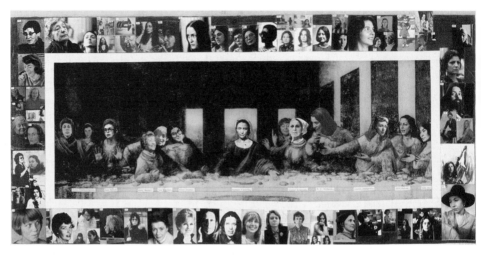

16. Mary Beth Edelson, *Some Living American Women Artists (1972). Last Supper Poster.* Courtesy of the artist.

Hamish Fulton took a 165 mile walk from Winchester Cathedral to Canterbury Cathedral. *The Pilgrim's Way* traveled was "the main prehistoric thoroughfare in South-East England."[65] Was Fulton reclaiming it from Christianity or was he in search of a conversion experience, suggesting that he was a modern saint (or a martyr to postart, as his slow motion marathon suggests)? (But St. Paul didn't go out of his way to convert on the way to Damascus. It just happened – the first happening?) Less courageously, but much more banally – which may make it the better work of postart – Adrian Piper presented a "proportional enlargement of one mapped block of New York City . . . in booklet form."[66] Has it become a collector's item? Does it make sense to speak of connoisseurs of postart? Among the more notorious postart pieces was Claes Oldenburg's response to an invitation "to participate in a city outdoor sculpture show; he (1) suggests calling Manhattan a work of art, (2) proposes a scream monument wherein a piercing scream is broadcast throughout the streets at 2 a.m., and (3) finally has a 6′ × 6′ × 3′ trench dug behind the Metropolitan Museum by

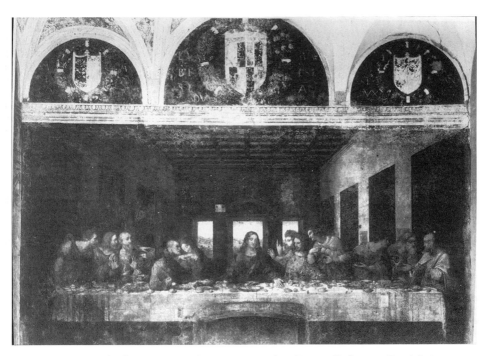

17. Leonardo da Vinci, *Last Supper*, 1495–97/98. Fresco. Refectory, Sta. Maria delle Grazie, Milan.

union gravediggers, under his supervision, and then filled up again."[67] Douglas Huebler famously said: "The world is full of objects, more or less interesting; I do not wish to add any more."[68] But it is also full of ideas and activities, more or less interesting. Why add to them?

Defamatory banalization of great traditional art has become more or less pro forma in postart, particularly feminist postart. Mary Beth Edelson's "revision" of Leonardo's *Last Supper*, in which photographs of the heads of trendy feminist artists replace those of the apostles, is the classic example. In a similar vein, but without feminist intention and much more nihilistically, if with the same heavy-handed irony, Vik Muniz re-does masterpieces – Caravaggio's *Medusa* and Gericault's *Raft of the Medusa* among them (suggesting that Muniz has a problem with the phallic woman as well as with high art) – in chocolate or spaghetti,

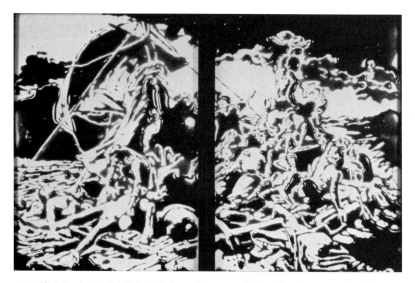

18. Vik Muniz, *Raft of the Medusa (Pictures of Chocolate)*, 1999. Cibachrome.
2 Parts: 70 × 100″ overall. © Vik Muniz/Licensed by VAGA, New York, NY.
Courtesy Brent Sikkema, NYC.

among other everyday edible materials. He democratizes the master-
pieces by turning them into cheap junk food, high caloric but with little
nutritional value, and very tasty, literally. But the subtle tastefulness of
the masterpieces has completely disappeared. Updating Rodin's *The
Thinker*, Keith Tyson, an engineer-cum-artist, designed a hexagonal
structure that hums electronically. Presumably it is thinking. (Or is it
humming some simple computer melody – the humming never varies,
confirming its banality – to itself?) We have clearly become high-tech
machines – forget about the body, inseparable from mind for Rodin.

Crudely copying several of Rubens's paintings of women, a craft-
less feminist postpainter added male hands around their voluptuous
bodies, suggesting Rubens's lechery. This is explained in an accompa-
nying text, which hypes the paintings as a telling revelation of Rubens's
all too male psyche. The long-winded text is a telling example of the
pseudo-profound theoretizing that has become *de rigueur* in postart.

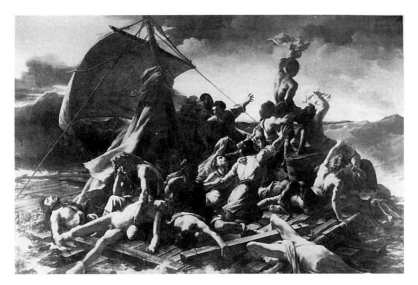

19. Théodore Géricault, *The Raft of the Medusa*, 1819. Oil on canvas, 16′ × 1″ × 23′ 6″. Louvre, Paris, France. Réunion des Musées Nationaux/Art Resource, NY.

Indeed, such texts – which are usually less interesting than the objects they pretend to enlighten us about (if there is any reason to choose between their banality) – have become essential weapons in the armory of ideological didacticism that supports postart. But Annie Sprinkle's exhibitionistic grid of *Sluts and Goddesses*, 1990, doesn't seem to get the feminist point, for her femme fatales, most naked and some in S-M attire, are frankly inviting and voluptuous. Sprinkle seems to be an old-fashioned feminist, using the female body to mock male desire, for the body is out of reach in a pornographic photograph, and thus more seductive than satisfying – a broken sexual promise. But Rachel Lachowicz's *Femme Fatale*, 1991–92, an installation of female body parts on meat hooks, restores us to our feminist senses, for it suggests male use and abuse of the female body. Men are so sexually infantile they can't help but dismember it into fetishized part objects – so many pieces of (white) meat in a morbid museum.

Perhaps the most consummate work of postart is the shortlived installation by Damien Hirst referred to earlier – or rather the events surrounding the installation. The cleaning man who cleared up the "mess," as he called it, was the perfect participant observer, for he responded to it as life rather than art – unoriginal garbage or anonymous waste rather than "an original Damien Hirst," as the gallery manager said it was – confirming that it was indeed postart and as such meaningless and valueless (he certainly wouldn't have paid the hundreds of thousands of dollars asked for it, if he had the money). Hirst was thrilled by the junking of his junk work – the dirty litter of his studio – for, being mistaken as life, it confirmed that "his art is all about the relationship between art and the everyday." Which is? That everyday life is more interesting than art, and art is only interesting when it is mistaken for everyday life, even if that means it loses its identity as art, which it only had because it was exhibited in a place called an art gallery, and thus on its way to being institutionalized as art. The cleaning man was clearly the right critic.

Hirst's work, which includes the fate that unexpectedly befell it and completed it, the way breaking the Large Glass completed it for Duchamp, is the example par excellence of what Kaprow called "work...located in activities and contexts that don't suggest art in any way."[69] ("Brushing my teeth...in the morning when I'm barely awake" was Kaprow's example of such an activity. It's clearly banal enough to be mistaken for postart.) For Kaprow, "the practice of such an art, which isn't perceived as art, is not so much a contradiction as a paradox."[70] I want to suggest it's neither a contradiction nor a paradox, but a negation of both art and life, and as such a type of black humor, like Dadaism. Or perhaps humorless blackness or nihilism, which is what Martin Creed's exhibition of a light bulb, turning off and on in an empty room – the so-called installation received the Turner Prize for 2001 – seems to be. The blackness of the humor is confirmed when what presents itself as a work of art – an advanced one, no less – is

mistaken for a slice of life, which is what Hirst's cleaning man did. The humor becomes even more black – or is it that the nihilism becomes more humorous? (at least to the skeptical) – when, after it is removed from the art situation, it can no longer be seen as art – no longer holds its own as art. Making art has become a case of putting on the emperor's new clothing and getting away with it – calling raw life interesting art and convincing people that it is, which suggests just how much postart must be taken on faith, indicating that it is a minor cult.

If "themes, materials, actions, and the associations they evoke are to be gotten from anywhere except the arts, their derivatives, and their milieu,"[71] then once they are seen for what they are – once it is realized that they have nothing to do with the arts – they can never again be viewed as art. The mistake of doing so in the first place – of buying into them as art ("buying" is the key word here, for to spend six figures on a Damien Hirst is clearly an act of faith in him, his originality, postart, the whole milieu that calls itself art, with its high rollers and holy rollers) – has been rectified. The moment of revelation occurs not when art and life are blurred, but when one becomes clear-eyed – like Hirst's cleaning man – and realizes that what presents itself as art is just a leftover piece of life. One has awakened from a bad dream. In Hirst's installation experimental art has become entropic – a decadent farce. For all of Kaprow's efforts to keep "the line between the Happening and daily life as fluid and perhaps indistinct as possible"[72] – which is what Hirst's happening successfully does, as the cleaning man's response to it indicates – the fact of the matter is that there is no line between them, whether fluid and indistinct or fixed and distinctive (as in high art), but rather the naive belief that there is one. This belief is instantly shattered the moment the postart happening is understood to be just another daily event, and exists to turn non-art milieus into art ones, giving one the sense that daily life is something special. Postart encourages us to see it that way, and we had better do so, because daily life is the only kind we can have in a postart world. What used to be

called high art becomes just another daily event in the everyday world, losing whatever uncommon qualities made it far from daily, indeed, helped it undo and transcend dailiness, putting dailiness back in its common place. The postartist's role is to convince us that no other experience is possible than daily experience. High art and original artists are superfluous, as Kaprow suggests. The postartist is much more popular, which is why everyone wants to be one – and everyone who has a daily life is, whether he knows it or not.

Kaprow's example of the popular postartist is Andy Warhol,[73] and Warhol was an expert in what has come to be called experiential marketing. He in fact became a brand name, like Campbell's Soup and Coca Cola, whose products he represented. Indeed, he reproduced them the same mechanical way they were produced. It was a mass reproduction that emulated the mass production and distribution methods of modern marketing. The power of the Warhol brand is shown by the fact that the 1950s cookie jars and Fiestaware that he owned have been exhibited as autonomous works of art. This occurred in 2002 at the Rhode Island School of Design Museum, confirming once again that the most mundane objects can become fashionable art if they are associated with a postartist. It was a supurb example of successful experiential marketing, which involves, as Bernd Schmitt writes, "moving away from traditional 'features-and-benefits' marketing" – which would have emphasized the functionality and retro-chic of the objects – "toward creating experiences for . . . customers,"[74] in Warhol's case, art experiences. To use Bernd Schmitt's wonderful term, exhibited in the museum Warhol's mundane possessions became "Strategic Experiential Modules." They became "sensory experiences (SENSE); affective experiences (FEEL); creative cognitive experiences (THINK); physical experiences and entire lifestyles (ACT); and social-identity experiences that result from relating to a reference group or culture (RELATE)," all in one object. Owning objects that Warhol once owned and thus implicitly identifying with him – owning relics of a secular

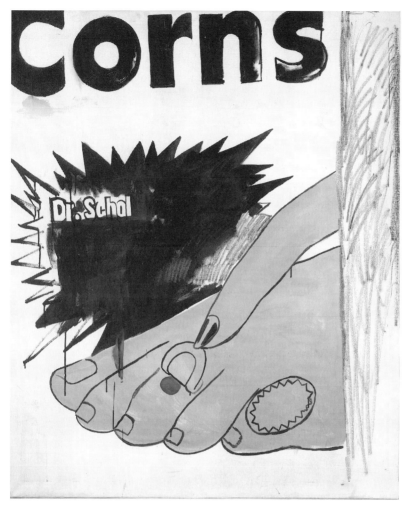

20. Andy Warhol, *Dr. Scholl*, 1960. Oil on canvas. H 40″ × W 48″. The Metropolitan Museum of Art: Gift of Halston, 1982. © 2004 Andy Warhol Foundation for the Visual Arts/ARS, New York.

art saint and thus sharing in his fame and sacredness (the fame that made him sacred) – one fancies, however unconsciously, that one is part of Warhol's inner circle. One believes that possessing the object gives one the power and license – clearly a magical power and poetic

license – to sense, feel, think, and act like a member of his in-group. The genius of Warhol is that he became a genie inhabiting his own objects – a power that was more significant than any of them.

But of course the postartist has to be a self-deceptive split personality, like Duchamp and Warhol – a personality "haunted by the ambition of high art, even as he trashes it," which is the way George Segal described Allan Kaprow – to make the change in meaning, value, and status work and remain binding. Warhol's possessions have become the ultimate unart, for they have been marketed as an experience of Warhol – as a substitute for the postartist himself. To market a personality through the person's possessions is a major feat of marketing, guaranteeing that the possessions will become charged with the personality's charisma – for the whole point of experiential marketing is to create charisma, that is, to make a banal piece of property seem charismatic, which means that it satisfies the unconscious emotional needs of the viewer, not simply his conscious material needs[75] – and thus will never revert to unart. Money and museums will keep them from doing so, for they have become important investment properties, rising above the intellectual speculation that made them works of art in the first place. This suggests that the postartist speculates in art in more ways than one – that for him to be an artist is to speculate in the art market as well as to engage in philosophical speculation (conceptual antics?) about the nature of art. Similarly, Duchamp's *Fountain*, 1917 can no longer be regarded as a urinal, despite the best efforts of certain postartists to return it to its pre-Duchamp condition by urinating in it. However, it seems clear that Nikki de Saint Phalle perfume, at $350 an ounce – according to *Allure* (May 2002) "It's a strong scent that has a touch of violet, but it's not sweet" – is unlikely to survive as either found art or expensive unart, for Saint Phalle does not have the brand name that Duchamp and Warhol have. Her work is interesting, but she doesn't have the public personality that they do. Perhaps she added her name to a perfume to give herself one, but the gesture was unsuccessful.

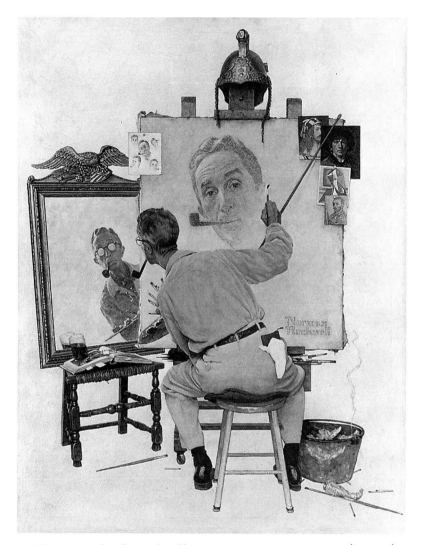

21. Norman Rockwell, *Triple Self-Portrait*, 1960. Oil on canvas, $44\frac{1}{2}'' \times 34\frac{1}{4}''$. Printed by permission of the Norman Rockwell Family Agency. Copyright © 1960 the Norman Rockwell Family Entities. The Norman Rockwell Museum.

The product is too select: Duchamp and Warhol added their name to cheap, commonplace, popular products, Hollywood actresses included. In the postartworld the artist's public personality counts more than the objects he presents as art, and in fact whatever he claims to be art will have instant credibility – even exalted significance – because of his public image.

Both Duchamp and Warhol have reached the exalted status of Jacqueline Kennedy, whose gowns have been exhibited at the Metropolitan Museum of Art, giving them the status of works of art and making them more expensive than they were when she purchased them. Here are remainders that have gone up in value and meaning. The Metropolitan Museum has also exhibited a collection of baseball cards. Their commercial value and emotional appeal can only increase by reason of the art milieu in which they were placed. Thus, people's art easily becomes high art these postart days. Indeed, it seems more charismatic than high art in a democracy of material objects. It is not only the boundary between art and life that has blurred, but between everyday art and high art – popular art, which makes no claim to aesthetic significance (it only wants to be user-friendly), and art that, as the years pass and it loses its social relevance and place, has no other claim to make for itself. Another case in point is the exhibition of Norman Rockwell's works in the Guggenheim Museum, which had previously presented motorcycles as works of art, confirming that paintings and sculptures are low-tech products, relatively uncomplicated compared to the technologically elaborate motorcycles.

Experiential marketing is the secret of postart's success. Postart, in social fact, has perfected experiential marketing, that is, the marketing of daily experience as aesthetic experience, which conflates and falsifies both. The point is to hype everyday objects as aesthetic objects, which makes us overlook their banality, even as it banalizes aesthetics – lowers the threshold, as it were, on what we are willing to call an aesthetic experience. Whether it knows it or not postart owes a great debt to

22. Rirkrit Tiravanija *(Untitled). For M. B.*, 1995. Plaster and enamel paint, $10\frac{1}{2}'' \times 17'' \times 17''$. Courtesy Gavin Brown's Enterprise, New York.

marketing aesthetics, that is, "the strategic management of brands, identity, and image," as Schmitt and his colleague Alex Simonson say.[76] When the postartist Rirkrit Tiravanija, who has achieved his fifteen minutes of Warholian fame for his food pieces (which he calls process pieces, showing he knows the legitimating and advertising art lingo, an important part of the product) – he served Thai curry at one gallery, "reflecting his dominant biographical and cultural reference," as one postcritic put it, "and at the [Venice] Biennale he evoked Marco Polo's discovery of noodles and their subsequent importation to the West in 1271"[77] – remarked that "a stove that had the brand name *Beauty* written on it in the window of a store on the Bowery" was "the perfect object," and used the money he received from a grant to buy it ("it was actually overpriced" but he "had to get an object which had everything in it that I needed" [was it the need for beauty or the compulsion to cook?])[78] – he testified to the power of marketing aesthetics. The stove – the perfect ironical Duchampian found object, for it was a practical

object branded as ideal Beauty – was a superb example of experiential marketing, especially because it marketed itself as Beauty as well as a useful object. Indeed, the stove seemed to embody the experience of beauty, rather than merely represent it.

The interplay of language and object in a game of referencing is the postart norm. It is a semiotic venture using everyday means to generate conceptual friction. The goal is to create an aporia not simply an ambiguity – an unresolvable dilemma not simply an uncertain meaning. (Tiranvija's found stove certainly does so better than his cooking, however saturated in references – a sort of intellectual sauce – the food is.) This tends to be combined with ideological marketing – the selling of a political program, or, more simply, politically hot topics. An example is *Solid Sea*, an installation by Multiplicity, an Italian group of postartists, presented at Documenta 11 (2002). It deals with the death of some 200 Asians who drowned when their overcrowded boat sank between Malta and Sicily. They were on their way to a new life in Europe, but never made it because the boat was forced to board by those they had paid to bring them there. In one room video interviews with friends and relatives, Italian authorities, and local fishermen are spliced together in a chorus of lament and anger. The imagery is managed, as it were, to make a dramatic point. Another room shows a video of the sunken ship and a satellite picture of the Mediterranean. Above and below converge, suggesting the cosmic significance of what has become an everyday event in some parts of the world. But it may simply be the usual split screen way of informing us about the event – pinpointing it geographically, as though with scientific rigor – although the juxtaposition of the scales adds a certain quixotic if limited energy to the video. Does the installation tell us anything about the meaning of the unfortunate event, and about the problem of illegal immigration into Europe, which has become a matter of political concern? No. It simply points to the event and problem – the particular event illustrates the larger problem. It is a semiotic signalling, using high-tech tools, familiar

to everyone, to communicate the obvious, much the way a television newscast would, probably with more commentary and analysis. No doubt the simultaneity of the videos makes it more arty, simultaneity or multiple perspectives being the "in" thing since Cubism. Does this make it art? No. For the information is not transformed, it is manipulated, in a rather conventional, even simplistic way. There is no insight into the event, no sense of the reason it occurred beyond the fact that it did – what were the motivations of the transporters? – no sense of what motivated the Asians to make such a difficult and dangerous trip (what, exactly, did they think a "better life" was?), no insight into them and their friends and relatives as individuals, no aesthetic subtlety in the relationship between the video mode of presentation and the subject matter. Is the installation a "statement?" No. It's undigested information about a social situation. And it's old information – information that has lost its topicality, however topical the issue it raises remains. More pointedly, it's marketing of social information as art. And even more pointedly, it's the marketing of other people's suffering as art. All this makes it postart not art – managed imagery with no aesthetic relevance, that is, with no transcendental import that would turn it into tragic art. Only such sensitive transformation would have made it a great experience not simply the marketable record of an event.

Whatever their intentions, the Multiplicity postartists reflect the marketing orientation of the modern world, which has been openly embraced by so-called art. Jeff Koons, who exhibits everyday products such as vacuum cleaners – they look very clean because they are new and unused – as works of postart, may be the prime example of an art-marketing personality. Haim Steinbach, who cleverly displays smaller products on modernist shelves, looks like a close second, although it's not a foto-finish; Koons is clearly the leader of the art-marketing pack. It is worth noting that Koons was a stockbroker before he became a postartist, indicating that he knew where the real money was, and knew something about marketing. Certainly the unregulated art market

is preferable to the regulated stock market. The vacuum cleaner obsession of Apple and Koons suggests that there is a new group of anally obsessed artists in our midst, confirmed by the fact that Odd Nerdum and Kiki Smith have depicted clean women defecating, and Gilbert and George have displayed giant feces cookies. Clearly anything can be marketed in the postartworld, which is something that Piero Manzoni, who signed cans supposedly containing his excrement, realized long ago, in recognition of the charismatic alliance of excrement and art in the postart world. Their synergistic association is a superb example of experiential marketing. Excrement and art already have a certain charismatic appeal – excrement has negative charisma; art, positive charisma. When each is accorded the status of the other, that is, when found excrement becomes readymade art – a standard Duchampian act – the charisma of both increases exponentially. Both begin to smell to high heaven as it were; that is, their charisma becomes cosmic: their association is the salvation of both. Of course, charisma compounded is also charisma debunked. Dali noted that "during the course of the Second World War" Duchamp expressed "a new interest in the preparation of shit, of which the small excretions from the navel are the 'de luxe' editions."[79] Anything – the more excrement-like or junky the better – can be sold as a work of postart, so long as it is signed by the right postartist. It's all in the mystique of the name, or rather in the mystique created by the marketing of the name.

As Erich Fromm has written, "the marketing orientation [is] the dominant one . . . in the modern era."[80] It influences our attitudes and character. "The market concept of value, the emphasis on exchange value rather than on use value, has led to a similar concept of value with regard to people and particularly to oneself. The character orientation which is rooted in the experience of oneself as a commodity and of one's value as exchange value I call the marketing orientation."[81] As Fromm notes, a new market has developed – the "'personality market'. . . . The principle of evaluation is the same on both the personality

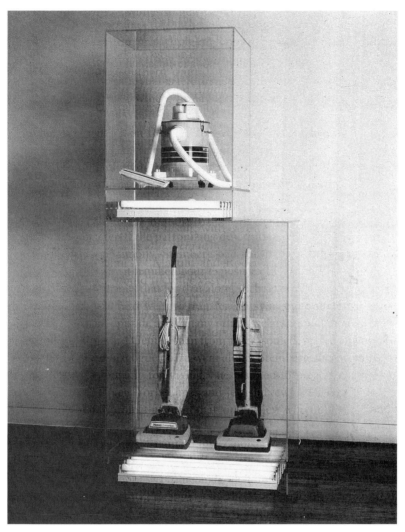

23. Jeff Koons, *New Hoover Convertibles, New Shelton Wet/Dry Displaced Double Decker*, 1981–87. Plexiglass, vacuum cleaners, fluorescent lights, $98\frac{7}{16}''\times 41\frac{3}{8}''\times 27\frac{1}{2}''$. Courtesy Sonnabend Gallery, New York.

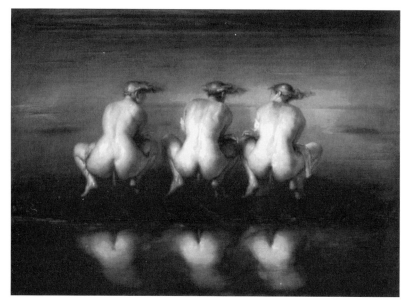

24. Odd Nerdrum, *Shit Rock*, 2001. Oil on canvas, $76\frac{1}{4}''\times 71''$. Courtesy Forum Gallery, New York.

25. Kiki Smith, *Tale*, 1992. Wax, pigment, papier-mache, $160''\times 23''\times 23''$. Courtesy Pace Wildenstein Gallery, New York.

and the commodity market: on the one, personalities are offered for sale; on the other, commodities. Value in both cases is their exchange value, for which use value is a necessary but not a sufficient condition . . . However, if we ask what the respective weight of skill and personality as a condition of success is, we find that only in exceptional cases is success predominantly the result of skill and of certain human qualities like honesty, decency, and integrity. Although the proportion between skill and human qualities on the one hand and 'personality' on the other hand as prerequisites for success varies, the 'personality factor' always plays a decisive role. Success depends largely on how well a person sells himself on the market, how well he gets his personality across, how nice a 'package' he is."[82] He experiences himself "simultaneously as the seller and the commodity to be sold,"[83] sacrificing his value to himself on the altar of exchange value.

There seem to be two preferred personality packages – two highly marketable types of personalities – in the postartworld, which is essentially a personality market. One is represented by Warhol, who markets indifference as receptivity (the next ironical step after Duchamp), and the other is represented by Julian Schnabel, who markets aggressive macho bluster as authenticity (showing his Abstract Expressionist heritage). (Schnabel declared himself "the greatest fucking artist since Picasso" – clearly a selling point, as every gain in notoriety is.) Looking at them, one would think – correctly – that the notion of a person has become bankrupt in consumer society. Entropy has overtaken it: having personality, as defined by the market, replaces being a person, as defined by the human condition. Simply put, having a personality is more important than being a person. Indeed, there's no need to be a person these days – no need to have human values – only a knowledgeable consumer. One only needs to know the exchange value of human beings. Similarly, there is no need to know the human value of art, only its value in the market. Marketing confuses values; we readily mistake inhuman values for human values because the former are so

well packaged, which is the problem with postart. The spectator has become the customer; he has to be confused – morally and intellectually – to invest in postart, emotionally and economically.

If the customer is puzzled about the use value of a product, he may want to exchange it for another one. This keeps the market moving. A work of art that has to wait for the judgment of posterity to decide its value has none. The judgment of posterity is too slow these fast-moving days, which is why it has been replaced by the judgment of the market. Every day is market day in the postart world. The point is quick turnover. The marketed work either quickly accrues economic value or loses all value – artistic, existential, critical. They're old-fashioned in the world of postart. Winning in the market means the work is a good bet not a good product. Commercial recognition and critical recognition have become interchangeable. A high price for a Damien Hirst is more scandalous than a good review. It is more provocative than the work itself. Art is a gamble in the postart world, which is why some of the gambling casinos of Las Vegas have built art museums on their premises, each adding its touch of class and charisma to the other. More than the association of art and excrement, the association of art and money adds to the charisma of both, making each more magical than it would be if it were indifferent to the other. Once again Duchamp, with his usual prescience, was in the socio-art avant-garde: he wanted to manufacture the word "Dada" as a trinket, in silver, gold, and platinum editions, so that every economic class of customer could afford an illustrious piece of art jewelry. It would presumably always be in fashion, for once an art movement becomes part of art history it becomes part of high fashion; that is, it becomes postart.

4

THE DECLINE OF THE CULT
OF THE UNCONSCIOUS:
RUNNING ON EMPTY

M odern art truly begins with the awareness of the unconscious –
with the turn inward, leading to the discovery of the uncon-
scious – which developed during Romanticism. Baudelaire says as
much when he writes in "The Salon of 1846": "Romanticism is pre-
cisely situated neither in choice of subjects nor in exact truth, but
in a mode of feeling. They looked for it outside themselves, but it
was only to be found within."[84] He speaks of the "new emotions"
that would be experienced,[85] and the "new world" that would be
revealed.[86] When, celebrating the imagination, he speaks of "the fur-
thest depths of the soul,"[87] he is speaking of the unconscious. "All
accepted behavior has become confused, all established ideas contra-
dicted, . . . the impossible mingles with the real" in the unconscious,
suggesting that it involves "faculties or notions of a special order, for-
eign to our world."[88] He knows that it speaks "the language of the
dream" and that it is the enemy of "banality," the "great vice."[89]
It is "creative" rather than "correct."[90] Where the traditional artist
"can find nothing more beautiful to invent than what he sees" in
nature, the modern artist aspires "towards the infinite."[91] He prefers
"the deep dreams of the studio and the gaze of the fancy lost in

horizons...to the open air."[92] He cherishes the "intimacy" of the "dearest dreams and feelings," which "the artists of the past have disdained or have not known."[93] He realizes that in certain mental states – he called them "supernatural," for they seemed to contradict nature – "the profundity of life reveals itself in the sight before our eyes," using "ordinary" life as its "symbol,"[94] suggesting that "hallucination" and "hysteria" are inseparable from artistic creativity, at least from a romantic point of view.[95]

Baudelaire's prescience was amazing. His ideas set the tone for a century of modern art: when Pollock declared that *he* was the unconscious, he was speaking Baudelaire's language. American Abstract Expressionism is in fact the grand climax of European Romanticism. It transposes romantic dynamics, with its emphasis on color, energy, and mystery – "indispensable obscurity," as Baudelaire called it[96] – into even more dynamic American terms, bringing what Odilon Redon called "suggestive art," which he "likened to the energy emitted by objects in a dream,"[97] to orgasmic fruition. It was the end of the cult of the unconscious, and with that the end of modern art and art itself, for without the unconscious art became uninspired – literally, for the unconscious has always been the source of art's vitality (Plato admitted as much when he spoke of the daemonic madness that inspired the best of it; for him, as for Aristotle, it had to be emotionally convincing to be art) – and lost its last defense against decadence.

I will pick up the story of uninspired postart – art that has turned to other sources of inspiration than the unconscious, which is why it is decadent, that is, art in decline (decline can last long, and become a permanent state of affairs) – after sketching in some detail what it once meant to make art that depended on the unconscious for its validity and significance. For unless the profound influence of the unconscious on modern art is understood, one cannot begin to understand the depth and credibility art in general lost when it foresook the unconscious,

falling into the banality that Baudelaire feared. Postart looks to ideology and, more broadly, theory for a foundation – and significance – and attacks the unconscious by reducing it to an ideology, more particularly, a phenomenon of bourgeois society. The Marxist art critic Benjamin Buchloh thinks only the bourgeois are paranoid and depressed, not the proletariat. Dreams are trivialized and feelings dismissed – subjectivity as a whole is demeaned. They are presumably incidental byproducts of social reality, and as such have no dynamic of their own. In other words, from the postart ideological point of view society rather than subjectivity motivates art, which loses its inner dynamic in the course of representing society, that is, artistically "realizing" its reality and "outer dynamic."

Postart is completely banal art – unmistakably everyday art, neither kitsch nor high art, but an in-between art that glamorizes everyday reality while pretending to analyze it. Postart claims to be critical of everyday reality but in fact is unwittingly collusive with it. Postart is art in which the difference between creative imagination and the banal reality that it uses as its raw material has become blurred, so that the mechanical reproduction of raw social material is mistaken for an imaginative triumph. Sometimes the postartistic reproduction involves a certain ironic wit or black humor – Duchamp is the role model here – which claims to be a creative transformation but in fact makes the raw material socially spectacular in a way it would never be if left in its everyday context. Nothing is changed except the scale of presentation, sometimes qualified by an identifying label that passes for explanation, as though to name the subject matter was to understand it. The subject matter and its headline label – sometimes amplified into a "clarifying" description – form a kind of tautology. (Duchamp's readymades, which usually have their titles inscribed on them – or some other text, which serves the same purpose, namely, to create an intellectual echo for the physical object – are the classic example.)

Subtleties of connotation disappear into blatant denotation, making the subject matter seem larger than life and, at the same time, instantly comprehensible: what you see is what you get, as both Warhol and Frank Stella said. Paradoxically, this "enlargement" into obviousness – this re-invention of the subject matter as an image, more pointedly, as a socially representative representation – desensitizes the viewer to it rather than intensifies his relationship with it. Unable to be taken personally, it becomes simply another social product on the market of mass-reproduced images – images meant for the masses not for the individual. Thus, mechanical reproduction makes social subject matter "comprehensible" to the mass mind by turning it into a facile spectacle. Given reproductive grandeur, it signifies its availability for mass consumption.

In truth it is no more than a small detail in a social whole too complex for any one mind to comprehend. Mechanical reproduction resembles the blind men who attempted to describe the elephant: each took a different quality as its whole reality – its defining characteristic. Without that elephantine whole each quality is an absurd fact – a fact made absurd by its separation from the whole and elevation into the whole. Thus, mechanical reproduction misplaces social concreteness, to use Alfred North Whitehead's idea that concreteness resides in the process rather than in the facts that emerge from it. They may exemplify it, and seem to symbolize it, but it is an error – a fallacy, as Whitehead says – to seriously believe that they are prior to it and comprehensible apart from it. In short, mechanical reproduction reifies process without offering any comprehension of its psychosocial logic – of the complex forces that created the facts that are mechanically reproduced into simple-minded objectivity. Walter Benjamin suggests that mechanical reproduction destroys the aura of the work of art, but in doing so it turns the work into a matter-of-fact spectacle. The mechanical reproduction of anything will turn it into a social spectacle, making it seem more matter of fact than ever. Spectacle replaces aura

as art's mode of presentation: unless it makes a spectacle of itself, it has no value and appeal. It is as though the artist realized that a halo – resembling "the energy emitted by objects in a dream," to recall Redon's words, that is, an object with an inner radiance so intense and consummate it emanates outward – was not enough to make a work of art sacred, at least not in a postmodern world. The work of art can only reach the crowd by becoming a spectacle, which makes it famous, if not sacred, although, no doubt, fame is the secular form of sacredness, that is, sacredness without the divine – without soul. (Which is what Redon accused Manet of lacking, and what Warhol and Stella lack.) Mechanical reproduction is a mode of mass exhibition, not a means of expression, as even Duchamp realized (see the last epigraph).

At other times social material is presented in a confrontational manner, with the hope that the spectator will become aware of its insidious character. But again the material is more celebrated than criticized – dramatized rather than undermined. The status quo, is supposedly used against itself in a provocative act of ironic defiance, but, however subliminally, the postartist confirms the status quo, however hard he tries to discredit and subvert it. Indeed, he unintentionally reinforces ingrained attitudes and ideas by making them visually emphatic – exaggerating them in the same way conventional spectacles exaggerate their "themes." Postart shows the emptiness of everything it deals with, which may debunk it but also makes it as entertaining as everything else in postmodern society. The cynicism that postart claims is uniquely its own is in fact endemic in know-it-all postmodernity. Theme shows, theme restaurants, theme works of postart – they're all cynically entertaining; that is, they all de-realize and depersonalize existence, thus emptying it of significance. They suggest that there is no reality, although it has a way of picking on you.

Thus, perhaps without realizing it the postartist is appropriated by what he claims to appropriate – subsumed by what he attempts to subsume – for the higher critical good. What is supposed to be

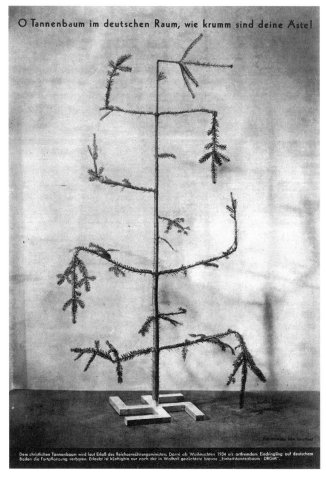

O Tannenbaum im deutschen Raum, wie krumm sind deine Äste!

Dem christlichen Tannenbaum wird laut Erlaß des Reichsernährungsministers Darré ab Weihnachten 1934 als artfremdem Eindringling auf deutschem Boden die Fortpflanzung verboten. Erlaubt ist künftighin nur noch der in Walhall gezüchtete braune „Einheitstannenbaum“ · DRGM.

26. John Heartfield, *Little German Christmas Tree*, 1934. Thin fir tree with branches bent at right angles. Photomontage from AIZ magazine cover, H 26 cm × W 20 cm. The Metropolitan Museum of Art, Purchase, The Horace W. Goldsmith Foundation Gift, 1987. © 2004 Artists Rights Society (ARS), New York/VG Bild-Kunst, Bonn.

subversive turns into show business – an artistic sideshow (radical chic) – because it uses the conformist methods of the status quo to make its nonconformist point. Unfortunately, this is the fate that be-fell the anti-fascist photomontages that John Heartfield made. Their

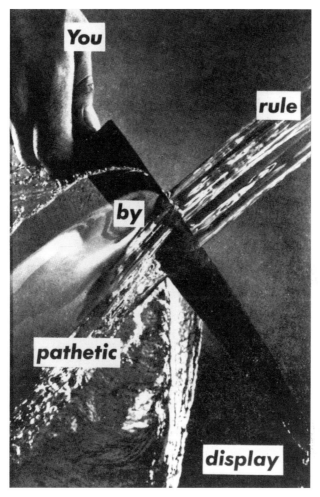

27. Barbara Kruger, *Untitled (You Rule by Pathetic Display)*, 1982. Photo-offset lithograph and serigraph, 73″ × 49″. Krannert Art Museum and Kinkead Pavilion, University of Illinois, Urbana-Champaign.

cartoon form got the better of them, so that their critical protest, however serious, ended up looking like a clever joke – a species of heckling, which indeed is what caricature is – hardly equal to the barbarism of fascism. Once fascism was no longer topical, the art showed its weakness as art, however alive it remained as information and

attitude. Unlike the work of Grosz and Dix, Heartfield's cartoons lacked aesthetic substance, which hastened their decline into social artifacts, signs of times gone by, their critical import replaced by their cultural import. They were no longer symptoms of social pathology, but fallen milestones on the path of history.

The same fate overtook the public art of Jenny Holzer and Barbara Kruger, which looks like minor social theater, more distracting than insightful. Lacking subjective resonance, their work becomes public entertainment. It ends up looking like what it exploits. No doubt, like Heartfield, they thought that you could enlighten the public in the course of entertaining it, but the public remained entertained without becoming enlightened – without changing any of its habits and attitudes (Kruger's "I am because I shop" was understood as a statement of fact not an ironical retort, and in fact was reproduced on shopping bags, and Holzer's Times Square *Truisms* are just another passing verbal fancy on the Spectacolor Board) – except for that small part of it which was already converted to the critical faith and knew what life was really all about. Holzer and Kruger not only utilize the methods and materials of popular entertainment – from the grandstanding billboard and glossy poster to the bright lights of the snazzy marquee announcing the latest show and moving as fast as it does – but also seem to endorse them. In other words, their means become their end, however unwittingly – the sign itself becomes more important (and noticeable) than what is written on it – suggesting that a little artistic cleverness is not enough to conquer the Goliath of popular entertainment. However much God is on their side, the postart Davids are no match for the philistine forces of entertainment, seasoned and sophisticated enough to beat back any threat to their dominance, especially by co-opting it.

What Baudelaire feared has come to pass: "Each day art further diminishes its self-respect by bowing down before external reality."[98]

The artist has become a "positivist," "represent[ing] things as they are, or rather would be, supposing [he] did not exist."[99] In postart this means things are understood according to ideology and theory, which become glosses on their banality. Ideology and theory confirm it: they use real things as banal illustrations (thus outsmarting them and suggesting that ideology and theory are in control of reality). The unconscious regarded real things as more mysterious than they appear to be, which is the point Surrealism made. But ideology and theory have replaced the unconscious in postart. Postartists are not Baudelaire's "imaginatives," for they lack the subjectivity necessary "to illuminate things." Instead they know the absolutely objective truth. The positivistic postartist regards himself as a theoretician, but his theories make objective things seem more banal than they are, at least from an unconscious point of view. Exposing the ideological underpinnings of social reality, the postartist grounds its banality theoretically rather than illuminates it from within – illuminates the psyche of those who live in society, a psyche no doubt shaped in part in response to it, but which has its own unique dreams and feelings, which are part of its human (not simply social) condition. As I have suggested, postart has a way of looking as banal as the everyday reality the postartist claims to see through with his theories and ideological criticism. Indeed the postart of Holzer and Kruger treats the banal as a spectacle, or turns it into a spectacle, indicating that spectacle has become an essential part of postmodern banality. All language postart tends to the condition of banal language, conceived as social spectacle, which has been the case since Joseph Kosuth's *One and Three Chairs*, 1965, and *Art As Idea As Idea*, 1966.

The turn inward which the unconscious represents was a desperate turn to a new source of creativity, but it also involved the recognition, as Baudelaire implies, that there was a different kind of reality than banal everyday reality, however superficially alike the two seemed, that is, however much internal reality used external reality to make

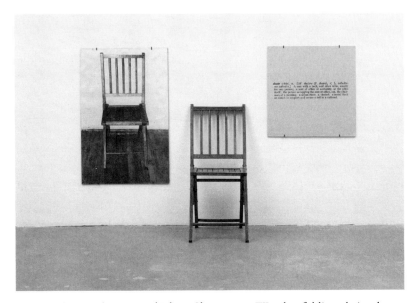

28. Joseph Kosuth, *One and Three Chairs*, 1965. Wooden folding chair, photographic copy of a chair, and photographic enlargement of a dictionary definition of a chair; chair $32\frac{3}{8}'' \times 14\frac{7}{8}'' \times 20\frac{7}{8}''$; photo panel $36'' \times 28\frac{1}{8}''$; text panel $24'' \times 24\frac{1}{8}''$. Larry Aldrich Foundation Fund. The Museum of Modern Art/Licensed by SCALA/Art Resource, NY. © 2004. Joseph Kosuth/Artists Rights Society (ARS), New York.

itself manifest. There was a strange new world waiting to be conquered – a terra incognita that in fact artists were the first to seriously explore, however many lost their senses in the effort to do so. Once one disordered one's senses, as Rimbaud advised, it was not easy to restore them to order. Fascinated by the unconscious, many artists became trapped in its labyrinth. They never found their way back to external reality – to the banality that is also a necessary part of life, and at times its saving grace, especially when one is threatened by madness, which is what it means to live entirely in internal reality. The unconscious became such a compelling source of fresh inspiration that a cult developed around it: the unconscious became the new muse, the modern Magna Mater, a Diana of Ephesus with a nourishing breast for every artist.

While external reality still engaged the artist and continued to be the subject matter of art, it was no longer as exciting and challenging as internal reality. Internal reality seemed to catalyze creativity more than outer reality – spurred it on while outer reality almost seemed to retard it. If perception of internal reality released creativity while perception of external reality inhibited it, then internal reality was more important for the artist than external reality. It was also more difficult and dangerous to deal with, which made it more of an artistic as well as human challenge. New methods were needed to describe internal reality; the traditional methods used to describe external reality were hardly adequate to the task. Slowly but surely the representation of external reality began to change, so that it could be used to represent internal reality, or at least suggest it, as Redon said.

In Symbolism and Expressionism the inner experience of reality became as important as everyday experience of it, almost more important. External reality was perceived through internal reality, which came to seem more intriguing – alarmingly intriguing. An uneasy balance existed between them: conscious perception of reality, with its normalizing tendency, was complemented by the unconscious conception of it, with its abnormalizing tendency. But the latter threatened to disrupt, overwhelm, and replace the former, destroying the balance between them – the precarious equilibrium between external and internal that makes Symbolist and Expressionist art so uncanny. The abnormal was certainly more fascinating than the normal. Indeed, Symbolism and Expressionism, in literature as well as in art, are all about its seductiveness – willing seduction by the abnormal, whether in the form of the femme fatale or what Duchamp called physical painting, presumably, like the femme fatale, all cunning body and no serious mind.

The tension between abnormal unconscious conception and normal conscious perception is evident in Postimpressionism, especially in Van Gogh and Gauguin, but also in Degas and Cézanne. They continued to paint external reality, but changed its appearance according

to the dictates of their abnormalizing unconscious, in effect distorting it, as has been said. In Cézanne external reality began to disintegrate and disappear – after efflorescing into astonishing concreteness, indeed, seemingly impenetrable density, as though to confirm that it would endure forever – and in Degas it became enigmatic, as though the shadow of the unconscious had fallen on it, making it obscure and mysterious to the everyday eye. External reality had to be seen with the inner eye, which became the preferred eye in modern art. (For the Symbolists, and later the Surrealists, "enigmatic" meant unconscious.) Gauguin's vision of a primitive paradise of self-expression was an unconscious conception with little or no basis in external reality. Tahiti as Gauguin painted it was hardly its objective correlative. The unconscious invariably looks exotic to consciousness – strange and exciting compared to familiar, boring external reality. Van Gogh misrepresented external reality, sometimes radically. Albert Lubin notes that the fields around Arles were never as green and flourishing as they are in Van Gogh's paintings, which are in effect wishful fantasies. *The Night Café at Arles*, 1888 is even more distorted by Van Gogh's unconscious, to the extent that it becomes a nightmare. Van Gogh became more and more estranged from external reality, which became more and more strange in his pictures. He seems to have lost his bearings in external reality, which came to exist only as a trigger for his feelings. They finally became more real than external reality, and less manageable. Appearances were altered by unconscious projection, making them more extraordinary – certainly profoundly different – than they were in everyday consciousness, which is supposedly unaffected by unconscious conception.

Odilon Redon thought that the consciously known was rooted in the unconscious or unknown – or is it the unconsciously known? – suggesting that what Kandinsky later called internal necessity was more fundamental, even primal than external necessity. Kandinsky made

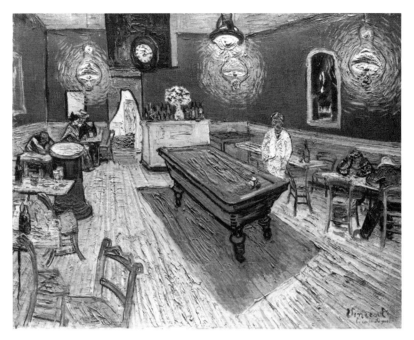

29. Vincent van Gogh, *Night Café (Le Café de nuit)* 1888. Oil on canvas, 72.4 × 92.1 cm. Yale University Art Gallery: Bequest of Stephen Carlton Clark, B.A., 1903.

the next decisive, courageous step: he separated external reality from internal reality and dispensed with the former. This was the defining moment of modern art. Kandinsky used intense color, impulsive painterly gesture, malleable line, and amorphous shape to convey internal reality. He was the first Abstract Expressionist, as has been said – the first artist to express internal reality in unconventional abstract terms, which brought out its vividness to the introspective eye. They were more appropriate than conventional representational terms, for internal reality seemed abstract compared to external reality, and more vivid once it was creatively apprehended. Malevich also turned completely abstract, but he used geometrical form, made dynamic by color and interplay, to evoke internal reality, or, as he called it, non-objective

sensation and non-objective feeling. Whatever the religious associations of their abstract works – Kandinsky regarded his art as spiritual, and Malevich's Suprematist paintings resemble sacred icons and were exhibited as such – religiosity signified inwardness for both. The same is true for Mondrian, who also made the agonizing transition from external to internal reality, ironically with the hope that sacred geometry would save him from his own internal reality – his own nature. Thus, the formal elements of art acquired an expressive aura or subjective glow, and a dynamic character independent of material nature – an autonomous abstract dynamics that reflected the dynamics of the unconscious, which also seemed to exist independently of material nature. For Kandinsky, Malevich, and Mondrian internal reality had a completely different dynamic than external reality. Initially they projected the former into the latter – which is the primal creative-imaginative act that gives external appearances depth of meaning, making them seem really real – but later they elevated the internal over the external as the primal source of "real" (aesthetic) experience and art.

Many artists have tried to heal the breach between internal and external reality – between abstraction and representation – with uneven if ingenious results, but it seemed irreparable. Unconscious conception remained primary and original; conscious perception, secondary and derivative. The dynamics of the former always trumped the dynamics of the latter. It was not until Surrealism, when the unconscious openly became the exclusive source of inspiration, that the bifurcation between unconscious conception and conscious perception was creatively bridged. The dream contained elements of both, and the dream, with its seemingly random association of images and ideas, was the royal road to the unconscious, as Freud said. The abstract representation of the dream made the contents of the unconscious manifest in disguised form. With Surrealism, the dream became the model for the work of art. With dream art – the artistic display of dreams, with all the mock verisimilitude and ironical abstraction that required (the Surre-

alist works of Picasso and Masson are the best example of both, while those of Dali tend toward the former; those of Miró, toward the latter) – the unconscious became the dominant force in modern art. The seemingly amorphous unconscious became the source of art's content and form. Aesthetic experience was beside the point; in a sense, every dream was an aesthetic masterpiece, for content and form were inseparable in it. Since aesthetics was taken care of by what Freud called the dream work, the interpretation of the work of dream art became as important as its production in the mind of the artist as well as that of the spectator. Indeed, the work's hidden meaning became more important than its manifest content, whatever the unconscious methods used to give it form. Form was the distorting mirror in which the unconscious saw itself as well as a springboard into its unfathomable depths, which the Surrealist work of dream art nonetheless attempted to plumb.

The clearest sign of the cult of the unconscious is the modern obsession with so-called primitive art that developed in the late nineteenth and early twentieth centuries. It has inspired – indeed, sustained – the work of many modern artists, from Picasso and Matisse to Karel Appel and Horst Antes. Without their lifelong commitment to it they would have lost their creative power. But before primitive art was "discovered," to use Robert Goldwater's term – and the search for it was relentless once Oceanic and African ethnographic artifacts were recognized as genuine art, extending, in the twentieth century, to Native American artifacts (centuries earlier Albrecht Dürer appreciated the artistic quality of Mayan and Aztec artifacts, mourning the melting into bullion of those made of gold) – there were and continue to be what might be called primitive human beings: children and psychotics, the former unformed, the latter ill-formed. Both are abnormal – the latter no doubt explicitly – that is, not normally formed adults. Thus, they had not lost the innocence, naiveté, and spontaneity of vision the rest of us are doomed to lose by becoming adults. It was their emotional primitiveness that endeared them to modern artists, who sometimes

modeled themselves on them, at least in their private minds if not in their public behavior, although the so-called bohemian artist seemed like a mad child. (Rimbaud once again is a conspicuous example, and the later Picasso implicitly identified with children, as the masks he made for his own suggest. He wore them himself. He also said that he had worked all his life to paint like a child.) But above all, they used children's art and psychotic art – both samples of so-called outsider art – to inspire their own art.

Innocence, naiveté, and spontaneity are disadvantages in the adult world, where it is wiser to be cautious rather than spontaneous, clever rather than naive, and normal to feel guilty rather than innocent. Unsocialized – the chronically psychotic seem permanently unsocializable, that is, untouched by external reality, and children are not yet seriously affected by it and still busy learning about it – their senses remained fresh, they expressed their feelings directly, and their thinking was unprejudiced and not influenced by practical considerations. They were open to the unexpected and seemed unexpected themselves. They acted as though everything was unexpected, which made everything a surprise. As Baudelaire said, every sensation was new for them, which made them absolutely modern. In short, they hide nothing and express everything, and thus seem liberated – the epitome of freedom. It was just their abnormality – the fact that they seemed to have direct contact with the unconscious, indeed, to live out of it, and were entirely uninhibited in its expression – that made them free spirits. (Non-normality may be a better term than abnormality, except that abnormality conveys their difference from the normal adult and also conveys their sense of being ob-scene, that is, of being able to see through and behind the social scene.) They were the new utopia – a personal utopia – because they seemed to resist, with no effort at all, adulthood, especially the adult bourgeois male, who thought of himself as the epitome of normalcy. Thus, the mentality of the child and the psychotic were

thought to be essentially the same and became the unconscious model for the mentality of the modern artist, especially because it seemed, paradoxically, unmodern while at the same time as novel as modernity. The unrepressed child and expressive psychotic were the opposites of the inexpressive machine, which symbolized social repression, for it conveyed standardization, regimentation, homogeneity, conformity – everything that seemed to mock and block the development of free, spontaneous individuality. The child and psychotic epitomized radical individuality and radical subjectivity, especially because they seemed to have extrasensory (supernatural) powers – an uncanny gift for perceiving the uncanny in the ordinary, which is the way Breton thought of the psychotic Nadja, a supposedly clairvoyant woman eventually confined to a mental hospital.

The most crucial thing about postart is that it signals the end of the cult of the unconscious. Without the unconscious for inspiration, art begins to run on empty, which is what much of it is running on today. The belief that the unconscious is a social construction – a bourgeois ideology – is an attack on it. Conceptual art, which lacks unconscious import – semiotic wit replaces the dream's wit – is in the forefront of the attack, as Kosuth's negation of a text by Freud suggests. (He supposedly put it under erasure by crossing it out, but he in visual fact made it unreadable and meaningless.) Technologically oriented art is also in the forefront. Indeed, technology has come to replace theory, social criticism, and the unconscious in postart, which is why it seems increasingly impossible to be an artist without also being – indeed, first being – an engineer, computer whiz, or video technician. Art was already on its way to becoming a fiefdom of technology in 1966 – or rather being appropriated by what it thought it was appropriating, the way Heartfield, Holzer, and Kruger were appropriated by the media they thought they were appropriating – when John Cage, Robert Rauschenberg, and Billy Kluver, an engineer, organized "9 Evenings:

Theater and Engineering" as the climax of their Experiments in Art and Technology (EAT). Many of the so-called artists in recent Whitney Biennials are technocrats – they appear under the guise of a celebration of "new media" – which is why their art seems expressionless, that is, seems to lack personality – except for marketing personality, that is, the instant marketability of any technical gimmick. As though to confirm that art is over – that postart reigns – some of them used computer technology to destroy the art of the past. One self-styled artist digitalized a Dürer print of the cruxifixion: the nihilistic result was a desert of black streaks – a dubious homage to Dürer, which is what the postartist claimed it was.

Technology is the last valiant attempt to discredit and devalue the unconscious, while offering an alternative inspiration. It is a deliberate assassination under the guise of re-modernizing modern art, presumably passé and old-fashioned in postmodernity – a retooling of modern art to bring it in line with what appears to be the dominant concerns of society. But fear of the unexpected and uncontrollable – all that Redon meant by the unknowable and mysterious, and what the everyday mind thinks of when it thinks of the unconscious – underlies the postmodernization of art. It has to be turned into socially transparent and manageable postart if it is to be brought under control. The unconscious is the bête noire in a scientifically and technologically managed world, which is why it must be killed or at least ostracized. The unconscious has been scientifically tracked, but it has not yet been scientifically controlled and technologically administered – despite the best efforts of psychopharmacology, which reduces symptoms without understanding their unconscious sources (it is worth noting that psychotics no longer make art when they are given mood-altering drugs, suggesting that no Adolf Wölfli is possible today, and in fact none has appeared). And in the postmodern world, even more than the modern world, control and administration (pseudo-mastery, one might say) are all, indeed, seem to have become the be-all and end-all

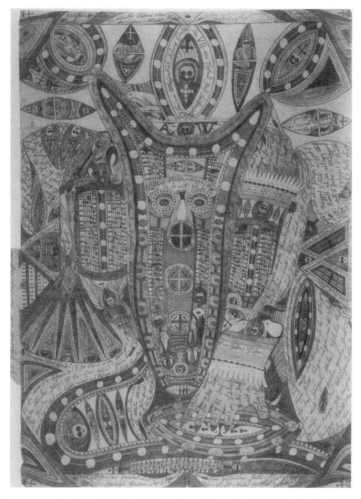

30. Adolf Wölfli, *Harbor of the Holy-Light-Island in the Pacific Ocean, An English – Great British Colony,* 1911, in *From the Cradle to the Grave,* Book 4, p. 283. Pencil and color pencil on newsprint, 99.6 × 71.6 cm. Copyright Adolf Wölfli Foundation, Museum of Fine Arts Bern.

of life. What Mitscherlich and Adorno have called the administered society has overtaken art, which has simply become another unruly – or perhaps delinquent or deviant (as revolutionary modern art was once called) – social phenomenon to be brought into line. It has been in the

form of postart, which is administered art – art administered for the greater glory of society. The lesser glory of the individual is achieved despite the administered society.

Despite ideology, theory, and technology, childhood and "psychoticism" – the term Hans Eysenck used to suggest that creativity and psychosis have a certain resemblance and perhaps affinity – have survived in postart. But they are no longer signs of primitive authenticity. They have been sophisticated into inauthenticity. They have become ideological sideshows, administered by theory and sometimes mediated by technology – as in Oursler's voyeuristic videos of mentally hospitalized people – all of which take the existential sting out of them. Paradoxically, it is the science that manages them from the heights of its superior understanding that turns them into picturesque entertainment. Normalized into entertainment for the masses, so that they become another quick thrill – art has become the most fashionable funhouse in postmodernity, marketing more predictably "different" leisure-time experiences than any other funhouse – they lose their creative potential. The pseudo-experiences – artificially manufactured experiences rather than those that unpredictably occur in the course of life – are all the more entertaining and exciting because they magically transport the "experiencer" to the margins of society, for example, the slums where graffiti art is made – the "raw," "savage" places where raw, savage art is "spontaneously" made (to use Gauguin's terms). Such unrefined places and unsophisticated art are supposedly inherently authentic just because they are raw, crude, "primitive," even deliciously barbaric and outrageous. Thus, the Museum of Modern Art's temporary move to (modified) "raw space" in Long Island City has been celebrated as a return to authenticity. Should we say a fashionable revival of authenticity, lowdown rawness having become another stuck-up style, as in the case of Jean-Michel Basquiat's and Julian Schnabel's Americanized Neo-Expressionism?

Here is the museum's own account of the "ceremonial procession" – otherwise known as a parade – that "commemorated" the move on June 23, 2002.

> Departing from 11 West 53 Street, moving over the Queensboro Bridge, marching up Queens Boulevard, and ending at MoMA QNS, the performance was evocative of both a saint's day procession and a secular celebration. Reproductions of some of the Museum's most well-known works, including Pablo Picasso's *Les Demoiselles d'Avignon*, Alberto Giacometti's *Standing Woman*, and Marcel Duchamp's *Bicycle Wheel* were carried on palanquins or litters, as was artist Kiki Smith. Uniformed participants spread rose petals along the route throughout the three-hour procession, and were accompanied by a Peruvian band.

This self-advertising parade was exemplary postmodern entertainment. It appealed to the public at large as well as to the art elite. Modern art was wrapped in the popular(izing) package of a spectacle and extravagantly hyped. The museum had come to the street – they were enemies in Breton's thinking (the former was full of dead objects; the latter, alive with people and movement) – which became the museum in permanent process. The museum now had music piped in, as it were – pitched to the large Hispanic population in Queens, as though appeasing the invasion by the art aliens – like so many other office buildings. (Just as music sets the mood in the movies – cues us in to the inner life of the characters – so music now sets the mood for the art. Would it be as meaningless and empty without the music as the movie characters are? Was the Peruvian band necessary to liven up what might otherwise be mistaken for a funeral? Most of New York's cemeteries are in Queens.) Supposedly sacred and secular at once, and with works

by artists who were once at odds but now rest comfortably together in a museum open to all the art faiths of modern times, the museum parade had something for every true art believer. The mechanical reproduction of the precious masterpieces confirmed the banalization of modern art as a whole. (Does it unwittingly suggest that there was nothing original in modern art – that there's no originality, only copies, as a fashionable theory suggests?)

There was something vainglorious about the event: it was less memorable and historic than a pathetic attempt at outreach. A pseudobang that was a desperate whimper in disguise – follow the parade to Queens, it pleaded, for to most art lovers Queens is more foreign than Europe, which is easier to get to and has so many more things to see – the parade legitimated the new era of art entertainment that Stella had criticized the museum for a year earlier. Art is not fun, he suggested, but to the museum's director, who had nothing of interest to say about the show he was guiding Stella through, it seemed to be nothing but fun. To administer art as fun is one way of stopping it in its creative tracks. But the march of Big Art Business – Art Show Business – is unstoppable, and the move to Queens, however necessary during the reconstruction of the museum, is a validating symptom of it. With its beachhead in the boondocks of Long Island City – which has become hot real estate property (art gentrifies whatever neighborhood it touches, which may be its social purpose in the postmodern world) – the Museum of Modern Art has in principle gone global. It does not just loan bits and pieces of its collection internationally but is now physically based outside of Manhattan, in a land not particularly known for its hospitality to art (pace P.S. 1, the first art base beyond the pale). The Museum of Modern Art's expansion is no doubt minor compared to that of the Guggenheim Museum, which has established colonial outposts in the boondocks of Bilbao and Las Vegas, all for the good cause of spreading the modern art gospel. Is there any difference between the circus tents in which shrill evangelist barkers made their pitch to

the yearning crowds and the hot new museum spaces planting the flag of modern art on the fringes of the art world? Cultural tourism for everyman is the postmodern motto. To build a museum fortress in a foreign land with false beliefs is one way of conquering the heathen for the true faith.

"'Long Island City has this nice raw quality,' says sculptor Joel Shapiro, who has just purchased a 22,000-square-foot studio. 'It feels fresh. It is not all about retail, which is what everything in Soho is like'."[100] (What a coincidence that he purchased it the same time the Museum of Modern Art made its move there. It's no doubt a good investment. Art upgrades whatever it touches, bringing in a crowd with more than the usual amount of money. Indeed, it soaks up surplus money like a blotter soaks up ink.) Presumably the rawness renews his creativity – returns him to authenticity. Rawness, savageness, supposedly loaded with danger and authenticity – like the art of the insane, and even children's art, which is also charged with the vividness that supposedly only latent violence gives – remain alive and well in postmodernity, but they have become fetishized into inauthenticity, standardized into pseudo-consequence. Creativity no longer depends on them for its vitality, but rather on packages and markets them as social novelties. The same thing has happened to childhood and madness, which are emotionally raw, as it were, and even physically raw. The minds of children and madmen are emotionally raw spaces which, in postmodernity, have become museum spaces full of curiosities, many that look mass produced to the postmodern eye. This dim eye has a penchant for banalizing the bizarre. The postmodern eye has a way of turning the astonishing into the trivial, or, to use Breton's term, the convulsive into the casual.

In modern art, then, regression to childhood and madness was in the service of creativity, while in postmodern postart they have become fun and games. Regression is a source of marketable novelties in a bored society which needs them to feel alive. The modern artist and spectator

accept the fact that a child and madman live inside them – a very active if hidden child and ghostly madman. Indeed, they are basic parts of the self, or at least the modern self. The postmodern artist and spectator can't imagine that they harbor a child and madman deep inside themselves. They have forgotten that they were once children and think they were never mad – certainly never become mad. It would be absurd to believe that there is anything mad and infantile about their normal adult lives. For them the child and madman are amusing anomalies that belong on the outside. A little bit of anomaly is the spice of life, but, for them, happily, not of everyday life. For Hanna Segal creative art sets one's psyche to unconscious work while entertainment doesn't require any creative emotional work at all. Through the symbolic forms of art we revisit the scene of childhood and face our inner madness, including the madness of childhood, which shapes our adult sanity. We work through them again to a liberating new comprehension – a comprehension that must be regularly renewed to be truly liberating. If what Segal says is accurate, then entertainment keeps us on the surface of our psyche, so that it seems shallow – however much it seems to reveal it, entertainment turns the psyche into a spectacle, which means that it turns it inside out so that it seems empty, thus encouraging amnesia about the emotional truth, or else makes it look trivial and playful if and when it finally emerges (the child and madman become teasing clowns) – while art is a diving bell into the psyche's depths, resisting its pressure while affording insight into the peculiar emotions that swim in it. In a sense, postmodern entertainment takes us back to the old days when sane people went to Bedlam to be entertained by the peculiar behavior of the insane inhabitants (who unconsciously represented their suppressed and feared inner selves). Aren't the most entertaining performances of postmodern art the television shows in which everyday people – the folks next door, as it were – behave like children and madmen, that is, deeply disturbed children?

In postmodernity, childhood and madness have lost their unconscious substance and become social constructions – cultural inventions, as it were. Regression to them is a matter of ironical choice – a matter of intellectual amusement, as in the postart of Mike Kelley and Oursler. Thus, it is pseudo-regression – pseudo-childhood, pseudo-madness – and as such socially pathological. Instead of caring for the child and madman inside every one of us, Kelley and Oursler turn them into cartoon characters. Kelley's art is a kind of mad comics; Oursler's art is mad comics made for television, that is, madness as soap opera. Both exploit abnormality rather than treat it with the respect that will make it creative. Indeed, if we accept and love the unconscious in all its seeming abnormality it will become a creative cornucopia of healthy fruit, as Winnicott suggests. It looks like a beast, but if we dare kiss the beast, it will change into beautiful art. That is the message of the modern cult of the unconscious – the reason it is worshipped with such fervor and devotion. Modern artists understood, as Breton said, "that the art of those who are classified as mentally ill constitutes a reservoir of mental health"[101] – which also holds true for children's art, also abnormal by conventional standards. "Through an astonishing dialectical effect, the factors of close confinement and the renunciation of all worldly vanities . . . together provide the guarantee of a total authenticity which is sadly lacking everywhere else, and the absence of which affects us more and more gravely day by day." This is certainly true these entertaining days, when total authenticity – including the total authenticity of the child, who has not yet understood worldly vanity and is closely confined in the madhouse of the family – looks like bad theater. We're no longer taken in by the child and madman; we know they're just acting a social role.

In modern art, regression to childhood and madness is under the control of the artist's working ego. It is a creative regression, in that it strengthens the ego by making it conscious of the instinctive forces

of nature and the superego forces of society that inhabit the psyche, which allows it to use them for its own sublime ends – enables it to put them to work for the larger creative good of life. This is as close as it is possible for the ego to come to liberating itself from their dominance. Creative regression increases the ego's tolerance of the unconscious, symbolized by childhood and madness, which gives it power over the unconscious. It can be harnessed for creative purposes once its power is seriously acknowledged. Many modern artists were inspired by the art of actual children and madmen, which was their way of making peace with the child and madman in themselves. Instead of dragging them down, the inner child and madman became creative resources. They were spiritual beings by being turned into creative artists. In my opinion it was not so much the art of the insane and of children that was important for the modern artist – although it undoubtedly was, to the extent that it was sometimes replicated in modified form – as the fact that despite their handicap and immaturity the insane and the child were able to make art: very original, fresh-looking, unconventional art compared to traditional art. It was the fact that they could keep on working creatively despite inner and social adversity – in the face of depressing reality and the quasi-creative mania that defends and rebels against it at the same time (both are self-evident in children's art and the art of the insane) – that impressed the modern artist, not just the art that resulted from such hard if desperate work. The modern artist clearly identified with the unique social and emotional situation of the insane and children and the compulsive art-making that helped them survive in it.

In contrast, in postmodernism regression becomes casually de-structive and routine at once, and perhaps above all a mass phe-nomenon no longer serving individual creativity. Instead of a back-road to creativity, sublimation, and compassion, it becomes a sideroad to chaos, banality, perversion, and anti-sociality. For George Frankl, "there is little compassion to be found" in Francis Bacon's paintings, but

"rather an exploitation of human tragedy and suffering for the sadistic pleasure they provide to the artist and, presumably, to the onlooker."[102] In other words, tragedy, suffering, and sadism have become entertaining in them. Bacon's morbid figures form a freak show and his paintings form a callous horror show. But Bacon is a passé modern artist compared to the postartists who "exhibit excrement" – the most banal of materials, even more commonplace and everyday than brushing one's teeth, which was Kaprow's postart, and which looks sedate compared to excremental postart – and

> flaunt it before the eyes of the world. In some exhibitions in London there was a great show of 'dirty knickers,' underpants with faeces, piles of excrement on the floor made to look very life-like. We can take this to be a defiant gesture of the self that has been made to feel dirty and bad by parents and by the 'clean and ordered' world at large. . . .
>
> There was recently a 'sculpture' of a vast pile of old motor car tyres in a prominent position on London's South Bank, causing affront to inhabitants and visitors to that area. . . . Even more disturbingly, perhaps, there is now in the same place a 'sculpture' which consists of a huge pile of books, many thousands in fact. What is the meaning of such 'sculptures'? Indeed, what is the meaning of old bits of iron, broken chimney pots, old bicycles, fragments of machinery, unwanted sewing-machines and such like exhibited as sculptures?
>
> They obviously serve to disturb and outrage the onlooker by claiming artistic significance for what most people regard as discards. We see here a declaration of war against the cultural Superego, a demand for a right to express any impulse previously considered taboo. Sublimation itself, the foundation of culture, is declared a barrier to freedom, an

instrument of repression. This new kind of [postmodern] libertarianism is not at all what the founders of modern art had intended.[103]

Clearly the raw has fallen on hard times, artists having to scrounge for it in garbage and feces, rather than find it in the glamorous form of primitive societies. Creativity also has fallen on hard times in postmodernity. Postartists don't know how to aesthetically transform the primitive – they're not even interested in doing so, and don't have the skill to do so – the way Picasso and the German Expressionists transformed African masks with their creative intuition. Thus, postartists lack imagination and have no need for it, since for them banal material is art in the raw state – an even more raw state than the art in the raw state Duchamp spoke of. Regressive desublimation, as Frankl calls it, reaches an entropic peak in postmodern postart, for there is no place left to regress to after has one regressed to feces.

But in fact Duchamp was once again in the avant-garde forefront. To repeat an earlier quotation from Dali, "during the course of the Second World War" Duchamp developed "a new interest in the preparation of shit, of which the small excretions from the navel are the 'de luxe' editions."[104] As though confirming Duchamp's prescience – his postmodern vision that all art would turn to shit and shit would be marketed as art, indeed, very expensive art, for it was the most entertaining art – Dali added: "Today [1968] a well-known Pop artist of Verona sells artists's shit (in very sophisticated packaging) as a luxury item!" Dali himself had an infantile interest in feces, as his use of beans to symbolize it in *Soft Construction with Boiled Beans: Premonitions of Civil War*, 1936, indicates. It is perhaps his most prophetic masterpiece. A gruesome Spain tears itself apart – the Spanish Civil War, in which fascism defeated republicanism, was the prelude to the second world war, in which the world tore itself apart – and the whole world turns into a wasteland of shit. But Dali's use of symbolization

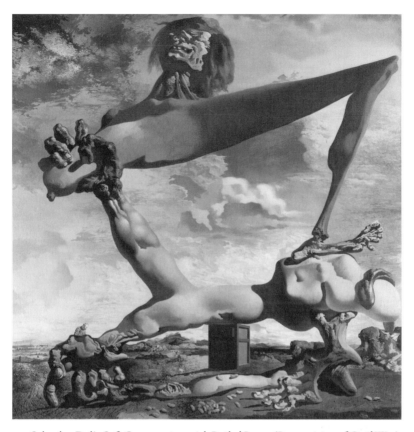

31. Salvador Dali, *Soft Construction with Boiled Beans (Premonition of Civil War)*, 1936. Oil on canvas, $39\frac{5}{16}'' \times 39\frac{3}{8}''$. Philadelphia Museum of Art: The Louise and Walter Arensberg Collection. © 2004 Salvador Dali, Gala-Salvador Dali Foundation/Artists Rights Society (ARS), New York. Photo by Graydon Wood, 1995.

was old-fashioned and modern, indeed, showed a certain modesty and respect for propriety: postmodernity and postart can be said to begin with the uninhibited exhibition of excrement for its own ironically exalted state. When raw shit shamelessly appeared on the horizon of art the postmodern process of regressive desublimation had produced its most consummate postart. Even Kaprow looks old-fashioned, for he was interested in his mouth not in his anus – in keeping his mouth

clean not in anal dirt. His postmodernity was much more wholesome than Duchamp's – a healthy American postmodernity, one might say, rather than a pathological French postmodernity: Duchamp seemed to have the same subliminal "horror of life" – masked by morbid curiosity about its secrets, supposedly revealing the real underlying truth about it – that Roger Williams documented in the life and work of Baudelaire, Jules de Goncourt, Gustave Flaubert, Guy de Maupassant, and Alphonse Daudet.[105]

In a sense, all of them – including Duchamp – were attempting to deconstruct life by focusing on its obscene lower side, but they did so to subvert and deny the reality – even possibility – of its sublime higher side. Thus, their work is a false deconstruction, for by (over)emphasizing one opposite and liquidating the other – collapsing the higher into the lower by showing that the higher is the lower in disguise, and thus a deception – they falsify the structure of the whole. They do not so much overcome the bifurcation of body and spirit, showing their inner unity and the way they can reinforce rather than hinder each other, as squelch spirit by reducing it to bodily terms. No sound mind in a sound body for them, but rather an unsound mind in an unsound body – perhaps the difference between the traditional tendency to glorify and sanctify life (holding it in awe whatever its shortcomings) and the modern tendency to pathologize and profane life (in unconscious horror of it). The harmonious body that appears in classical art is certainly a long way from the fragmented, disjointed, abused body – a seemingly arbitrary assemblage of various part objects that can hardly be called a whole and complete body, and in fact is a very distorted, pathological idea of the body – that appears in modern art, perhaps most famously Picasso. This de-idealization of life and the body reaches a peculiar climax in postmodernity. Life is a hospital, as Baudelaire said, in which the best one can do is change beds. Or, as Duchamp might say, life is a raw deal in which one eats shit, one's own and the world's. But for Duchamp this is entertaining and amusing

rather than tragic and disturbing, which is the postmodern difference. One can do nothing about the pathology of life – about the misery called fate – as Duchamp's alias, Rrose Sélavy, makes clear. Sélavy – c'est la vie, that's life. But for Duchamp life was not only Rrose – eros – but, less obviously, anus: his art was anally sadistic – anally defiant or rebellious, as Frankl says – which was finally made clear by his interest in the preparation and marketing of shit, that is, the use of shit as a medium for transference. Such false deconstruction, involving a holocaust of high art – of anything high, sublime, spiritual (life is certainly not sacred for Duchamp; if it was it wouldn't be horrible) – is the intellectual case par excellence of perversion. As Janine Chasseguet-Smirgel says, the pervert "sets out . . . to make a mockery of the law by turning it upside down,"[106] a "reconstitution of Chaos out of which there arises a new kind of reality, that of the anal universe."[107] Thus, there is no difference between up and down – high and low. De Sade is her prime example, and Duchamp is implicitly her back-up model, as her clinical account of a female patient she code-names Rrose Sélavy suggests. De Sade's attitude to and understanding of life is implicitly the model for that of Duchamp and the decadent French writers Williams discusses. Duchamp is one of them.

As though commenting on the postmodern "aestheticizing" and exhibiting of feces – implying that all art is shit, the core of the postmodern idea of postart – Chasseguet-Smirgel writes: "this in-differentiation is inherent to the sadistic-anal phase, where all objects, erotogenic zones, ideals, etc. are pulverized by the alimentary canal and homogenized into identical particles, the faeces. . . . this regression is inherent to perversion, whatever form it may take, and not only to sado-masochism. My theory is founded on the equation, penis=faeces=child, which in perversion is to be taken literally. Faeces belong to both men and women, children and adults, whereas one has to be a man to own a genital procreative penis, one has to be a woman to bring a child into the world, and in either case one has to

have reached the status of adulthood. In other words, . . . considering the penis and the child as equivalent to the faeces results in erasing the double difference between the sexes and the generations – the basis of reality and of all differences."[108] The entertaining exhibition of excrement – turning it into a spectacle so that it's real nature (as well as its function as a symbol of nothingness and meaninglessness) is forgotten, especially because spectacle distances us from whatever it displays – is the consummate ironical example of entropic modern art, as well as the beginning of postart. That is, the idea that art is everyday excrement made entertaining by being exhibited out of its everyday context – the waste material of daily life made into an amusing spectacle by being elevated to the (increasingly dubious) status of art. Excrement is in fact the entropic end-product of life – life in an exhausted, empty, devalued state, and thus in principle death (excrement is lifeless) – and as such the ultimate deconstructed material of reality, all the more so because it is the homogeneous result of a necessary annihilative alimentary process that ends in an explosive anal happening. Art's turn to feces as a subject-matter/theme – the perfect formless content – also suggests its impotence and sterility, for if feces replaces the penis, and child art is no longer a creative act, then art is simply a matter of moving one's psychic bowels.

The most primitive, raw, insane work of art is the toy, and it was the child's toy, fraught with unconscious meaning, that became the model for the modern work of art, from Gauguin to Appel. (Appel's *Psychopathological Drawings* are among the most amazing images inspired by the unconscious, just as his toylike figures are among best examples of avant-garde toy art. He has explicitly acknowledged that his art is inspired by children and madness.) Strange as it may seem to say so, such art is aesthetically consummate – subject matter and form are one in it – as Baudelaire suggests: "I have moreover retained a lasting affection and a reasoned admiration for that strange statuary art which, with its lustrous neatness, its blinding flashes of color, its violence in

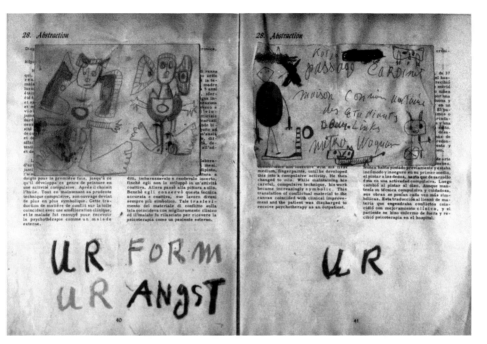

32. Karel Appel, "Abstraction," *Psychopathological Art*, 1950. Crayon, ink, collage on pages 40–41 of *Psychopathological Art*, International Congress of Psychiatry, Paris, France, September 1950, 26 × 20 cm. Courtesy of the Karel Appel Foundation.

gesture and decision of contour, represents so well childhood's ideas about beauty."[109] For Baudelaire, toys are "barbaric" and "primitive" – which means potent – but they have "souls." As though echoing him, Gauguin writes: "infantile things, far from being injurious to serious work, endow it with grace, gaiety and naiveté." He speaks of going "back very far, even farther than the horses of the Parthenon, . . . as far back as the toys of my infancy, the good wooden hobby horse."[110] Thus, Gauguin confirms Baudelaire's idea that "genius is nothing more nor less than *childhood* recovered at will – a childhood now equipped for self-expression with manhood's capacities and a power of analysis which enables it to order the mass of raw material which it has

involuntarily accumulated."[111] He adds: "It is by this deep and joyful curiosity that we may explain the fixed and animally ecstatic gaze of a child confronted with something new," noting that "the child sees everything in a state of newness; he is always *drunk*," and thus mad. De Chirico, another pioneer of modern art, makes the link among primitive art, childhood toys, and modern art explicit: "the pleasure I felt holding [toys] in my inexperienced little fingers, like the fingers of primitive painters and those of modern painters, was certainly linked to that profound feeling of perfection that has always guided my work as an artist."[112] In particular, he recalls "an enormous mechanical butterfly. . . . I looked at this toy, with curiosity and fear, as the first men must have looked at gigantic pterodactyls which in the sultry twilight and cold dawns flew heavily with fleshy wings over warm lakes whose surface boiled and emitted puffs of sulphurous vapour."[113] Clearly his later "interest in the metaphysics and mystery of dreams"[114] is a byproduct of childhood fantasy, not to say childhood psychosis.

Perhaps the climactic defense of the avant-garde interest in the art of children, of primitives, and of the insane, was made by Jean Dubuffet, who collected such Art Brut, as he called it, as well as graffiti, "the pictorial language of the street and the washroom," and automatic drawing. Along with many other artists who found their avant-gardism in such distinctive art – perhaps most noteworthily Paul Klee and Oskar Schlemmer – he was profoundly influenced by Hans Prinzhorn's *Bildnerei der Geisteskranken* (Imagery of the Mentally Ill), 1922. He observes that this "alternative" art has been

> rejected with the condescending label "art of children, of primitives, and of the insane," which conveys a very false idea of awkward or aberrant stammerings standing at the very beginning of the great road which culminates in "cultural art." The common character which certain individuals believe they can identify in all of the products which are

subsumed under this label is illusory. These works have nothing in common except a rejection of the narrow rut within which ordinary art is confined, and a tendency to trace freely their own pathways in the immense territory which the highroad of culture has allowed to fall into disuse to the point of forgetting that other possibilities exist.[115]

Dubuffet adds: "Other artists identified with da Vinci or Michelangelo – in my head I had the names Wölfli and Muller etc. [Both long-term patients in Swiss asylums.] It was these artists whom I loved and admired. I was never influenced directly by Art Brut. I was influenced by the freedom, the liberty, which helped me very much. I took their example."[116] As John MacGregor writes, Dubuffet had "an intense hunger for images free of the pathology of Western civilization" (like Gauguin) – he began collecting Art Brut in 1945, immediately after the second world war, a salient example of such pathology, as though to restore the West to health (health always exists in other, more primitive, unsophisticated, unfamiliar, exotic societies than one's own civilized, sophisticated, familiar, banal society, which is where Joseph Beuys also found it [in Russian peasant tribes]) – "images expressive of human nature in its purest and most individualistic state."[117] Did Dubuffet realize that human nature in such a state – another version of Rousseau's healing return to nature – might be pathological, indeed, that human beings might be inherently insane? His rebellion against "beautiful lines and beautiful harmonies of color" addressed to the eye resembles Duchamp's rebellion against physical painting, with the difference that Dubuffet thought "art addresses itself to the spirit," of which the mind is only a part. "It has always been considered from this angle by 'primitive' societies, and they are right."[118] Thus, Duchamp's New Guinea wooden spoons were spiritual to begin with for Dubuffet. They didn't have to acquire artistic significance to become humanly important. For Dubuffet soul is as self-evident in them as it is in toys

for Baudelaire. Are Duchamp's readymades mock primitive art – or perhaps objects made by an intellectually savage mind (and as such a little more timid)?

"Western civilization might...profit from lessons provided by these savages," Dubuffet writes. "It could be that in many areas, their solutions and their ways, which were once seen as so simplistic, could in the long-run be more far-seeing than our own. As for me, I hold the values of the savage in high esteem: instinct, passion, caprice, violence, insanity."[119] Are these the values of savage art – they must be if he thinks primitive means "savage" – or is he projecting his own inner values onto it, especially those he dares not express socially except in the form of art? Speaking about his own art, Dubuffet states:

> I have always tried to represent any object, transcribing it in a most summary manner, hardly descriptive at all, very far removed from the actual objective measurement of things, making many people speak of children's drawings. Indeed, my persistent curiosity about children's drawings, and those of anyone who never learned to draw, is due to my hope of finding in them a method of reinstating objects derived, not from some false position of the eyes arbitrarily focused on them, but from a whole compass of unconscious glances, of finding those involuntary traces inscribed on the memory of each ordinary human being, and the affective reactions that link each individual to the things that surround him and happen to catch his eye.[120]

This Baudelairean-Surrealist statement, with its open acknowledgment of his debt to children's art, led one critic to describe Dubuffet's work as a "graphic demonstration of a laboriously achieved infantilism." Another critic declared: "M. Dubuffet is in all honesty only an academic painter, a 'Pompier' of infant painting."[121] But children's art and the

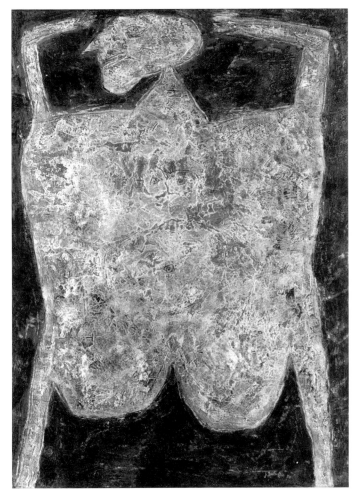

33. Jean Dubuffet, *Triumph and Glory (Triomphe et gloire)*, December 1950. Oil on canvas, 129.5 × 96.5 cm. Solomon R. Guggenheim Museum, New York. © 2004 Artists Rights Society (ARS), New York/ADAGP, Paris.

art of the insane had to wait for the American Neo-Expressionists and such artists as Kelley and Oursler, among other perverse California artists – including California Funk and Punk artists, such as the witty William Wiley and the violent Paul McCarthy – to become academic and pompier, that is, to become another conformist procrustean bed.

Their quasi-transgressive pseudo-savage art indicates that the sacred cult of the unconscious has become decadent and profane. Indeed, they have profaned the unconscious with their regressive desublimation, as though the unconscious was nothing but a source of obscene, irredeemable dirt, with no potential for the sublime and sacred – as though the unconscious wasn't the source of constructive spirituality and emotional redemption as well as spiteful destruction and emotional emptiness. Their simplistic postmodern misreading of the unconscious turns it into a one-dimensional farce. Mined for its last bit of excrement, its absurdity popularized as theater, the unconscious is bankrupted by its postart exploiters. Indeed, postart is perhaps best called pseudo-unconscious or postunconscious art.

Excremental postart – art that performs the banal, turning it into a spectacle, without offering insight into it – is self-defeating. Instead of being outrageously existential, as it claims to be – an unexpected revelation from the unconscious depths in which the postartist seems to swim with enviable ease (but he brings up mud rather than pearls from its bottom) – it becomes minor cultural entertainment. This is true especially when postart is compared to mainstream popular entertainment, which has always made the existential entertaining, as though to mute its import for the masses – a consoling trivialization of the enduring horrors and short-lived joys of life. Its slick products are socially primary – which is why they are popular – compared to the crudely personal ones of postart performances, which are popular only among the art crowd. In fact, there is no way happenings can compete with "with the fast-paced world of MTV, computer games and the Internet," let alone Hollywood movies, which are much more "rapid, colorful and stimulating."[122] As Eric Hobsbawm has argued, movies are the advanced art of the twentieth century, socially as well as technically speaking, not high avant-garde art, which is socially naive and technically simple in comparison.

Performance art is the dominant form – even essence – of postart, which in principle began with the move away from object making to quasi-theatrical action that occurred in Dadaism and Futurism. It is much more entertaining and engaging, for it enters the public's everyday space rather than staying at a discreet contemplative distance, and has no aesthetic pretensions and museum ambitions. But performance art looks like *retardataire*, slow motion entertainment – a kind of amateur hour hobby art – compared to popular spectacles, which are not only more relaxing, or at least less demanding – for they are not trying to revolutionize the world as well as art – but more socially informative and adaptive. However much it is a kind of entertainment manqué, the "King of the Wood" syndrome of avant-garde art is more evident in the performance movement than in any other postart movement. Julian Schnabel acknowledges as much in one of his best works, the grim plate painting-performance called the *King of the Wood*. Describing "the remarkable rule"[123] by which the King of the Wood came to power, James Frazier writes: "A candidate for the priesthood [of Diana at Aricia] could only succeed to office by slaying the priest, and having slain him, he retained office till he was himself slain by a stronger or a craftier. The post which he held by precarious tenure carried with it the title of king; but surely no crowned head ever lay uneasier . . . than his."[124] Ironically, the King of the Wood is a suicide as well as a murderer, for he knows he will be killed by the next king, in a relentless cycle of social insanity. However subliminally, the King of the Wood syndrome drives avant-garde art, especially in postmodernity, for the measures of strength and craft no longer exist in postart. Every artistic performance – and what isn't a performance catering to a seen-it-all before postart public? – has come to look "creatively good" since Duchamp.

There are an enormous number of performance postartists – every postmodern artist seems to be a kind of performance postartist – all

competing with each other in a brutal game of avant-garde one-upsmanship and outrageousness – a game played much more fanatically than it ever was in modern art. They range from the intellectually and emotionally sublime and dialectically deep to the ideololgically simplistic, ridiculous, and shallow, that is, from Laurie Anderson and Beuys to Orlan and Adrian Piper. The former add a fresh nuance of critical meaning to art and life, the latter compulsively repeat themselves before the mirror of the public, as though to be sure that they have a self. They end up as names on the long list of some ideological roster. But the point is that both the most and least interesting are self-styled kings in a one-person art-self performance – Beuys annointed himself with honey in one happening and put on a crown in public (at a Documenta press preview at which I was present) – that tends to be hermetic whatever its worldly resonance. It has become *de rigueur* for every artist to do a performance, even if he's not officially a performance artist. And of course many installations, for example, Hirst's, are performances in all but name.

Indeed, I venture to say there are more performance postartists than painters these postmodern days. But painting itself has become a kind of performance art. Postmodern paintings are more like public theater performances than stepping stones to an inner sanctum. They tend to be more spectacular than enigmatic, however hard they try to be enigmatic. George Mathieu's public painting action, 1957, and Yves Klein's 1960 painting performances, in which the bodies of nude females were used as paintbrushes, make this transparently clear. David Salle's paintings are a more subtle example of what might be called postpainting performance. Losing the unconscious point, like Mathieu and Klein – their works are depersonalized happenings with no unconscious import (the unconscious is neither after-feeling nor model for them) – Salle appropriates and performs cultural history, turning it into a waxworks of reproduced images. Contradicting each

other, the images, drawn from high art as well as popular (often porno-graphic) culture, generate a certain amount of intellectual friction – cognitive dissonance, as it were – but not enough to spark an emotional fire. Salle's works are a dry reprise of modernist irony, particularly in the form Jasper Johns gave it. Johns himself suggests that his irony was a legitimating reprise of Duchamp's irony ("hilarity," Johns called it) – and thus already decadent before Salle confirmed its decadence, that is, confirmed that irony had become so overfamiliar and pro forma as to be passé. That is, it had become the entropic excrement secreted by the navel of postart, to paraphrase Dali. Johns and Salle stage or perform irony (incongruity, absurdity) – for them the ironical act *is* the creative act, as it was for Duchamp – in effect turning it into convenient in-tellectual entertainment, not particularly exciting but piquant enough to pique the spectator's curiosity.

McCarthy and Raphael Montañez Ortiz are supposedly the most narcissistic and nihilistic – the two tend to go together in performance art more than in any other avant-garde art – performers of the uncon-scious. According to them, it is always morbidly infantile. They are sup-posedly dealing with trauma, but the trauma is nothing more than the fact that they are infantile. Simulated infancy is their modus vivendi; unfortunately, infancy is a kind of Rocky Horror Show for them. Sim-ulated insanity was the Surrealist modus vivendi; fortunately, they had some clinical understanding of it (particularly in the case of Breton and Max Ernst). Right there, once again, is the difference between the postmodern and modern approaches to the tragedy of being human. Famously, McCarthy shows us Santa Claus's female elves defecating and smearing Santa's nice clean uniform with the precious shit (vi-carious anal intercourse with Big Daddy?). All his performances show that he is a master of excremental postart. Ortiz's *Self-Destruction*, per-formed in London in 1966, is not quite as sensational, but it was also influential. Ortiz became an abandoned baby crying for his mother,

who doesn't come, which causes him to scream – supposedly an example of what Arthur Janov called the primal scream (long associated with Expressionism, from Oskar Kokoschka and Ludwig Meidner on).

McCarthy and Ortiz are typical postartists, ostensibly in the tradition of the Viennese Action artists (Gunter Brus, Otto Muehl, Hermann Nitsch, and Rudolf Schwarzkogler). They supposedly spill out their unconscious guts to show us the emotional truth about life. But McCarthy and Ortiz are much less enigmatic and daring – emotionally if not physically – than the Viennese Actionists, who identify with the suffering and crucified Christ and equate their performances – which are evocative aesthetic masterpieces with the cathartic quality of revelations – with his healing work. In comparison McCarthy and Ortiz are entertaining exhibitionists, exposing themselves in performances that are supposed to be provocative but that devalue and trivialize the self exposed – like kitsch, which devalues and trivializes (not to say one-dimensionalizes) whatever it represents. Their irrationality is all too manufactured and predictable – at once forced and familiar – which is why their performances lack the surprise and incomprehensibility of the unconscious. They are not so much acting out, as acting. What they regard as unconscious content is a socially reified idea of unconscious content. Blurring – indeed, collapsing – the difference between manifest and latent content, they normalize the unconscious into an entertaining cliché. In their performances the unconscious has lost its power to question consciousness, bringing it into doubt – showing that it is deceptive and self-deceptive. They have no comprehension of the dialectic between the unconscious and consciousness. Consciously unconscious, they banalize the unconscious. In short, they do not so much alter consciousness as work with an idée fixe of the unconscious.

To put this another way, they disorder their senses to conform to a preconception of "senseless" experience rather than to experience the world in a radically different way than one experiences it in everyday experience, which is why Rimbaud disordered his senses. They in fact

make a mockery of Rimbaud, confirming that they are avant-garde conformists in obsolete nonconformist disguise. Coleridge succinctly described this radically different way of experiencing when he said that the task of art is to mark the moments of "transcendence [in] the incidents and situations of common life." A good deal of modern art – Bonnard, Matisse, and Morandi are superb examples, and so, in a different way, are the Synthetic Cubist works of Braque – has attempted to do this. In other words, it has dealt with the commonplace – even the unconsciously commonplace – in an aesthetic way that shows that it doesn't conform to commonplace expectations. In contrast, McCarthy and Ortiz deal with a commonplace idea of the unconscious in order to ratify the commonplace attitude to life – defend the commonplace as the substance of life, in no need of aesthetic reconfiguration and reconsideration to become "relevant" (the aesthetic not being commonplace and so irrelevant) – which is what all postart does, as Kaprow has said.

The postartist is thus a clever social mirror – he doesn't distort at all (when McCarthy smears himself with mayonnaise and ketchup he's just being a naughty child) – not a Rimbaudian rebel offering the saving grace of radical subjectivity in an administered world. Even at their most destructive McCarthy and Ortiz show that the abnormal has become normal entertainment: when Ortiz destroyed a piano with an ax in his *Piano Destruction Concert*, 1966, he did what rock musicians do when they destroy their guitars on stage. "Classic comics," which turn high art into popular art, giving it a mass audience, are a modern phenomenon. It seems that in postmodernity popular art can be turned into (pseudo) high art, giving it a smaller, supposedly more distinguished audience. Performance postart is desperate to show that it is an oppositional practice, which at the same time is an educational opportunity and healing intervention in everyday life, but it depends upon everyday life for its credibility – not as art, but as a special experience in everyday life. Thus, McCarthy and Ortiz do not so much bait the

audience with their oppositionality as give it what it wants – banality made entertaining, with or without art credentials. Art is no longer the phenomenological reduction of the everyday in and through the aesthetic. Instead, the common denominator of the everyday reduces the oppositionality of the aesthetic to farcical entertainment, making people feel independent and unconventional – at least for the moment of everyday illusion, that is, the replication of everydayness in an illusion – without giving them emotional independence from social convention and belief.

Again the model is Duchamp, for his readymades, which present themselves in opposition to aesthetic works of art, are everyday phenomena made farcical. They are in fact a kind of improvised performance art, even commedia dell'arte, which is always improvised: they make a mockery of the social plot called art, which is full of stock characters (traditional artists), turning it into a farce – which is what postart may well be. Perhaps more to the point, readymades are bit actors doing a poor imitation of art because they can't make the aesthetically real thing. Readymades were made to upstage the grander object-actors in those performances called art exhibitions, which in fact they did, as the reception of *Nude Descending a Staircase No. 2* at the 1913 Armory Show and the rejection of the comic *Fountain* for the 1917 exhibition of the New York Society of Independent Artists indicate. The social effect of Duchamp's works has always been more interesting than the works themselves, however clever they may be. Duchamp's kind of oppositionality has become a cliché in postmodernity – modern art's oppositionality never amounted to much in social fact – while the revelation of transcendence in the everyday remains a constant, despite the efforts of such very different performance postartists as Kaprow, McCarthy, and Ortiz to deny that transcendence is possible – to deny that the aesthetic inhabits the everyday or that the everyday can be self-transcending when experienced aesthetically. Postartists refuse to do so, or rather are incapable of doing so, for they do not believe that

art involves imaginative transformation – certainly not in Baudelaire's sense – which is why they are always proclaiming that everyone is an artist (the point of the Fluxus movement). If artists have become commonplace, as Trilling suggests – which means that everyone is a postartist (which is true, if they realize it) – then it has become meaningless to call oneself a creative artist, however narcissistically gratifying, and however much it may give one a touch of status in one's small, commonplace circle.

All art comes to a dead end in reproduction, and everything banal, when reproduced, is art: these are the premises of postart. Reproduction is the foundation of postart, and reproduction is entropic: the reproduction is a memento mori of the original. It is both the instrument and excremental result of the process of social assimilation and neutralization of seriousness. The reproduction lacks the suggestive power, inner spirit, and seriousness of purpose of the original. Nuances of detail are lost, contrasts of form are blurred: what survives is a mute denotation of the original. Reproduction is often misunderstood as representation, but it is mechanical and reifying, while representation (whether "realistic" or abstract) is imaginative and expressive. The original, however well-preserved by the reproduction, remains stiff with rigor mortis – petrified into oblivion. Original works of art enter the everyday by being reproduced, becoming one among many appearances, thus losing their special place in life, and even their raison d'etre – their "originality," that is, power to evoke the unconscious and transcendental, more generally, to remind us of the originality and creativity of life through their originality and creativity. Similarly, reproduced as (post)art by conceptual decree, everyday phenomena lose their place in life, and with that their human importance. One among many indifferent works of everyday art, they no longer make a serious difference. Preserving one's teeth by brushing them makes a small but important difference in life – it is an essential weapon, however humble, in the war against entropic decay which threatens life from

within. Kaprow forgets this when he trivializes it into an entertaining happening – an "interesting" piece of postart.

But of course Kaprow may simply be entertaining himself when he brushes his teeth. Does its daily repetition seem inane? Does he re-conceive it as postart because he is bored by it? Does that "re-creation" make it more interesting? Calling it postart makes it interesting – whatever that might mean – while seeing it for the banal but necessary act of self-preservation it is makes it boring. If boredom is creeping psychic entropy, then the postart happening is a creative attempt to resist it. It is entropy in seminal action, that is, creativity inspired by entropy. Indeed, the happening is a creative straw grasped by a person drowning in banality – a creative straw that emerges from the depths of banality itself, like the hope at the bottom of Pandora's box of evils. Indeed, the happening is creative hope sprung from the depths of daily despair – but the hope embodied in the happening is not eternal, but a flash of false gold in the pan of creativity. It is at best a minor imaginative act, if the conceptualization of an everyday activity as a postart happening can at all be regarded as creative. It is hardly the imaginative "re-vision" of everyday life that Baudelaire and Coleridge believed creative art offered. Kaprow's postart happening in fact exists to deny that life has any unconscious and transcendental – as well as aesthetic – dimension. This is why life is boring, or at best interesting – if it becomes postart.

But the boring always wins in the war between the boring and the interesting, because the happening is interesting only as long as it happens. And by its nature it does not last very long. It is interesting for the duration of its performance, which by definition is brief. The happening then shows itself for what it is: the everyday hyped by being "represented" as art. For Kaprow, the postart happening is a tenuous holding action against the boredom of life. The happening turns it into postart fun, which is a kind of dance of death that looks like the dance of life for the short exciting time it is happening. Afterward one awakens to its fatal banality. It is a point succinctly made by Tehching Hseih's *Punching*

the Time Clock on the Hour, One Year Performance, 11 April 1980, 12 April 1981. Was the punching performance fun? It looks like a modern dance of death – life reduced to a repetitive series of robotic actions, or, to put this another way, mindless behavior absolutized into postart. Banality is built into it, and no doubt, as Hseih repeats himself, it seems funnier and funnier, although Henri Bergson tells us, in his essay on humor, that such numbing repetition becomes, after a while, very unfunny. Indeed, it even loses its quality of black humor. The fun of the happening affords momentary relief from the heavy hand of everydayness rather than insight into why it seems inescapable and boring. Thus, the happening has no significant healing effect, that is, makes no creative change in life, which is what genuine imaginative art does. Interesting postart is art that has lost its creative seriousness – its imaginative nerve.

The reproduction of children's art and the art of the insane as postart also lacks creative thrust and depth, however nostalgic it is for the sense of authenticity and outspokenness that childhood and insanity bring with them. Their postmodernization loses the unconscious and transcendental point of both. A good example of this futile nostalgia for uninhibited childhood and insanity is Jonathan Borofsky's endless serious of drawings *Counting from 1 to Infinity*, begun in 1969. Borofsky admires Wölfli's drawings, as so many others have before him, but his lack their intricacy and intimacy. They are more interesting than insane. The interesting is always rational rather than irrational. Indeed, they are faux insane art. Like all faux art, they are oddly stylish; one invariably stylizes one's sources when one does not understand their depth and meaning. For Borofsky, as for so many other postmodern artists, insanity is intellectually fashionable. Not having experienced it, they have no empathy for the insane. The art of the insane is a novel resource, not a visionary expression of suffering. The insane are the newest art savages – the ultimate fauves, as it were – not the victims of life and themselves.

As though echoing Dubuffet, Borofsky wants the artist to "scratch through the surface and get to the texture beneath the slickness . . . to scrape through the slick surface and get to the grittiness that's a little off center, a little crazy."[125] If this is what he thinks the art of the insane is about, then he'd better think again. The insane don't deliberately scratch through the surface in search of crazy images, the gritty depths spring up at them and engulf them. They live in a dream world, as Bion has said; they're not simply daydreaming to pass the artistic time. Savage scratching – anti-slickness – is an old modern idea of creativity, and Borofsky's drawings don't breathe much new life in it, however automatist they become, as he implies when he describes them as scribbling. But their automatism has run down. They lack both the intensity and delicacy of Masson's automatist scribbling. The images that appear during the course of Borofsky's scribbling – it seems more voluntary and calculated than involuntary, uncertain, and risky (because a matter of chance) – look less spontaneous than Masson's. While not manufactured, Borofsky's drawings look matter-of-factly – routinely – "different." They lack the aura of the unexpected that surrounds authentic automatism. Borofsky is a failed insane artist, or rather too sane to be an insane artist – indeed, too canny about insane art to grasp its uncanniness.

Donald Baechler is a much sadder example of a pseudo-insane – or is it neo-insane? – artist. He has studied the art of children, prisoners, alcoholics, as well as schizophrenics, and knows the art of the Prinzhorn Collection. What is the result of all that research? Rather simplistic, mechanical looking, inexpressive representations of doll-like, schematic figures. The irrational has been mechanically rationalized in Baechler's paintings. There is nothing spontaneous about them; everything is predictable and manufactured, down to the least detail. Even his pentimenti look slick and mechanical. The unconscious has become mindless business as usual in his art. Baechler is too wide awake – too self-consciously "artistic," too eager to do the currently right artistic

thing – to let himself dream. Instead, he copies – badly – the dreams of strangers. Baechler makes the unconscious seem inherently banal – a normal part of everyday life. One wonders why one should attend to it. What is all this talk about the rupture of the unconscious? There's nothing disruptive, eruptive, or interruptive – dangerous, uncanny, bizarre – about Baechler's imagery and handling. His works are certainly a long way from Wölfli's overwrought works. Baechler not only lacks his horror vacui – a characteristic of much insane art – but his tactless energy. Baechler is simply a decadent opportunist, another faux insane artist taking advantage of artists who are genuinely insane, and thus much better artists than he will ever be. The art of the insane dies an insipid death in Baechler's silly pseudo-insane art.

Not that all pseudo-insane art is banal and banalizing, that is, postart. The postmodern work of Annette Messager, Michel Nadar, Andy Nasisse, Arnulf Rainer, Italo Scanga, and Pascal Verbena, among others, seems to have successfully "erased the distinctions between outsider and insider artists."[126] They have caught the spirit of insane art while imaginatively aestheticizing it. Before them, the artists who best captured the spirit of insane art without forfeiting aesthetic sanity – indeed, they discovered a rare aesthetic sanity in insane art – were the CoBrA artists. Nonetheless, on the occasion of their 1949 exhibition in the Stedelijk, William Sandberg, the museum's director, declared that they were "trying to foist upon the public the total destruction of our age-old Western culture, contempt for art of past centuries, a fondness for a few deformed snapshots taken by mental defectives and the revolutionary rumblings of a few kids."[127] Sandberg is to be given credit for putting on the exhibition (it was an eye-opening success) despite his beliefs – which have a certain truth to them – but he failed to realize that the art of past centuries does not speak to the West the way the art of the insane does, especially in 1949 when the West was still reeling from the outburst of insanity called the second world war. Before that the first world war had revealed the insane

reality behind socially sane appearances. That is the big lesson of the twentieth century: reality is more insane than any artistic fiction could ever be. To be childlike was the only way of renewing one's sanity in an insane world, even if the child's sanity has something insane about it from the adult perspective. The child's world is hardly as insane as the adult world, and its insanity is tempered by delight in life. The dialectic between the living death called social insanity and the personal rebirth symbolized by the delightfully creative child – it is a dialectic between social pathology and individual health – drives and shapes modern art and society.

Children's art has suffered a similar misunderstanding as the art of the insane in postmodernity. It too has been reduced to "interesting" postart. Kelley's use of "soiled and sullied toys . . . bought in thrift shops . . . [and] elicit[ing] sexuality, aggression, solitude, and yearning"[128] is the inevitable example. It is as though toys had lost their creative transitional function, as Winnicott called it. Instead of being both the child's creation and a found object – subjectively unshareable and socially shared reality at once – they are anal derivatives. But not all children's postart is a facile exercise in regressive desublimation, in which childhood is reduced to a sado-masochistic adventure. Writing about Keith Haring's *The Radiant Child*, René Ricard remarks: "We are the radiant child and have spent our lives defending that little baby, constructing an adult around it to protect it." Francesco Clemente's picture of a frog in a green pond preserved "a lost moment from childhood, perfectly seen and remembered in a flash." Ricard argued, as Baudelaire might have, that it was this childlike quality that "sets this picture apart as art."[129] However, Nayland Blake is more typical than Haring and Clemente. Blake's 1994 installation *El Dorado* "features yellow toy rabbits (apparently cloned) as parts of a model-size community. One rabbit is gleefully smearing some brown substance on the wall, another is drawing. One group has constituted an execution and is preparing to shoot one of their fellow rabbits; another group is

simply playing. One rabbit, chased by yet another group, is trying to hide; another lies dead in a refrigerator. There seems to be no moral or other scale to differentiate between individual actions. Killing is like 'playing at execution,' being dead is like 'playing dead'; drawing may be interrupted for shooting. Since the toy world so resembles the real one, there is no clear-cut borderline between feigning an action and performing it."[130] Thus, the blurring of art and life – feigned and real happenings – returns us to anal aggressivity, which is dominant in postart. Indeed, the "making" of postart is an act of anal aggressivity, especially against imaginative art.

From *Challenging Mud*, a 1955 performance by the Gutai postartist Kazuo Shirago, to Beuys's 1972 *Ausfegen*, an installation of the debris Beuys collected when he swept Karl-Marx-Platz in Berlin (the broom is included), postart has shown a serious interest in excrement, as Frankl has argued. Kiki Smith's *Tale*, 1997, depicting a female figure on all fours, with a t(r)ail of shit emerging from her anus, is one of the latest examples. One wonders if Smith is updating Robert Mapplethorpe's 1978 *Self-Portrait*. It is as though she has removed the handle of the fetishistic whip inserted in his anus, releasing a stream of shit. Mapplethorpe's photograph is more daring than Smith's sculpture, however daring it is to depict excrement. Mapplethorpe proudly shows himself as masochist, sadist, and voyeur in one. He promiscuously implies that any spectator's voyeuristic glance – any stray eye with an eager erection – can penetrate him at will. He is truly the polymorphously perverse imperial infant, to use Freud's language, rather than simply abject, like Smith's humbled female.

It is perhaps inevitable that shit should become the preferred fascinating subject matter once Wolf Vostell declared that "the theater is in the street" (to refer to his 1958 performance sculpture). For shit inevitably appears on the street, whether in the form of discarded objects and material – the street is where Rauschenberg found his – or animal waste. But art inevitably turns to the street when it has lost

its importance in life. It needs a new place in life, and the lively street is that place, as the Surrealists argued. But in becoming part of street life art is no longer exactly and unmistakably art – it is postart, which is easily mistaken for life. In modern times art came down from its pedestal to consort with the crowd because it felt isolated. It was no longer exactly high art, for it was no longer a path to the higher world of the aristocracy and the church. Supposedly both had an inside track to the higher life, and they used art to picture it. But they no longer ruled society; the egalitarian crowd did, which is why art joined it. But when it did – when crowd art developed and began to regard itself as high art (excremental postart is clearly the most exemplary crowd art, since everyone understands it instantly) – it was doomed to become a kind of street waste. The gallery literally became a "wasteland"; Hirst's installation is once again the obvious example. Works that featured waste were welcome in the museum. After all, they livened it up. They're certainly entertaining. Christopher Ofili's *Madonna*, adorned with elephant turds (supposedly symbolic of Ofili's African heritage), is a prominent example. Ofili offended some Catholics in the audience: they didn't like mud in their eyes, and certainly not on the Virgin Mary. But Pop art is perhaps the most exemplary postart, for its subject matter is crowd art itself – the comic strip and the poster, as Roy Lichtenstein and Warhol make clear. Both are made for the street, and in fact can be understood as street performances, like happenings. Warhol in fact deals with crowd celebrities – mass-produced products with the street smarts to become successes. Highly marketable brand names, and thus hot topics on the street of dreams, they seem charismatic personalities, whether they are Coca Cola bottles or Marilyn Monroe. Like puppets, such social objects only come to life when they are entertaining on some stage, including the stage Warhol puts them on.

But there is a deeper reason postmodern artists are obsessed with excrement: they are uncertain about their creativity. Indeed, creative

momentum and courage seem to have been lost in postmodernity, which is why much of it – even its performances – is a postart of appropriation. It is easier to appropriate something from another artist – which is not the same as being influenced by him – than to make something of and on one's own. That is, it is easier to make a reprise of the past – which doesn't necessarily mean to understand it – than to make something with a presence of its own. (Influences are integrated into one's art. Michelangelo, for example, integrated Giotto and Masaccio into his own figural art, as his drawings after their figures indicate. Similarly, Pollock integrated automatism and Picasso into his dynamic abstractions, as his so-called psychoanalytic drawings indicate. In contrast, appropriations are passed off as one's own art, even though they are, at best, clever manipulations of other artists' art. Mike Bidlo, for example, exists only through his parodic appropriations of Pollock and Picasso; he has no artistic identity of his own – no original identity, one might say, only the facile identity of the postartist.)

In postmodernity originality is not valued and no one thinks it exists – not even in Fromm's sense, which holds that an idea or image is original when it originates in the existential course of one's experience. That is, when it is original to one's existence and helps one realize the originality of one's existence. To not believe in originality is to not believe in creativity. It is really to lose faith in something that one no longer has, if one ever had it. In short, this lack of belief, involving the elevation of the unoriginal copy over the originally created – secondary reproduction over primal creativity, the consciously mechanical over the expression of the unconscious (mechanical reproduction regarded as social expression) – is the artist's conscious expression of his unconscious fear that he is not creative enough to be original. This means that his art is excrement – that it is literally a "waste" of time to make art. Such anxiety – a kind of annihilative anxiety – signals the bankruptcy of creative imagination. Hanna Segal makes the point clearly when she

talks of the artist's "constant terror that [his] product will be revealed as shit," his narcissistic fear that "the artistic product is put forth as self-created faeces," and as such lacks life.[131]

What the artist always fears has become reality in the social phenomenon called postmodern postart. It is the end of art as it has existed from the prehistoric caves to the Rothko Chapel. It certainly no longer exists in sacred space, but on the street, and there's nothing sacred about it because it's made for the street crowd. Of course, postart can be enjoyed in the museum, but the museum has become an entertainment center, which is why there is no longer anything sacred about it, except by critical default. At best it is an elegant boulevard made for leisurely strolling, which is why, in many cities, high art has been put on the street, turning it into postart, and showing that, after all, it belongs to the crowd. The street has become the museum of last resort, showing how readily the profane is confused with the sacred in postmodernity.

5

MIRROR, MIRROR ON THE WORLDLY WALL, WHY IS ART NO LONGER THE TRUEST RELIGION OF ALL?: THE GOD THAT LOST FAITH IN ITSELF

"Whatever may be said of the art world, it is not rotten," Vincent van Gogh wrote in the early 1880s.[132] "Painting is a faith," he declared. It is "not created by hands alone, but by something which wells up from a deeper source in our souls...with regard to adroitness and technical skill in art I see something that reminds me of what in religion may be called self-righteousness." A painting is a sermon: "I never heard a good sermon on resignation, nor can I imagine a good one, except that picture by Mauve and the work of Millet.... The sermon becomes black by comparison, even when the sermon is good in itself."

Thus, the religion of art replaces ordinary religion and the painting becomes a confession of faith, at once anguished and elated. In a novel version of the *imitatio Christi* – not only does the artist become Christ but Christ becomes an artist – van Gogh announced that Christ was "*a greater artist than all other artists*, despising marble and clay as well as color, working in living flesh." Could paint be living flesh? van Gogh tried to prove that it could be, hoping to show that to be a

painter was the next best thing to being Christ. He seemed to think he was in fact Christ when he empathically portrayed the wrecked flesh of the coal miners of the Borinage and that of his mistress, Sien, both "marked by fear and poverty" and socially "despised," as he himself felt he was. He identified with these outcasts and felt that the artist in general was an outcast – which made Christ the most outcast of all artists – but he felt that art could redeem their lives and show their humanity, just as he felt being an artist could redeem his life and show his humanity. To make art was not humiliating, but a way of recovering from the humiliations of life – the same humiliations that were inflicted on Christ, who was treated as though he was less than human rather than more than human, which he was, even as he was all too human. Indeed, van Gogh wanted to show the humanity of art, which saved it from self-righteousness, from the hollow pride of craft and the arrogance of self-sufficiency.

It is as though by working with their living flesh, which seemed close to death – life was a burden for the miners, as such images as *Bearers of the Burden*, 1881, and *Miner's Wives*, 1882, suggest, and pure suffering for his mistress, whose misery seemed engraved on her flesh, as *Sorrow*, 1882 and *Sien Suckling Her Child*, 1883, indicate – van Gogh believed he could save their souls, thus showing that art could perform miracles. It is as though van Gogh thought he could raise the miners and his mistress from the living dead by re-creating their flesh in and through art. It was an act of faith in the power of art, however powerless he may have felt as a person. He endowed art with human purpose to the extent he felt he was not respected as a human being. He privileged art to the extent he felt life had denied him any privileges, which is why he identified with the underprivileged.

Christ also was underprivileged, coming from a humble working class family. He also believed that lowly workers and social outcasts were the chosen of God, for their suffering had prepared them to receive him. Christ also associated with those society devalued, finding

the highest human values – faith, hope, charity – in their lives. Poverty and suffering are social disadvantages, but they are also an opportunity to live spiritually. Society deplored poverty and suffering – even though it hypocritically permitted them, doing next to nothing to eliminate them – but they emotionally prepared one for the spiritual life. This is why art was associated with them for van Gogh, and why he associated his poverty and suffering with that of the miners and his mistress. To be an artist was to take a vow of poverty and to suffer, which is why van Gogh was ready to share his life with people whom society seemed to have destined for poverty and suffering from the beginning of their lives. However vulnerable he may have felt, van Gogh – like Christ – had the ego strength and insight necessary to turn emotional and economic deprivation into religious renunciation. They became the self-sacrifice necessary to gain a higher self – a more authentic self than the social self. Poverty and suffering were the asceticism necessary for his religious vision of art. Van Gogh never thought of himself as a genius, but rather as someone humbly doing the Lord's hard work. Yet clearly he was a religious genius, even though he found his religion in art. But for him art was premised on poverty and suffering, not on social glory.

Van Gogh deeply identified with Christ the artist, fusing his identity with Christ's, to the extent of attacking "the Pharisees of art" the way Christ attacked the Pharisees who academicized religion, turning it into authoritarian dogma and lifeless ritual: "The old academic school, often detestable, tyrannical, the accumulation of horrors, men who wear as a cuirass a steel armor of prejudices and conventions." Unlike the academicians, van Gogh wanted "to accomplish something with heart and love in it." His art preached universal empathy rather than blind obedience to aesthetic law. It was informed by the spirit not the letter of religion; a painting was a spontaneous sermon rather than a theological lesson in correct religious thinking. A convert to the living religion of art, and perhaps its greatest exemplar, van Gogh

believed art could bring religion to a doomed and damned world, saving it from itself. Similarly, he felt he was doomed and damned to failure in life, but he could triumph in art, which would give him eternal life, saving him from his own wretched life. In his new kind of religious art, he was no longer the victim of life and society, but a secular saint. Victimization, a cruel fact of life, was turned into martyrdom for the sacred cause of art – the greatest cause. Van Gogh quoted Christ's "mysterious words, 'Whosoever shall lose his life shall find it'," then subtly changed them: "Whosoever will save his life will lose it, but whosoever will lose life for something more lofty shall find it." That something more lofty – that something for which van Gogh expected to be crucified by the academicians, for which he was ready to give his life – is art. To find art was to find true religion for van Gogh – a lonely, ecstatic religion superior to that of his father, a sober career minister in the Dutch Reformed Church.

Which artist thinks this way today? Which artist commits himself as completely to art as van Gogh did? Which artist experiences art as sacred? Which artist believes that making art is an act of faith? Which artist regards art as the hope at the bottom of the Pandora's box of emotional evils that is life? Which artist believes that art is more lofty than life and worth dying for? Which artist regards it as an act of empathic charity to other human beings? Which artist thinks it can make a hellish world seem like emotional heaven? Certainly no postartist, who sacrifices himself for neither art nor life, suggesting, by the triviality of his response to both, that neither is worth the trouble, which is why he blurs the boundaries between them, devaluing both in countercultural nihilism. Socially critical artists preach to the world at large, cursing it for its evils, but their aesthetics and criticality have become academic clichés, and even then remain secondary to the artist's self-righteousness. Socially critical art has fallen on hard times since the days of Max Beckmann, Otto Dix, and George Grosz. They believed in the critical power of art even as they realized that it had no power

to change society. They were stoic realists, revealing human tragedy in social action. They may have advocated social revolution, but they knew that tragedy was inescapable in life, and they revealed the tragedy of modern life and the tragic results of social upheaval. They believed in art as much as van Gogh did – they also thought it was a lofty calling (rather than the cynical career it seems to have become) – but were even more despairing of life.

Who is naive enough today – more than a century after van Gogh's death – to think that the art world is not rotten, at least in part? Van Gogh himself, despite his assertion that it wasn't, realized that it was. He doesn't quite believe what he says, as his ambivalence suggests. "Whatever may be said of the art world" – what might be said of it? – undercuts his conviction that "it is not rotten," revealing his doubt. His faith in the art world is negated by the skeptical remark that introduces it. It is a wish not a statement of fact. Something is seriously and conspicuously wrong with the art world, as he complains. "The exhibitions, the picture stores, everything, everything, are in the clutches of fellows who intercept all the money. . . . There are real, serious connoisseurs, yes, but it is perhaps one-tenth of all the business that is transacted that is really done out of belief in art." That is the belief that he had. His uncles were art dealers who had become wealthy selling art, and he himself had been an apprentice art dealer, but he "would rather live from hand to mouth . . . than fall into the hands of Messrs. van Gogh."

Show me the contemporary artist who would prefer to live from hand to mouth rather than fall into the hands of an art dealer. It seems impossible to be a martyr to the cause of art in an art world that has become all business – ruthless business. It is impossible to avoid the temptation of money, because art itself has become money. Capitalism transformed the *prima materia* of time into the *ultima materia* of money. It has now performed a greater alchemical miracle, for in transforming art into money it preempted art's role as the representative on

earth of that *ultima materia* called eternity. Until our unapologetically materialistic times art was the closest thing to eternity on earth, which is why it has sometimes been called "the eternal present." However much art was of its times, it always had something timeless about it. But today art seems completely of its times – Pop art was the moment when this truth became self-evident. Eschewing even the suggestion of timelessness, that is, the allusion to eternity, which is beyond time (but can be represented in time), art has lost its idealism, and with that its empathy. For art's ability to eternalize human beings who live and die in time – to eternalize the sensation of life, as Umberto Boccioni put it – thus creating the illusion that they are immortal, that is, endure in the present in the form of art, is an extension and expression of its empathy for humanity. One immortalized the mortal out of poignant love for it.

The success of the transformation of art into money became explicit in 1975, when Warhol nonchalantly declared, with deceptive cleverness:

> Business art is the step that comes after Art. I started as a commercial artist, and I want to finish as a business artist. After I did the thing called "art" or whatever it's called, I went into business art. I wanted to be an Art Businessman or a Business Artist. Being good in business is the most fascinating kind of art. During the hippie era people put down the idea of business – they'd say "Money is bad," and "Working is bad,"" but making money is art and working is art and good business is the best art.[133]

The interchangeability of art and money – the completeness of their correlation – suggests that there is something rotten about both. This has nothing to do with whether art is good and money is bad, but with the fact that they belong to radically different realms. Or at least they

did until Warhol confused them by forcing them together. Giving each the value of the other he devalued both, however much he meant to use each to increase the value of the other. What looks like a dialectic is not really one. Art and money do not share common existential ground; they have no essential connection. Claiming – or pretending – that they do is nihilistic. (Just as Duchamp's "theoretical" conflating of art and non-art – Warhol's conflating of art and money is the "practical" American version of it – is nihilistic.) In a genuine evolutionary dialectic, the opposites organically inform each other, forming a unified whole that is greater than the sum of both. Growing together on common ground, they synergistically interrelate, creating an unexpected revolution in consciousness. Each signifies an old consciousness of self and world, but their dynamic integration revolutionizes our consciousness of both. A new perspective on the lifeworld emerges from their synthesis – achieved by hard emotional and cognitive work – affording uncommon insights into what had hitherto seemed commonplace. A world and self that seemed stale, finished, and familiar suddenly seems fresh, full of possibilities, and unfamiliar. Even as the old sense of world and self is brought into question, both acquire a new sense of purpose, and with that new value.

But in Warhol's pseudo-dialectic the facile conjunction of art and money disillusions rather then enlightens us about both. It is a social association, and as such unessential – it may make sense in money-mad American society, but it is meaningless in the tribal cultures that produced so-called primitive art – rather than a necessary evolutionary synthesis. Art and money do not synergistically reinforce each other, bringing us to a new consciousness of both. Nor does their relationship give rise to a consciousness that transcends both by seeing them in a larger perspective. Instead, each compromises the other – not exactly a true reconciliation. Instead of making money more important and meaningful by associating it with art, and art more important and meaningful by associating it with money, both become meaningless

and unimportant. Warhol's remark about "the thing called 'art' or whatever it's called" suggests as much. It is no longer clear what art is, or what it means, or why it is important. But it is quite clear what money means for Warhol. Art may be indeterminate, but money has the power to determine what is art. For Warhol all art is commercial, which says more about the power of commerce than it does about the power of art. It took little more than half a century to undo Kandinsky's idea that art was the last bastion of spirituality against materialism. It seems no accident that it was an American artist who elevated commercial art – art that is a means to a commercial end, that is, art that exists to make money – over high art, that is, art which remains an aesthetic and existential end in itself, however much money may appropriate it.

Thus, if in modernity art is the only genuinely spiritual religion, for it is the only endeavor that is existentially authentic – that is, conveys, in an emotionally comprehensible, personal way, the archetypes and universals that are the mysterious fundament of the human spirit and human values – and money is existentially irrelevant, impersonal, and far from mysterious, then their union is a marriage made in hell. If art is an empathic response to the human condition, and the will to make money – clearly all-consuming in Warhol – is indifferent to the social conditions under which money can be made and to the insidious effect making it has on the human beings who make it in large quantities as well as on those who don't make it in any socially significant quantity, then their union is an unholy alliance. If art has intrinsic value, which makes it priceless – whatever price the world puts on it – and money's value is its exchange value, then their union is perverse. If "the pervert in general . . . sets out, consciously or unconsciously, to make a mockery of the law by turning it 'upside down'," as Chasseguet-Smirgel argues,[134] then Warhol, consciously or unconsciously, sets out to make a mockery of art by turning it upside down, that is, turning it into money. By identifying art with money, Warhol devalues art while giving it the value of money – which is valueless

unless it can be exchanged for something. Art loses spiritual cachet to gain social and economic cachet – the credibility, influence, and power that only money has in a consumer society.

The artist was once thought of as sacred – he had a spark of God's creativity in him – but Warhol's artist is a businessman, profaning everything sacred and creative by putting a price on it, as Marx said. Warhol is a born salesman; with him art loses its mystery and openly becomes a commodity for sale. It seems to have no other identity than that of a commodity and no other value than the economic value it acquires by being sold. It also has the built-in obsolescence of every commodity. It inevitably loses excitement with time – after the fifteen minutes in which it was famous (and thus exciting), as Warhol said. Again and again we see Warhol replacing an obsolete old celebrity with an exciting new celebrity. None of them have any staying power, nor does his art – insofar as it is art as distinct from money. Warhol's art was in fact as commonplace – and seems as mass produced (Warhol imagined that he was a machine, suggesting that he felt his life as well as art was manufactured) – as any cheap commodity. It depends on the commercially commonplace to make its own commercial point. Warhol made art as consumable as the popular commercial culture it preyed on. The commercial celebrities he portrayed are popular commodities – preconsumed (preowned?), as it were, as their popularity suggests. They are commercial products that Warhol re-packages as commercial art, suggesting that it is just another product.

They are hardly the sacred mysteries he suggests they are. His *Gold Marilyn Monroe*, 1962, turns a commercial icon into an art icon, but she remains the "plastic invention" that Billy Wilder said she was, just as Warhol's icon remains plastic art. His art is ultimately as unsatisfactory as any popular product, for while it satisfies a social need – his imagery caters to envy by gratifying the wish to identify with celebrities, as though they were superior beings (and as though identifying with them will magically give their fans the material and social success they

have) – it does not satisfy existential needs. Warhol's art exploits the aura of glamor that surrounds material and social success, ignoring its existential cost. His art lacks existential depth; it is a social symptom with no existential resonance. "If you want to know all about Andy Warhol, just look at the surface: of my paintings and films and me, and there I am. There's nothing behind it."[135] This consummate statement of postmodern nihilism suggests the reason that art has lost faith in itself: it has lost emotional and existential depth, and sees no reason to have any. It no longer wishes to plunge into the depth – it doesn't believe there is any depth in life, and wouldn't be able to endure the pressure of its depth if it believed life had any – which is why it has become risk-free postart dependent upon superficial experience of life for its credibility.

There is no existential reality let alone depth to the celebrities Warhol portrays, including himself. They enact existence rather than actually exist. Like them, Warhol is a social illusion – a shallow image, a more or less theatrical surface. Another reason art has lost faith in itself is that it has become part of the entertainment business, in effect capitulating to popular commercial culture, as Warhol makes clear. If, as Ezra Pound said, "the artist is the antenna of the race," then Warhol is an antenna broadcasting the American attitude to art. It is business and entertainment, as American celebrity culture makes clear. Art continues to pay a high price for Warhol's exposure of its real interests. It sells itself to the highest bidder, which suggests uncertainty about what it has to sell. If what it has to sell is valuable only because the people with the most money want to buy it, then it has only the value their money gives it, suggesting that it doesn't believe in its own value. How can it have unique value in a society in which business and entertainment show us that there are no unique values?

Some interpreters have thought that Warhol was deliberately cynical, or at least ironical, but I think his seductive equation of money and art – not to say pernicious confusion of their terms – was dead

serious and honest. It is ruthlessly cool, in a world where "coolness *is* the aesthetic. . . . Cool is the way to be both indifferent to commerce and commercial at the same time."[136] This is what Warhol thought he was doing – making art that was indifferent to commerce yet commercial at the same time. It's a wonderful paradox, but Warhol was not as cool as he seemed; money made him hot – hotter than art did. His art was a kind of hot money – counterfeit art that could be exchanged for real money. He began his career as a commercial artist, and never stopped being one, ultimately making upscale commercial art – a deadpan art about commercial celebrities, including himself. Perhaps that made him ultra cool, but it also corrupted art. He assimilated art into money, robbing it of spirituality and integrity. For Warhol, art is not a private religion that promises personal salvation, but a branch office of the religion of money. He subsumes art in the capitalist worship of business and success. What would van Gogh think of Warhol's statement? He would have thought that art has gone to the devil. Warhol, like Duchamp, who was also obsessed with money and also made deadpan art, is what the law calls a "corrupt persuader," not to say panderer, toying with desire the way Duchamp toyed with intellect.

And what would van Gogh think about Chuck Close, a painter who is a trustee of the Whitney Museum of American Art? "It is no surprise," Langdon Thomas Jr. writes, "that the museum's board has so aggressively courted some of the flashier and more unpredictable money in town – like that of Vivendi's Jean-Marie Messier, who is still a board member with [Dennis] Kozlowski, and Veronique Pittman, second wife to AOL Time Warner's Bob."[137] Vivendi and AOL Time Warner are among the corporations caught up in the scandals that have rocked the capitalist world, ushering in the new millennium with an unprecedented display of corruption, and Kozlowski, chairman of Tyco Corporation, was indicted for evading New York City tax on the expensive art he purchased. Tyco has been said to have "conspicuously

poor standards of boardroom governance."[138] Can the same be said of the art corporation called the museum? Should we be as suspicious of it as we are of any other capitalist corporation? Will it also show itself to be a fraud and scam? Who's doing its accounting? What account of itself can it give apart from the fact that its collection is worth millions of dollars – at least on paper? Close comments: "You have to be realistic. This is not like putting together a cocktail party. . . . You are looking at the future of the museum. When you are the Avis in town to everyone else's Hertz, you do try harder." That is, try harder to raise money – to be beholden to money. What are such people doing on the Whitney's board in the first place? There are no art historians and art critics on the board, and Close is the only artist. Does that make him particularly knowledgable about every art? Is he open to all kinds of art, or does he have a sense of what is the right kind of art – the expensive kind? Doesn't he have a vested interest in his own kind of art? He's no doubt more knowledgeable than the corporate tycoons on the Whitney board, who have their own vested interests. It is not so much that the museum has sold out to big money, laundering itself by yea-saying art, but rather that it doesn't fully realize what it has bought into. But then again it wants to be a corporation and govern itself by people who know how to govern corporations, which seems to mean to milk them for all they are worth. Art is simply another investment property – the holdings of an art corporation that happens to call itself a museum.

It is worth noting that Maxwell Anderson, the Whitney's [former] director, whitewashed Kozlowski's purchase of paintings by Monet, Renoir, Beert, and Caillebotte, declaring "he was clearly someone who saw virtue in having them." That is, he scored social points – gained status – by flaunting his wealth in the form of art. A few months earlier, Anderson, defending the then current Whitney Biennial, asserted "that traditions don't fare well in the contemporary art world. The Whitney follows the instincts of artists, rather than the art market."[139] But it

clearly needs people who speculate in the art market – who know the art business – on its board and who own traditional art. Is this shameless two-facedness or naive hypocrisy? Or is it just the usual "combination of art smarts and money?"

What's true art in a world in which art is money? Who's a real artist, if there is any reality other than commercial reality to art? Van Gogh wanted to rid the temple of art of the moneylenders the way Christ rid the temple of God of the moneylenders. But today they own the temple of art, or at least the mortgage on it. Where for van Gogh art was a way of celebrating God's creation, for the moneylenders it is a Golden Calf. Warhol makes it clear that they have taken over the temple, and that the artist himself has become a kind of moneylender. Today money seems to have become more essential to art than spirituality. Warhol was not on a spiritual mission when he decided making art was a good way to make money. Not van Gogh's poverty and fear for him. A homosexual artist, Warhol proved that homosexuality and art could be "in" in capitalist society. Both were good business – they could sell – which proved they were not social outcasts. It is not clear whether money whitewashed art and self-identity or art whitewashed money and self-identity for Warhol, but both became his commercial way of identifying himself.

When the psychologist Mihaly Csikszentmihalyi writes that "people who are attracted to art, at least in our culture, tend to . . . stand outside the normal network of social relations and cultural constraints,"[140] one wonders if he understands anything about the culture of art today and the people who are attracted to it. Are they as "aloof from conventions" as he thinks they are, or is their unconventionality another convention? The outsider stance has become another insiderism, as Andy Warhol's social success and wealth – Roy Lichtenstein's seems to have been greater, suggesting that he was a better businessman (at last estimate his estate was worth $1,000,000,000 while Warhol's was officially declared to be around $660,000,000) – makes clear. Clearly,

to be an outsider is a great way of marketing oneself. The artist out-
sider is well rewarded in our society – so long as he is an insider in art
society – and even becomes a business leader. That is, as the sociolo-
gist Daniel Bell has noted, he "dominate[s] the audience," influencing
"what is to be desired and bought," which confirms that the "adversary
stance" of "the new and experimental" no longer signifies "the self (in
its quest for originality and uniqueness)"[141] but rather the self as novel
commodity. As Bell suggests, "defying the conventions of society" is no
longer "the imago of the free self" but a business stategy – a successful
one, as the high price of Damian Hirst's work suggests.

 Examining the contemporary relevance of "the notion that artists
are, or at least ought to be, somewhat mad," which he traces back
to Giorgio Vasari's description of "the Florentine artists he knew as
having 'received from nature a certain element of savagery and mad-
ness . . . making them strange and eccentric,'" Csikszentmihalyi notes
that "to be original, one must distance oneself from the average, from
the normal . . . from commonly accepted thought patterns." Thus, "to
be original, one must to a certain extent be alienated. The danger . . . is
that originality might slip into autism or into 'idiocy,' the Greek word
for being alienated from the community of one's peers." But Csikszent-
mihalyi does not seem to realize that in postmodern business art society
madness has become a social stance – role-playing, as Julian Schnabel's
proclaimed pursuit of it indicates. What one might call the stance of the
abnormal has become art-normal. Indeed, the stance of originality has
become unoriginal. Savagery has become a convention, and eccentric
has become a qualifier of abstraction, hopefully enlivening what looks
dead, at least to the eyes of the much more socially nimble Pop art.
"I am thinking of frankly accepting my role of madman," van Gogh
wrote, but he was a madman, that is, socially alienated and mentally
disturbed, whereas Schnabel cannily plays the role of madman, because
he knows it gives him credibility as an avant-garde artist. Indeed, to be
a savage madman carries a certain social cachet, which is why a movie

has been made about van Gogh rather than Redon, who also looked madness in the eye but remained healthy, and whose art is gentle and delicate rather than harsh and violent. Picasso famously said: "It is not what the artist *does* that counts, but what he *is*."[142] But today it is what the artist does for his career that counts, not what his art shows that he is despite what he claims to be.

Writing about nineteenth century English landscape painting, John Ruskin asked: "Is English wet weather, indeed, one of the things which we should desire to see Art give perpetuity to?" He answered: "Yes, assuredly."[143] Van Gogh wanted to immortalize the Arles landscape, as his association of its autumnal colors to the "heavenly blues and yellows in a Van der Meer [Vermeer] of Delft" suggests." Just as Ruskin admired "the religious art of the sand-lands," so van Gogh admired the religious art of nature. How many contemporary artists seriously believe that the goal of art is to immortalize the mortal? Otto Rank, in *Art and Artists*, argues that this has been the age-old task of art. But it seems absurd and old-fashioned in the rapidly changing modern world, in which the artist is concerned to make his mark now rather than wait for the judgment of posterity – which, anyway, is less the matter of considered consensus that Greenberg thought it was than a matter of media manipulation and public relations. It is a consensus of vested interests not of detached judgment. What does immortality – let alone immortal art – mean in such a world? When turnover means more than tradition, mortality means more than immortality. The mortality of art is taken for granted, and immortality means no more than the fifteen minutes of fame that Warhol thought was everyone's due.

Writing about Henry James and Friedrich Nietzsche, Stephen Donadio notes "the extraordinary emotional investment made by both ... in the power of art as the only activity capable of creating values and raising experience from insignificance."[144] (Both, incidentally, seemed to be failures in human relationships, which is

why they thought they were less valuable and significant than art, and cultivated them with less enthusiasm and effort than they made art.) With Friedrich Schiller, they believed that "it is only through Beauty that man makes his way to Freedom [from the limitations of experience]."[145] Donadio notes Thomas Mann's view that the "major premise" of Nietzsche's philosophy is "that life can be justified only as an aesthetic phenomenon," which is what Mann thought Nietzsche's own life was, "down to his self-mythologizing, . . . down to [his] madness."[146] "Within the closed circle of aesthetic contemplation," Donadio writes, "inconclusive temporal experience is exchanged for the comprehensive calm of eternal form: at the same time, reason takes on the aspect of sensuousness, and the abstract form is made concrete and vibrant with the immediacy of the moment."[147] Is it possible to make such an extraordinary emotional investment in art in a world in which art has become a business? Yes, one can answer, for the artist – like everyone else in capitalist society – is invested in business and marketing himself whether he knows it or not. Who believes in aesthetic contemplation when there is no time to contemplate and time is money? Life can never become an aesthetic phenomenon in a world in which economic survival is more important than emotional survival. The belief in eternal form has to be self-deception in a world that prides itself on being up-to-date and believes in change for the sake of change – a world in which everything is relative to everything else and nothing is absolutely what it is. And what is sensuousness in a world of simulation and reason in a world of computers?

Clearly, art, aesthetic contemplation, beauty, eternity, freedom are experientially and conceptually passé in a world of relative values and technological necessity. The best art can hope for – whatever calls itself art and the society agrees to call art (or is forced to do so by art administrators) – is to become a current, newsworthy social event. This is easily done by addressing some social phenomenon which is likely to continue to be current and newsworthy when the art no

longer is, for example, AIDS. Publicity also helps: when Madonna presented the Turner Prize to Martin Creed in 2001, she made his name by reason of hers, showing the power of kitsch celebrity over avant-garde celebrity, that is, showing that kitsch has become avant-garde. Not that Creed's work – an empty room in which a light turned off and on – has any artistic virtue, although it did have the virtue of generating controversy, which by Pop cultural standards is even better than being immortal, and especially good when the alternative is to be forgettable. Controversy guarantees that one will have a certain place in short-term social memory if not in long-term art memory – not that anyone dares to believe in the latter these postmodern days. Controversy is the contemporary substitute for contemplation, and even though controversy – is it or isn't it art? (it must be art because it was presented in an art institution, that is, it was administered into art) – is the cliché contemplation no longer is, if only because it has gone out of fashion.

If to be modern means to question the idea of immortality and even doubt its possibility (Nietzsche's nihilistic mantra "God is dead") – if it has become preferable to be modern and timely rather than to be immortal and timeless – then to be postmodern means to lose all interest in immortality as well as modernity, giving up belief in both, and simply marking time. Art becomes the preferred way of doing so among the intellectual and commercial cognoscenti. In postmodernism the sense of futility implicit in the nihilistic disavowal of immortality – although for Nietzsche art was its last ditch defense – becomes explicit. So does the melancholy of making art and with it the death of art. Postmodern art often looks like the corpse of art – Neo-Expressionism looks like the corpse of Expressionism, Neo-Abstraction looks like the corpse of Abstraction, Neo-Conceptualism looks like the corpse of Conceptualism (all cosmetically embalmed). Ingenious, hyperactive corpses, but nonetheless corpses – robot-like corpses, going through the motions of life in a dance of death. There is an air of sophisticated

ennui to postmodern art – appropriation art is the prime example – suggesting that art has become meaningless however much meaning it claims to have. The postart blurring of the boundary between art and life supposedly remedies the boredom and meaninglessness of both, for if life is arty it is no longer boring, even if artiness is boring. Art becomes empty and hollow when it no longer makes life feel timely and vivid – when it no longer seduces us to life, as Nietzsche said – and when it no longer makes us the gift of immortality by suggesting it through its own aesthetic substance.

In short, art these postmodern days seems to have become another depressing way of passing time rather than of reaching beyond time, which is what it was for van Gogh. Art is no longer the path to salvation it was for him, but rather confirms that life is damned because it is meaningless, which is ultimately why art is meaningless, since it can do nothing to rescue life from itself. Today's postart seduces us to death not life. Warhol is the ultimate postmodern postartist, for he neither knows nor cares whether his business art – or is it art business? – is more art than business or more business than art. This suggests that he neither knows nor cares what art is, indicating that he doesn't believe in it – certainly not the way van Gogh did. More particularly, Warhol doesn't believe that it has anything to do with eternity. It can no longer envision a world that is not run like a business, that is, a world in which everything is for sale and nothing is priceless. The void left by the absence of faith in art is filled by the presence of money. Art's existence comes to depend on it, as though without money to sustain it, it would collapse into non-art. But Warhol's work shows that it is possible to be both art and non-art – it's the postmodern way of being nothing in particular while seeming to be everything. If money is only as meaningful as what it buys, and if what it buys is not meaningful as art – art that is unequivocally art rather than art whose identity is equivocally split between art and non-art – then money becomes meaningless. Money can only compromise itself by buying into something compromised

in itself – something as inherently flawed as business art. If postmodern business art also signals the bankruptcy and meaninglessness of modern nonbusiness art, then it is completely nihilistic.

In a brilliant account of "The Rise of Art as Religion," Jacques Barzun wrote that in the nineteenth century art became "the gateway to the realm of spirit for all those over whom the old religions have lost their hold."[148] The question today is why the religion of art has lost its hold – why art is no longer the gateway to the realm of spirit – however many artists continue to think that making art confers upon them "the attributes of a seer and prophet."[149] Indeed, contemporary art seems to have closed and barred the gateway, as though to declare there is no such thing as a realm of spirit. The artist may still believe he is a seer and prophet – it is no doubt narcissistically comforting for him to think he is – but the larger society no longer does. The artist is no longer "the model of human greatness" he once was, and it is no longer self-evident "that man's loftiest mode of expression is art."[150] The artist's vision is no better than anyone else's in a multicultural world. Indeed, the claim to a universal artistic vision, that is, the belief that art can convey universal experience, seems absurd and meaningless in a world where there are no universal experiences, only a variety of culturally determined experiences. In such a world art is simply one more elaboration of a cultural version of everyday life rather than a revolutionary challenge to it. Science is much more revolutionary and courageous, not to say demanding, in such a world, and has a more revolutionary, enduring effect on the lifeworld. Art may shape its surface – but then what art, what aesthetics? In the wide open world of postart, aesthetic judgments close down the ever-expanding horizon of art, precluding new possibilities of art making – indeed, new conceptions of art – which is why they are rarely if ever made. It is considered naive and short-sighted to make them.

Is it because after more than a century of avant-garde art – art which carries the banner of the religion of art (the banner changes,

but belief that "the life of art is the only one worth living" remains constant)[151] – avant-garde art has become as tediously dogmatic and emotionally stale as any other institutional religion? "The spirituality of art can [be] demonstrated," Barzun writes, by the fact that "in art the force and quality of the effect are out of all proportion to the cause," which proves "the inadequacy of all materialistic explanations" of art.[152] But in postart there is no discrepancy between cause and effect. Indeed, the social material and material condition of the work have no deep effect: we are hardly "shaken to the core" by "the arrangement of material particles" in Warhol's art the way we are by their arrangement in Cézanne's art.

Is it because what Blake feared in 1820 has come to pass? "Where any view of Money exists, Art cannot be carried on," he wrote on an engraving of the Laöcoon.[153] Seventy years later Gauguin wrote: "A terrible epoch is brewing in Europe for the coming generation: the kingdom of gold. Everything is putrefied, even men, even the arts."[154] Certainly, Warhol is this nightmare come horribly true. If "Christianity is Art and not Money," and "Money is its Curse," as Blake said, then Warhol's commercial postart is clearly cursed and far from Christian. Art viewed through money – as money – lacks spiritual meaning and purpose, and is thus only nominally art. When Blake wrote that "the Man or Woman who is not one of these [a Poet, a Painter, a Musician, an Architect] is not a Christian," he never imagined that there could be an un-Christian artist like Warhol. Gold has become king in the kingdom of art, and Warhol, whose art and person were putrefied by the "struggle for money," was king in the kingdom of art gold.

He is a long way from being the "mystic of art" that the Symbolist art critic G.-Albert Aurier said we must become if we are to save ourselves from the "brutalization, sensualism and utilitarianism" of modern society.[155] But Warhol had no interest in becoming a mystic of art; he regarded money, rather than art, as the "plank of salvation." His

subtly brutal, ironically sensual, unabashedly utilitarian art celebrates the values of profane modern society. "The love of a woman is no longer permitted us" in modern society, Aurier wrote, for society "has denied us the ability to see in a woman something else than flesh suitable for the appeasement of our physical desires." "The love of God is no longer permitted us," for modern "skepticism . . . has denied us the ability to see in God anything else than a nominal abstraction, perhaps non-existent." Warhol's loveless art is the epitome of the modern denial of love – indeed, the modern inability to love. The people Warhol depicts lack "the superior qualities of the soul," of which the capacity for love, "the source of all understanding," is the most important. In short, Warhol's art lacks "transcendental emotivity." "Emotion first! understanding later," Gauguin famously declared,[156] but Warhol's art has neither emotion nor understanding.

It is thus an art of death. If "Art is the Tree of Life" and "Science is the Tree of Death," as Blake wrote, then Warhol's art has a scientific bent, as its mechanical character indicates. It is based on photography, which is not "beneficial" for art, as Gauguin argued. It belongs to the "aberration caused by physics, chemistry, mechanics," which caused artists to lose their "instincts," even "imagination," thus leading them "astray."[157] "When machines have come, art has fled," Gauguin wrote,[158] which suggests that Warhol, who identified with the machine – there was neither irony nor shame in his abandonment of humanness – was not an artist. He symbolizes the primacy and power of the machine in modern society, confirming that the tree of science – and technology – has grown higher than the tree of art. However much it has grown, it looks stunted in comparison – art in fact seems to exist in the shadow of science and technology, which are worshipped more than it ever thought of being. Indeed, the ripest fruits of art seem like sour grapes compared to the ripest fruits of science and technology.

Barzun writes: "the dogma that daily life is trivial, coupled with a denunciation of those who do not agree, has been repeated innumerable times by artists and their advocates, not with regret but with scorn."[159] But in postart daily life is not trivial, but art itself, suggesting that the "social alienation that aggravates man's spiritual alienation" no longer exists. Avant-garde art is hardly alienated socially (although it must act as though it is to maintain its avant-garde credentials). However, in the form of postart, it remains spiritually alienated, for spiritual experience has become completely meaningless to it. Postart regards spirituality as a bad joke – indeed, like God, non-existent. According to postart, man has no need to transcend daily life and could not do so if he had the need. Postart denies the existential reality of what Erich Fromm called the human "need to transcend one's self-centered, narcissistic, isolated position."[160] It implies pathological separateness from and indifference to others, and may be pathologically necessary in mass society, for it gives one a psychic space – ironically empty – in which one can survive, that is, not be engulfed by the enormous mass of endless others.

According to Fromm's humanistic understanding, transcendence involves "the acquisition of specifically human qualities" through which individuals "overcome the role of being merely created,"[161] both by nature and society. Postart lacks such human qualities and does nothing to encourage them, and thus help people humanize themselves. Warhol's postart portraits make this transparently clear. His figures are unhuman – they are robotic papier-maché creations of daily life. They find it gratifying, and define themselves by it, to the extent that they do not seem to exist – certainly lack selfhood – apart from it. People are nothing but their social identity for Warhol. They are centered in it, and apart from it they have no identity. They are not persons, but occupy a social place. Apart from their social roles, they are human blanks. They are all social surface, which is what Warhol acknowledged he was. Like him, they have no inner lives, and deny that inner life exists. His art

devalues and discards inner life, for it seems meaningless compared to social life.

This is why we feel no empathy for Warhol's figures. Lacking critical consciousness of their unhuman condition, they are narcissistically isolated in daily life. Critical consciousness can humanize them – the same "advanced" consciousness that once gave art spiritual originality – but there is no critical consciousness in Warhol's art. Unless its indifference is critical consciousness. But Warhol's indifference, like Duchamp's, mirrors society's indifference rather than critiques it. Their indifference is "critical" only with respect to art. Since Symbolism, we expect art to be responsive and sensitive to – rather than disdainful of and indifferent to – the spiritual condition and needs of humanity. We see such human concern, expressed in very different ways, in Expressionism, Fauvism, Cubism, Constructivism, Abstract Art, Surrealism, New Objectivity – even Dadaism, which registered the spiritual bankruptcy of Europe after the first world war by declaring the bankruptcy of art, which seemed to have failed in its civilizing mission. The Dadaists were disillusioned with art – they even thought that art was dead – because it failed humankind, which implies that art without its humanizing effect is not art.

Disillusionment with art – even by artists – seems to go hand in hand with its development in modernity, so much so that disillusionment seems to drive innovation. The more completely modern an art seems, the more indifferent it seems to human concerns – which suggests just how humanly indifferent we feel the modern world to be – and thus the more unconsciously disillusioning, however consciously we celebrate the advance of art as such. However unintentionally, the doctrine of art for art's sake – the belief in the absolute autonomy of art – is a defense of art's right to be indifferent to human concerns. The skepticism and anger that greeted Manet's art – even Redon rebuked it as soulless (unhuman), implying that it could not be taken seriously

as art – has to do with its apparent indifference to the human spirit. Clement Greenberg, who celebrated it as the beginning of pure art, seems to confirm its indifference, without realizing that it is the same indifference that informs Duchamp's and Warhol's art, and like theirs mirrors the subtle indifference – to their own humanness as well as the humanness of others – that permeates mass society.

Avant-garde art once made a critical, spiritual, and human difference – a genuine difference – because it offered, in a perhaps incomplete, unsatisfactory form, a kind of transcendence of daily life, sometimes by transforming it, sometimes by renouncing it. In genuine avant-garde art the existential yearning for spiritual transcendence – inner liberation from the mentality and perspective of daily life to the extent that one feels nominally rather than necessarily connected to it, so that it no longer feels compelling and intimidating (in the transcendent state of mind one views existence from what seems like the perspective of eternity, which gives it the enigmatic value it lacks in daily life) – takes the form of alienation. There is something "unworldly" and ascetic about alienation. Alienated from daily life, one is able to resist its temptations. One repudiates the unhuman superficial self of one's daily social role. Thus, social alienation is a necessary emotional step toward complete transcendence of society – total detachment from the social surface one's social identity is part of. One realizes the superficiality of social identity and social appearance, subverting their hold on one's existence. In a sense, postart – art that lacks avant-garde alienation and with that critical purpose, indeed, art that is not only no longer alienated from daily life but uncritically immersed in it – takes an emotional step backward. Instead of boldly taking the next and final avant-garde step, completing the creative transformation of alienation (negation of society) into transcendence (affirmation of selfhood) necessary for emotional survival, pseudo-avant-garde postart retrogresses to daily life. Instead of renouncing its values, postart endorses them. For postart, daily life and the unhuman social role we have in it, are the

only possible life and identity we can have. (The struggle toward pure abstraction, which is an attempt to uproot all traces of dailiness from [self-]consciousness, shows the transformation in difficult process.)

Warhol, once again, is exemplary: his figures are completely un-human – not simply socially fabricated simulations of humanness, but unhuman beings for whom there is no human alternative, and who would not be interested in having a human identity if there was one. They are the absolute antithesis of the human beings pictured in traditional art. Postart, then, asserts that there is no escape from unhu-manness – from the superficial self of daily life. Postart sells not only humanness short but also the humanizing potential of art. The best traditional art reveals the qualities – dignity and empathy especially – that make us human. It is morally concerned, and often shows the moral under siege in an immoral world. Integrity and generosity of spirit struggle to hold their own in a world that lacks both. It is not simply because of ideological and social reasons, but for existential reasons, that the story of Christ, the ultimate victim of the world – the human being who was brutally crucified by it but maintained his integrity and concern for others to the bitter end – is the subject of so much traditional art. Avant-garde art adds the unusual belief that creativity for the sake of creativity is the only way to become human – fully and desperately human – in the unhuman modern world. Avant-garde art may not be the humanistic religion for everybody, let alone a universal religion, and few people may experience it mystically, or feel re-humanized by its radical creativity, but postart mysticizes dehu-manizing dailiness.

The collapse of the religion of art was inevitable. This is not be-cause the postart tendency to demystify art – postart disillusionment with art – was built into avant-garde art from the start, suggesting that it was doomed to self-contradiction and self-defeat – the "ugly" avant-garde paintings of Courbet and Manet contain the seeds of postart in their "realistic" representation of daily life – but because of the

anomie of modern society. It brings with it the "ephemerization" typical of contemporary life[162] and "the ruling mass man."[163] They shape daily life in modernity, suggesting that postart, which "artistically" apotheosizes daily life, is a symptom of anomie rather than a strictly art phenomenon. (The dandyish Manet tried to distance himself from the masses, but he was fascinated by them and depicted people en masse, that is, as a crowd. So did Courbet, who was a man of the people rather than a bourgeois aristocrat. For all their differences in class and attitude, both revealed the ephemerality that subtly informs mass society. But Manet was more "advanced": his gestures show that modern ephemerality has infected art itself. Ephemerality masks itself as spontaneity, but then spontaneity is ephemeral.)

As André Haynal writes,

> the stress inherent in contemporary society is due first and foremost to an accelerating rate of change and loss of stability in our surroundings and semiotic environment. [Alvin] Toffler used the term 'ephemerization' for the phenomenon of nonpermanence, that is, the fleeing, transitory, and ephemeral nature of situations in postindustrial society. Given this, it is more and more difficult for individuals to anticipate events, to foresee the consequence of their acts and, especially, the value that will be attached to them, the reactions of other people and institutions.[164]

Thus, "one of the main characteristics of contemporary society is the growing isolation of the individual"[165] and the normlessness typical of anomie, that is, the lack of "superego" norms by which the individual can guide and judge his behavior and in which he can find meaning and value as well as measure his own value and give himself meaning. Instead of stable, convincing norms and meaningful values there is the weed-like growth of numerous ephemeral norms and values – including

those of art – which have an ephemeral appeal to the individual, just because they confer an ephemeral individuality. Ephemerization – in art as well as in the social life of which it is a part – is a direct consequence of the deep uncertainty that exists in normless anomic society.

Anomie infects art, making it ephemeral to the extent that it loses any pretense to being eternal. The eternal is no longer the norm by which art measures itself. The fact that ephemeral movement rapidly replaces ephemeral movement in modern art, and ephemeral artist rapidly replaces ephemeral artist in postmodern postart – with a seasonal frequency more breathtaking than that of fashion, so that what was valuable, meaningful, and "normal" one ephemeral season becomes valueless, meaningless, and "abnormal" the next ephemeral season (and the seasons get shorter and shorter) – suggests as much. Postart must make its impact very quickly, for it has less time to do so than any previous art, since it is more ephemeral than any previous art. This means that it must be instantly comprehensible to the masses. Eagerly assimilated by the mass culture it eagerly caters to, postart quickly becomes the fashionable emblem of isolated individuality. It is the ephemeral sign of an ephemeral individuality, indeed, an individuality that only exists to the extent that it identifies with the currently fashionable postart, which is as pseudo-individual as it is.

Thus, postart keeps keeps one suicidally "attached" – addictively bonded – to ephemeral contemporary society. But the excitement of ephemerality – and the ephemeral is supposed to be more exciting than the eternal, just as the contemporary is supposed to be more exciting than the historical and the abnormal more exciting than the normal – masks the sense of futility that invariably exists in an ephemeral, rapid turnover society. It is impossible to keep up with ever-changing norms, however desperately one tries to, so that one always despairs of knowing what the true – even au courant – norms are. In unstable modern and especially unstable postmodern society durable values, sustained meanings, and a hard-won sense of deep purpose seem impossible,

for nothing has any significant hold on one's inner life. All of this is obscured by the celebration of the plurality of values, the multitude of meanings, and the variety of everyday purposes, along with mass culture manipulation of inner life. It too must conform to ephemeral norms, and it seems as ephemeral as they do.

For Émile Durkheim, anomic suicide was one possible result of the breakdown of commonly believed standards and socially unifying norms. But exploitive acceptance of the breakdown is a kind of living suicide. That is exactly what Duchamp's and Warhol's indifference was. It was already latent in Manet's dandyism, as noted. Indeed, Duchamp and Warhol carry the tradition of the artist dandy into the twentieth century; the former was an intellectual dandy, the latter a populist dandy. A symptom of the breakdown and confusion of values and standards in art, and of its loss of meaning and spiritual emptiness, their indifference is a form of depression. Indeed, indifference is depression inside out, that is, depression expelled from the self back into the disillusioning world that caused it. Indifference is hardened insensitivity, and the indifference of Duchamp and Warhol is their way of giving the world's insensitivity back to it, hardening themselves against it in the process. If insensitivity poisons the wellsprings of life, then their indifference poisons the wellsprings of art. The indifference of Duchamp and Warhol is the Achilles heel of their anomic, suicidal art, just as the indifference that exists in the masses is the Achilles heel of anomic, suicidal society. It needs entertaining ephemeralities – including Duchamp's readymades and Warhol's celebrities – to feel that life is valuable, exciting, and meaningful, rather than the depressing daily grind it seems to be. Accepting mass society's everyday version of life, one unwittingly acknowledges one's indifference to life, however different one may believe one's particular life is because it seems exciting for a few ephemeral "artistic" moments.

Writing in 1957, Richard Huelsenbeck observed that "the dada assertion that art is dead is not too far from the truth."[166] A few years

later, in 1963, the Constructivist sculptor David Rabinowitch remarked that "art has ceased to exist" because it has become "literal" – he was thinking of Minimalist objects, but he could also have referred to Pop imagery, which was then also trendy – even as he made works that eloquently finessed literal objectness or givenness while acknowledging it, suggesting that art could still live, that there could continue to be artful not simply literally given objects.[167] As Rabinowitch suggests, literalism is a form of indifference to meaning and inquiry into meaning, even a way of canceling and finally denying meaning. At the least, literalism implies a refusal to reflect on meaning, so that the given has only its material (and social) face value. As Huelsenbeck suggests – so does Greenberg in "Avant-Garde and Kitsch," written in 1939 – things (including art) tend to be taken literally rather than reflectively by mass man. For both Greenberg and Huelsenbeck the simple-minded literalism of the mass mind – a mind which denies the slippery vagaries of meaning, which lacks the openness to complex meaning implicit in Keats's concept of negative capability – is responsible for the death of art.

For Greenberg the fact that mass man cannot see art as anything more than a literal slice of daily life – at one easily overcome remove – is the cause of its death, for it renders art meaningless as art. This is why mass man prefers kitsch, which offers itself as nothing but a readily comprehensible slice of daily life. Mass man's attitude to art is comically – tragicomically? – illustrated by an episode that occurred in the twenties. It seems a customs inspector refused to regard a Brancusi bird as anything more than a piece of polished metal. Thus, it was subject to an import duty; art objects were exempt. He couldn't see the art in it and refused to believe that it was art. To call him stupid and unsophisticated, or to think that he could not see beyond the concerns of his job, is to miss the point: he could only see literally. Brancusi's sculpture had no meaning as art. Like many of the first viewers of avant-garde art, he couldn't begin to conceive it as art. It is a problem that continues to haunt avant-garde art, especially when it walks a

tightwire between imaginative transformation and everyday life, like much performance art.

For Huelsenbeck the death of art is caused by the persistent confusion of it with entertainment in mass society. It is another way that mass man neutralizes it. He enjoys it by trivializing it. He also shows that it is possible to live without it. As Huelsenbeck ironically writes, "Mass man proves that without the slightest contact with quality one can not only live an excellent life but also attain a much greater age than our forebears."[168] The task of artists is "to prove that creative quality is a necessary component of life." The fact is that mass society "can get along without art as easily as without religion despite all assertions to the contrary," indeed, despite "the assumption that mankind would not be able to survive without the artist." "The agony of the modern artist is due to his revolution's being integrated in the mass life of our time," Huelsenbeck writes with devastating accuracy.[169] It becomes the entertainment which adds a little leaven to daily life. "In a highly industrialized country like America, in which universal conformity is lauded as a sound desire of the people, abstract art has become occupational therapy for the emotionally threatened. It is part of the general relaxation program. 'Relax with art' is taken as seriously as, say, 'Relax by bike riding'." Thus, abstract art, which involved "a strong desire for a new form as well as a demand for a new feeling of form," and which "wanted to transform man by warning him in symbolic form to turn his back on egalitarianism," that is, mass society, has been assimilated by the materialistic mass society it repudiated. This does not mean it has been understood. It has become minor entertainment, indeed, a kind of novel R&R, offering mass man a short-lived respite from the trench warfare of daily life – a respite in which he can pretend he is creative, by proxy.

As Huelsenbeck says, the question is whether "what used to be called quality" is still in demand. He doesn't think so, or else what used to be called quality and what used to be understood as art and

regarded as creative have radically changed their character, so that they are no longer comprehensible – even recognizable – by those who once believed in them. "In a mass civilization art and religion can be so attenuated and changed that the mania for taking surrogates as something essential can be so encouraged that what we used to call quality is no longer in demand." For Huelsenbeck, "dada was a kind of shout of alarm and warning. 'Art,' said the shout, 'is moribund, and the artist, sensing his uselessness, is in a state of agony'." Modern artists "want to reintroduce art wherever it has been destroyed by an altered world" – a world in which people have become part of the masses and lost their individuality and with that the sense that their existence has significance. Have the artists succeeded, or has art finally and completely died? Huelsenbeck, ever the "true dadaist," as he says, has "to reverse my stance at the end of my comments. Naturally art is not dead, but it needs a new effort at clarification of its principles in an age that is giving itself over to self-destruction with terrifying enthusiasm."

It is not clear that the clarification Huelsenbeck called for has occurred in the half century that has passed since he wrote these words. Nor does the world seem any less destructive and foolish than it was when it greeted "the detonation of H bombs" with "optimism." Mass destruction is now visible on television, as Huelsenbeck foresaw. Like some recording of the handwriting on the wall, it repeatedly announces our impending doom, keeping us up to date about developments in the death of our civilization. It may be that the only way modern art can finally clarify its principles and become up to date at the same time is by finishing the job of destroying itself that officially began with Dadaist anti-art. Postart seems to have done that, finishing what anti-art began, which suggests that modern art may have been a Dadaist farce all along – an unfolding drama of self-defeat, as its ironical attitude to itself and the world suggests – which is what the modern world has come to be.

POSTSCRIPT: ABANDONING AND REBUILDING THE STUDIO

———

In my theory about . . . the postmodern age, Jay was the first guy to offer a picture of people living in the media world – demonstrating that we're *in* the media, rather than merely watching it.

Michael Wolff, "The Last Adman"[170]

Durham, NC: I can't believe you all are giving any publicity to these "artists," who are single-handedly ruining our culture.

N'Gai Croal: These artists aren't single-handedly ruining anything. Popular entertainment has always been drenched in sex and violence, from the Iliad to the Sopranos. The problem is this: is the entertainment-industrial complex letting enough alternatives through? Are they promoting those alternatives to the fullest? And the answer is no.

N'Gai Croal, "Battle for the Soul of Hip Hop"[171]

. . . American culture moves so readily to legitimize the latest enthusiasms of mass taste – snowboarding! game shows! Irish step dancing! – that it always seems in danger of overwhelming art that demands quieter attention. The devilishly effective machinery of American

pop culture turns our attention constantly to whatever is loud, vivid, swaggering.

<div align="right">Richard Lacayo, "America's Best Artists and Entertainers"[172]</div>

The sight of a masterpiece checks you in spite of yourself, captivates you in a contemplation to which nothing bids you except an invincible charm.

<div align="right">Eugène Delacroix, Journal, Septermber 23, 1854[173]</div>

Are there any masterpieces being made today? Does "masterpiece" have any meaning in a situation in which money, the media, and popular entertainment *determine* culture? Can everyday postart happenings be cultural masterpieces? Can a work of ideological postart be an aesthetic masterpiece? Or is the concept of an aesthetic ideological masterpiece a contradiction in terms, since aesthetic mastery and ideological communication seem incommensurable? Postart seems to mean postmasterpiece – LeWitt's dismissal of "beautiful execution" and "craft" suggest as much (postartists have no idea of what it means to master a medium) – as well as postmodern. Does "culture" have any meaning, except in the broadest sense, namely, as a term that encompasses every belief, behavior, value, and object made in a certain society and thus representative of it? If everything in a society is part of its culture, so that society and culture are interchangeable, which is what the notions of material culture and visual culture suggest, then culture no longer has any special significance. There are no uniquely cultural objects.

I emphasize "determine": money, the media, and popular entertainment no longer only underwrite and inform us about culture, but shape its values, even create it. In our society "culture" seems to be whatever they say it is. Contemporary culture must satisfy mass taste, which means that its form must not be too complex and its meaning

must be transparent. It must bring us together in the crowd rather than help us become individuals, which may alienate us from one another. This is why mass taste, and the money, media, and entertainment that cater to it, has an entropic effect on culture. Mass taste loves spectacles, which are inherently entropic, for they reflect the homogeneity of the crowd – the tendency to sameness that prevails in the masses – while making it seem exciting. The spectacle creates the illusion that homogeneity is enlivening rather than deadening. Indeed, a spectacle is homogenized excitement and exciting homogeneity, as the avant-garde spectacles of Robert Wilson as well as the popular spectacles of Busby Berkeley make clear. In short, the spectacle is a social space in which de-individuating orderliness is made to seem individualizing and vital impulsiveness is neutralized into devitalizing orderliness. One is brought to life by entertainment, but it is the same old administered daily life in exciting disguise. In a sense entertainment makes belonging to the crowd a virtue. In other words, the spectacle creates the illusion that one is only liberated – a free-thinking, free-spirited, fully alive individual – when one is part of the crowd. It is the big lie of modern life – indeed, the real modern ideology – and entertainment is the means of communicating and enforcing it.

In modernity culture attempted to defend and renew itself by becoming esoteric. This was done in avant-garde fits and starts; it sometimes seems that being an avant-garde visionary means throwing an intellectual or expressive fit. Avant-garde culture turns to the happy few – a limited circle of devotees – for approval. They become initiates into its mysteries, which they keep from the crowd. Exposure to the crowd would destroy avant-garde culture's mystery – its sacred core. It has privileged access to the mysterious depths which the crowd can never comprehend. The avant-garde visionary has insight into the unconscious, giving him a certain freedom from it – a sense of autonomy, perhaps only when he is making art. Avant-garde art has been said to be autonomous. I would rather say that it embodies – in a fleeting

apotheosis – the autonomy that is rare in life, including the avant-garde artist's life. In the crowd one is the unwitting puppet of the unconscious. The strings of one's life are pulled by its dictates without one realizing it. Avant-garde culture lets one know the strings are there and allows one to cut a few of them, so that one can walk on one's own, however awkwardly. However, in postmodernity, where popularity and commerce seem all – where social belonging and success seem the basic values – avant-garde culture has become completely exoteric. Achieving existential authenticity by way of aesthetic authenticity – feeling real and true to oneself by way of aesthetic experience, where the seamless unity of subject matter and form Pater spoke of symbolizes the spontaneous unity of thinking and feeling in the fully alive self – is no longer the issue. Avant-garde culture welcomes the embrace of money, the media, and popular entertainment – confirming their rule – for it has lost the creative will to resist them. (Exoteric avant-garde culture is a contradiction in terms from the point of view of esoteric avant-garde culture. The difference between them is the difference between early and late avant-garde culture, that is, between an originary avant-garde culture with a fresh vision of culture and life and a decadent avant-garde culture living off the dwindling capital of the avant-garde past while ideologizing life, which devalues it. What was once hot has become cool.)

Masterpieces are still being made today, enduring beyond the dead-ending of art in entertaining postart. The anti-aesthetic, anti-imaginative, anti-unconscious seem to have destroyed the possibility of making an aesthetic masterpiece, but there are still artists who believe in the imaginative refinement, under the auspices of the unconscious, of raw social and physical material into aesthetically transcendent art. They are holdouts against postart, utilizing avant-garde modes of art making that seem historical and passé from a postmodern point of view. There are masterpieces of painting, particularly German Neo-Expressionist painting – even more heavily and desperately indebted to the unconscious (to "pandemonium," as Baselitz said) than the first

German Expressionist painting – but also of abstract and realist paint-ing, for example, the works of Sean Scully and Richard Estes. Their "silent charm operates with the same force and seems to increase every time you cast your eyes upon" them, to quote Delacroix.[174] Looking at such masterpieces, one "feel[s] oneself transported to a realm of ideas completely different from the one in which one found oneself formerly."[175] They induce "the mysterious and profound sensation of which the forms are in a way the hieroglyph."[176] Aesthetic masterpieces are dialectical: they are "closer to the human heart for seeming to be more material." They subtly integrate "external nature" and internal nature, that is, the finite and the infinite, "what the soul finds to move it inwardly in objects which strike the senses alone."[177] There are even masterpieces of sensitive photography, a more exoteric art than paint-ing, which tends to the esoteric because of the painter's sensitive touch, however intense or delicate.

"Masterpiece" has no meaning apart from the studio in which a master produces it. What has been the fate of the studio since the artist moved to the street, abandoning its thoughtful solitude and silence for the noisy street, where one can hardly hear one's own thoughts? What has happened to the studio when everyday events on the public street came to seem like creative acts, suggesting there was no need for a private studio in which to create art? The imaginative creativity the studio symbolizes was usurped by the chance creativity of the street. In a sense, the modern studio was an extension of the street, as Manet's café scenes imply. Manet's *Olympia* is a streetwalker, however high class (?), as her maid suggests. When the artist became a dandy – Manet was among the first who did – he became a detached observer of street life, that is, of the passing crowd. But he was really more of a participant observer, however seemingly apart, as Courbet's *The Painter's Studio: A Real Allegory Summing Up Seven Years of My Life as an Artist, 1854–55* makes clear. Courbet didn't have to go to the street, the crowd came to him, patiently waiting for the chance to be painted – observed and

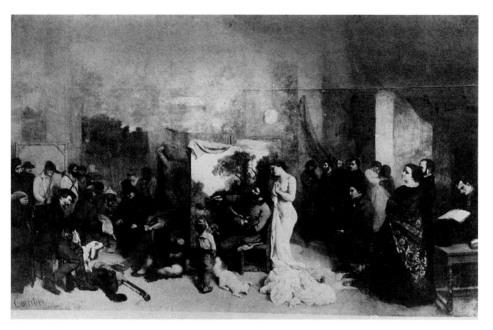

34. Gustave Courbet, *The Painter's Studio: A Real Allegory Summing Up Seven Years of My Life as an Artist*, 1854–55. Oil on canvas, 11′ 10″ × 19′ 8″. Réunion des Musées Nationaux/Art Resource, NY. Musée de Orsay, Paris, France.

immortalized. The street was the whole of life, and Courbet embraced it in all its raw reality. The muse was present in Courbet's painting, standing behind him and watching him paint, but she was just another model chosen from the crowd, undressed to suit the artist's vision, like Olympia.

Eventually only the artist and the model were left in the studio, the crowd having been ousted in the name of pure creativity. Picasso depicts many scenes in which the artist is alone with his model in the studio. It has become a mythical, sacred place, a sanctuary from the world devoted entirely to art. The model has become a mysterious presence – however everyday she looks – suggestive of the mystery of creativity. She becomes a projection of the artist's unconscious, more particularly, the creativity it makes possible. Indeed, she becomes

desirable – or at least interesting – because she embodies his desire to be creative. He concentrates on her appearance, investing himself in it, because it catalyzes his creativity. This is the point of Picasso's 1927 illustration of Balzac's *Le Chef-d'oeuvre inconnu*. Hard at work, the artist transforms the banal model – she's knitting – into a mysterious masterpiece, suggesting the miracles that creativity can perform. She may look ordinary, but there must be something extraordinary about her, because she has inspired the artist to a remarkable feat of creative daring. Her banality may have been the whetstone on which his creativity has sharpened itself, but in doing so it has shown that she – that even the most ordinary human being – is far from banal. Perhaps nowhere is the modern studio more of a sublime creative space than in Braque's late *Atelier* paintings. His studio is clearly very different from Courbet's. What was an extension of public space has become hermetically sealed private space. No one is allowed to enter. No model is present to disturb the peace. The creative act does not depend on the muse. External nature is no longer necessary to stir the artist's soul. Internal necessity, symbolized by the white bird – a traditional symbol of the purified soul – that dominates the space, is all that matters.

Braque's kind of sacred studio – in effect a *hortus conclusus*, that is, an aesthetic paradise – disappeared when the artist looked to the street for inspiration, as though acknowledging there was no inner drive or reason to make art. (It is the basic problem of the postmodern artist.) Bruce Nauman's video *Mapping the Studio II*, 2001, shows the result: the studio has become an empty space strewn with debris. To recall Arnheim's words, Nauman's desolate studio is a frank exhibition of bankruptcy and sterility. The studio is no longer the site of creativity; entropy has completely triumphed. The studio has become a postartistic alley littered with garbage, that ultimate entropic happening. Nauman cleverly turns this lifeless space into a performance – a somewhat tedious, pretentious performance. The video is projected on huge screens, engulfing the viewer spatially, and lasts hours, which

35. Bruce Nauman, *Mapping the Studio I (Fat Chance John Cage)*, 2001. From the installation at Dia Center for the Arts, 545 West 22nd Street, New York City. January 10, 2002–July 27, 2002. © 2004 Bruce Nauman/Artists Rights Society (ARS), New York.

engulfs him temporally. But he is given an office chair with rollers, thus becoming a performer in the studio space as well as in the gallery space. The studio's empty space, amplified by the gallery's empty space, is turned into a postmodern performance space. It is a pseudo-creative environment – an environment brought to "creative" life by the viewer's movement, not by anything the artist does. He simply sets it up – sets up the viewer in the wasteland the studio has become.

Why should we attend to Nauman's video – waste our time seeing the whole thing – once we get its ironical, nihilistic point? It is easy to get. There is a monotonous hollowness at the core of the video (in this it resembles Warhol's repetitive early films). The studio has become a hollow space for a hollow artist. Whatever creativity there is depends entirely on the spectator – an idea derived from Duchamp, who said that the spectator turns art in a personal raw state into

intellectually and socially refined art. Presumably Nauman's raw studio space is Duchamp's art in a raw state. But it cannot be called that even by Duchamp's standards, for Nauman has invested nothing of himself in it – it remains physically raw, not emotionally raw – which is something even Duchamp thought the artist had to do. (Like all postmodern people, the postmodern artist has nothing of himself to invest, for he has no true self. He is all false self, which is why he finds himself on the street, which is the space of social or public compliance.) The events that seem to breathe life into Nauman's video – the movement of a mouse and moth, and also the systematic movement of the camera and the random movement of the viewer, both sweeping the scene – do nothing to alleviate the sense of emotional as well as physical barrenness. (Mice and moths are symbols of death and decay – the underworld of loss rather than the higher world of salvation [in which the dead are restored to everlasting life] – thus confirming the deadness of the space and the unconscious. Nauman's studio is sterile because the dynamic unconscious has fled from it. It is no longer the temple in which the artist can express his inner necessity. Thus, neither the studio nor the artist has a reason for being in postmodernity.) If the video is a mournful homage to John Cage, as its ironical subtitle *Fat Chance John Cage* suggests, then chance – symbolizing the unconscious – is no longer as creatively meaningful and inspiring as it was for Cage and before him Duchamp. Chance is no longer art's dumb luck; in postmodernity it has become an everyday event, which is how it occurs on the street.

But the studio has come to life again, signaling what might be called post-postmodernity. Nauman thought he finished the studio off, but it has been reborn. It has once again become creativity's sanctuary from the world. But there is an important difference: the art created in it is neither traditional nor avant-garde, but a combination of the two. It brings together the spirituality and humanism of the Old Masters and the innovation and criticality of the Modern Masters. It is a New

Old Master art. Craft is once again at a premium, but art remains conceptual. Kosuth once said that "art only exists conceptually,"[178] but the New Old Masters show that it is not art unless it also exists materially. "Art is not in the object," the conceptualists argued, "but in the artist's conception of art to which the objects are subordinated."[179] But the New Old Masters show that unless the concept is embodied in the object – is brought to life and lives through its material – there is no art. In short, New Old Master art is at once aesthetically resonant and visionary. It is an attempt to revive high art in defiance of postart. It returns art to the studio, in defiance of the street. Art is again a means of aesthetic transcendence, with no loss of critical consciousness of the world. Eysenck writes that "artists . . . inevitably search for novelty: what has been done once cannot be done again."[180] But what has been done and seems dead can be brought to life again if there is a human need for it. It can have new "arousal potential," to use Eysenck's term, if it makes us aware of what we have been missing in life as well as art – in postart that has little or nothing going for it but its novelty.

David Bierk, Michael David, Vincent Desiderio, April Gornik, Karen Gunderson, Julie Heffernan, Odd Nerdrum, Joseph Raffael, Paula Rego, Jenny Saville, James Valerio, Paul Waldman, Ruth Weisberg, and Brenda Zlamany are important New Old Masters. Don Eddy and Eric Fischl have evolved into New Old Masters, and Avigdor Arikha and Lucian Freud are the Deans of New Old Master art. They are all masterful, reflective artists – visionary humanists with complete mastery of their craft. For them expressive form is a way of thinking about subject matter. They know, in detail, both modern and traditional art. The former looks as old as the latter from a postmodern perspective. Like Winnicott, and traditional artists, the New Old Masters believe that originality is possible only on the basis of working knowledge of the past. They are not slavish imitators of the past – they do not model their art on it, nor mechanically appropriate it in the usual postmodern way, nor does Old Master style become a mannerism in their work,

36. David Bierk, *Flowers in Steel, Locked in Migration, to Fantin-Latour*, 2002. Oil on board, steel, $49\frac{3}{4}'' \times 47\frac{1}{2}''$. Courtesy Nancy Hoffman Gallery, New York.

however influenced by it they are – but look to it for inspiration not perfection. And they all have different ideas of it, as the diversity of their styles indicates. Marinetti once called an "old [Master] picture" a "funeral urn."[181] But the New Old Masters find fresh life in old pictures. For them it is more like a phoenix than a funeral urn. They do not believe that "admiration of the past" is "useless," as Marinetti said it was – as though the future he believed in will necessarily be better. The art of the past does not consume their "best strength" but gives

37. Vincent Desiderio, *Pantocrator (Triptych)*, 2002. Oil on linen, overall $82\frac{7}{8}''$ × 194″. Courtesy Marlborough Gallery, New York.

them new strength. It offers something that does not exist in postart: beauty, but with no sacrifice of modern ugliness – the tragic sense of the ugliness of life that has reached a kind of crescendo in modernity.

Hanna Segal, writing about classical tragedy, which she regarded as "a paradigm of creativity," declared: "the ugly is largely in the content . . . including [the] emotionally ugly . . . and inevitable destruction and death." But "there is beauty in the feeling of inner consistency and psychological truth in the depiction of those destructive forces of conflict and their inevitable outcome." Thus, there is "a counterbalancing of the violence by its opposite in the form," which is in effect "an unflinching facing of the forces of destruction."[182] "Let a great artist get hold of this ugliness," as Rodin says – Segal quotes him – "immediately he transfigures it – with a touch of his magic wand he makes it into beauty." The "unhealthy" ugly, "which is contrary to regularity – the sign of health," becomes "aesthetically satisfying" when it is given artistic form, as though cordoning it off so that it does not become contagious. By giving ugliness beautiful form, showing that it can be contained if not expunged – thus making it less traumatic – art reveals

38. April Gornik, *Edge of the Marsh*, 2000/2003. Oil on linen, 72″ × 99″. Courtesy Danese Gallery, New York.

its essential theodicean character. It makes evil good without denying its inevitability.

"Aesthetic experience is both socially and metaphysically relevant," Adorno writes, "since works of art register and objectify dimensions of experience which, while lying at the basis of art's relation to reality, are almost always overlain by reification."[183] But artistic form mediates ugliness without socially and metaphysically reifying it, which allows it to give birth to beauty. Art in fact strips ugliness of the social and metaphysical overlay that obscures and sanitizes its insanity. Art does not rationalize ingrained irrationality but lets it stand forth in all its inevitability. Art is not a mode or branch of social science and speculative philosophy, but of memory. Art reminds us that ugliness will continue to exist despite art. Indeed, when artistic form seems inevitable and memorable – it is the hardest thing in art to create a form that does, that is, a form that seems absolutely beautiful – it does so

39. Jenny Saville, *Reflective Flesh*, 2002–3. Oil on canvas, $120\frac{1}{8}''$ × $96\frac{1}{16}''$ × $3\frac{6}{8}''$. Courtesy Gagosian Gallery, New York.

because it dialectically mediates the inevitability and power of ugliness, which is why the aesthetic pleasure beauty gives always has a mournful, poignant undertone. (And why ugliness always outlasts beauty – why it sooner or later breaks free of the chains of beauty. Scratch a work of art and one will discover the urgent ugliness beneath its beauty – the rupture within its harmony – which is why it is a sacred monster.)

40. Michael David, *The Death of Painting*, 2001–2. 108″ × 240″. Oil, wax on canvas on honeycomb aluminum.

Art reminds us that every effort to understand the ugliness of life socially and intellectually – objectify it by revealing the conditions under which it appears to exist (implying that if they were eliminated there would be no ugliness) – ignores its deep subjective roots. (It also ignores the fact that what seem like social conditions are its consequence not cause. That is, they are the form ugliness takes not the reason for its content.) Destruction and death can never be adequately objectified because they are the one permanent raw spot in subjectivity. If only by reason of its presentational immediacy and evocative power – its perceptual and emotional demandingness – art lets us know that subjective depth can never be given completely convincing intellectual form, that is, explained once and for all (reified by reason). At best it can be given temporarily convincing artistic form. Destruction and death are the plight at the core of the subject, even as the subject becomes stably human dialectically defining itself in opposition to them. It is the emotional nimbleness of dialectical art that does the job, not the heavy-footedness of reifying intellect. Art registers the nuances of subjectivity much more subtly than intellect can ever do, because art

41. Don Eddy, *The Hesychia Tide*, 2002. Acrylic on canvas, 50″ × 34″. Courtesy of the Nancy Hoffman Gallery.

exists in and through the same unreifiable timely moment in which subjectivity exists, while intellect reifies time so that it loses every trace of timeliness and with that subjective significance. Optimally existing in the unreifiable moment – the only eternity – art implies that every attempt to reify the ugliness of destruction and death necessarily ends in failure. Serious consciousness of destruction and death shakes the

self to its depths, especially because it involves the consciousness that they are an inalienable, fundamental part of the self. Faced with its own annihilation, the self loses all sense of itself. Recognizing that it will be destroyed and die – realizing to its very depths that it is ultimately nothing – it can no longer manage its feelings and loses its mind. But if it re-cognizes and re-realizes them through art, the self can plumb the depths of destruction and death in itself and the world. It can never fathom them, but art enables the self to explore their effect on its sense of life, which gives it some hold on itself despite its insecurity. Art can never give it the enlightenment of Buddha, but aesthetic experience can show the self that life is not futile, however limited.

Pure intellect is a poor defense against the traumatic ugliness of life compared to art, for ugliness has to be defended against with the whole psyche not simply a part of it. Even if it could be achieved, intellectual objectivity has no deep effect on psychic life. It is emotionally empty by definition, and thus not even consoling. It can do no more than mark, with a certain crude efficiency, the givenness of what it claims to understand. No amount of theory can do justice to the physical and psychic reality of ugliness. Only by identifying with the body of beautiful art can we shield our body ego from the destruction and death we feel in it as well as experience in the world. Only when art is truly beautiful can it defy the ugliness in life – resist if not defeat it (although modern art sometimes seems like a Pyrrhic victory over life). This creates a small space of momentary happiness within the larger depressing and everlasting ugliness, even if that space is only a stay of execution and illusion. Thus, the aesthetic transformation of ugliness creates the sense of being in subliminal control of the feelings aroused by our consciousness of our own destruction and death – which confirms that we are part of the ugliness of the world. The tragic aura ugliness acquires in art makes us less susceptible to it even as it confirms that it is the permanent flaw in existence.

To put this another way, in art, destruction and death are no longer the stark naked ugly truth about life – the superordinate truth to which all other truths about life are subordinate, the ultimate truth that makes life seem trivial and pointless – but truth covered by an aesthetic veil. This affords a measure of detachment from them while confirming their seductiveness. Experienced aesthetically, they no longer cast their terrifying shadow over everything. Aesthetically conscious of them, we are no longer overwhelmed by them. They lose their hold on us – their power to victimize us. We no longer compulsively brood about them, as though that would bring them into intellectual focus – give us a clear idea of them – and as though that could end their inevitability and remove their sting, as the Bible says.

In a sense, art makes the ugliness of destruction and death less unconsciously appealing because it enacts their unconscious appeal to us. It makes us self-conscious about them by showing us the fate we would have if we had fatalistically accepted and blindly given in to the ugliness that pervades life. Ugliness is always more seductive than beauty, because there is more ugliness in us and in the world than beauty – until art puts beauty in both. In art ugliness becomes the fuel that powers the illusion that life can be more beautiful than it is. Thus, art puts us in a radically different emotional place than we are in everyday life – a place that seems beyond life, however lifelike. This is as much liberation from life as it is possible to have while living. The purpose of art is to dialectically transcend ugliness by revealing its immanence through beauty. It is the deepest sense that art can make. This sense was lost when art became postart. But the New Old Masters restore art's depth of meaning, implying that postart is meaningless as art, all the more so because it is a reification of life. Through their pursuit of tragic beauty in the inner sanctum that is the studio at its most ideal, the New Old Masters replace what Breton called "miserabilism" – "the depreciation of reality" implicit in postart – with its aesthetic "exaltation."[184]

"A major part of contemporary art," Zbigniew Herbert writes, "declares itself on the side of chaos, gesticulates in a void, or tells the story of its own barren soul." (Pollock seems to do the first, Newman the second, and Nauman the third.) "The old masters – all of them without exception – could repeat after Racine, 'We work to please the public.' Which means they believed in the purposefulness of their work and the possibility of interhuman communication. They affirmed visible reality with an inspired scrupulousness and childish seriousness, as if the order of the world and the revolution of the stars, the permanence of the firmament, depended on it. Let such naiveté be praised."[185] It may be that the New Old Master artists have a similar naiveté. Their art reaffirms visible reality with no sacrifice of its inner resonance. They make even the starkest appearances – and all appearances are oddly stark to the sensitive eye – pleasing with no sacrifice of their starkness. Their art is an unexpected gift in these dark postart times. It is an alternative art, without the condescension that money, the media, and popular entertainment – and postart, which is their lackey – have to their audience. New Old Master art brings us a fresh sense of the purposefulness of art – faith in the possibility of making a new aesthetic harmony out of the tragedy of life, without falsifying it – and a new sense of art's interhumanity.

NOTES

EPIGRAPH

1 Lionel Trilling, *Sincerity and Authenticity* (Cambridge, MA: Harvard University Press, 1972), p. 67.

2 Hermann Broch, "Das Böse im Wertsystem der Kunst" (1933), *Dichten und Erkennen* (Zurich: Rhein Verlag, 1955), p. 348.

3 Rudolf Arnheim, *Entropy and Art: An Essay on Disorder and Order* (Berkeley: University of California Press, 1971), p. 52.

4 Warren Hoge, "Art Imitates Life, Perhaps Too Closely," *New York Times*, October 20, 2001.

5 Karsten Harries, "Hegel on the Future of Art," *The Review of Metaphysics*, 27/4 (June 1974):677–78.

6 Pierre Cabanne, *Dialogues with Marcel Duchamp* (New York: Viking, 1971), p. 104.

1: THE CHANGING OF THE ART GUARD

7 Frank Stella, "Mindless play and thoughtless speculation," *The Art Newspaper*, No. 114, May 2001, pp. 62–64.

8 Christos M. Joachimedes and Norman Rosenthal, eds. *The Age of Modernism: Art in the Twentieth Century* (Berlin: Zeitgeist-Gesellschaft and Stuttgart: Verlag Gerd Hatje, 1997).

9 Trilling, p. 170.

10 Alexander Mitscherlich, *Society Without The Father: A Contribution to Social Psychology* (New York: Schocken, 1970), p. 43.

2: THE AESTHETIC MALIGNED: DUCHAMP AND NEWMAN

11 Marcel Duchamp, "The Creative Act" (1957), *The Writings of Marcel Duchamp*, eds. Michel Sanouillet and Elmer Peterson (New York: Da Capo Press, 1988), p. 139. All subsequent quotations from Duchamp are from this essay unless otherwise noted.

12 Robert J. Stoller, "Erotics/Aesthetics," *Observing the Erotic Imagination* (New Haven and London: Yale University Press, 1985), p. 53.

13 Duchamp, "Rongwrong," ibid., p. 178.

14 Cabanne, p. 16.

15 Ibid., p. 42.

16 Ibid., p. 48.

17 Ibid., p. 70.

18 Ibid., p. 48.

19 Barnett Newman, *Selected Writings and Interviews* (Berkeley: University of California Press, 1992), p. 158.

20 Ibid., p. 109.

21 Ibid., p. 158.

22 Ibid., p. 159.

23 Ibid., p. 160.

24 Walter Pater, "The School of Giorgione," *The Renaissance* (New York: Modern Library, n.d. [1873]), p. 114.

25 Newman, "The Sublime Is Now" (1948), p. 173.

26 Hanna Segal, "A Psychoanalytic Approach to Aesthetics," *The Work of Hanna Segal* (Northvale, NJ and London: Jason Aronson, 1981), pp. 200–201.

27 Duchamp, "The Great Trouble with Art in This Country" (1946), ibid., p. 124.

28 Ibid., p. 125.

29 Newman, p. 67.

30 Pater, p. 107.

31 Ibid., p. 108.

32 Ibid., p. 109.

33 Ibid.

34 Clement Greenberg, *Perceptions and Judgments, 1939–1944, The Collected Essays and Criticism* (Chicago and London: University of Chicago Press, 1988), vol. 1, p. 32.

35 Clement Greenberg, *Affirmations and Refusals, 1950–1956, The Collected Essays and Criticism* (Chicago and London: University of Chicago Press, 1993), vol. 3, p. 224.

36 Ibid., p. 55.

37 Ibid., p. 122.

38 Mikel Dufrenne, *The Phenomenology of Aesthetic Experience* (Evanston, IL: Northwestern University Press, 1973), p. 44.

39 Ibid., p. 12.

40 William H. Gass, "The Baby or the Botticelli," *Finding a Form* (New York: Alfred A. Knopf, 1997), pp. 291–92.

3: SEMINAL ENTROPY: THE PARADOX OF MODERN ART

41 Duchamp, "The Great Trouble with Art in This Country," p. 126.

42 Ibid., p. 125.

43 Robert Motherwell, "Introduction," Cabanne, p. 12.

44 Ibid., p. 11.

45 Cabanne, p. 93.

46 Duchamp, "The Great Trouble with Art in This Country," p. 125.

47 Duchamp, "Regions which are not ruled by time and space....," p. 137.

48 Cabanne, p. 40.

49 Ibid., p. 66.

50 Arnheim, p. 55.

51 Ibid., p. 52.

52 Allan Kaprow, *Essays on the Blurring of Art and Life* (Berkeley: University of California Press, 1993), pp. 97–98.

53 Ibid., p. 103.

54 Ibid., p. 107.

55 Ibid., p. 106–107.

56 Ibid., p. 108.

57 Ibid.

58 Ibid., p. 109.

59 Ibid., pp. 81–82.

60 Ibid., p. 102.

61 Ibid., p. 106.

62 Lucy Lippard, ed., *Six Years: The Dematerialization of the Art Object from 1966 to 1972* (New York: Praeger, 1973), p. 76.

63 Ibid., p. 168.

64 Ibid., p. 192.

65 Ibid., p. 260.

66 Ibid., p. 70.

67 Ibid., p. 30.

68 Ibid., p. 74.

69 Kaprow, p. 219.

70 Ibid.

71 Ibid., p. 62.

72 Ibid.

73 Ibid., p. 144.

74 Bernd H. Schmitt, *Experiential Marketing: How to Get Customers to Sense, Feel, Think, Act and Relate to Your Company and Brands* (New York: Free Press, 1999), p. xiii. Schmitt's basic thesis is that we are "entering a new century of marketing," in which use value no longer matters. What counts is the use of communications and entertainment – ubiquitous in modern society – to "brand" the product as an entertaining, communicable experience (unlike enigmatic modern art). A brand that becomes an "experience" – and Schmitt instructs us, seemingly with scientific rigor, how to associate a brand with an experience in the customer's mind – becomes an emotional staple. In other words, customers buy the brand out of emotional rather than practical necessity – which is why consuming becomes compulsive and contagious – not because of the product's use value.

75 David Aberbach, *Charisma in Politics, Religion and the Media: Private Trauma, Public Ideals* (New York: New York University Press, 1989), p. ix, notes that "even in its secular forms, charisma retains a religious dimension." He notes that the charismatic gains power over the public by craving to be loved by it and even belong to it, "though hurt and disillusioned in private life." Thus, the charismatic becomes a kind of helpless baby and brings out the helpless baby in everyone. As Aberbach writes, "The baby's seemingly aimless 'charismatic' appeal – what baby is not charismatic? – has an almost mystical quality" (p. x). The baby seeks "charismatic union" with a parent – the public at large in the case of an artist like Warhol, whose charismatic appeal was so great, that is, whose "craving for relation" (wish to belong and be unconditionally and uncritically loved) was so intense, that it rubbed off on his possessions. "Charismatic 'appeal' has two meanings: a powerful aesthetic attraction to the public, and a cry for help artfully disguised or transcended. The public response to charisma is not just an aesthetic phenomenon but it is sometimes also a simple human reply to the appeal for help" (p. xi). One helps Warhol by believing that everything he touches is aesthetically significant.

In a remark that seems tailor-made for Warhol, Aberbach quotes Billy Wilder, who "commented acidly" about Marilyn Monroe (one of the many charismatic figures Aberbach studied – Churchill, Hitler, Krishnamurti, and Charlie Chaplin were others – and that Warhol represented): "The question really is whether Marilyn is a real person or one of the greatest synthetic products ever invented." Aberbach adds: "The same question might be asked of charismatics generally. The actress herself spoke of 'Marilyn' as her creation, a product of much calculation, a fabricated superstructure without a foundation" (p. xi). Aberbach also notes that "Charisma also involves a virtual

state of amnesia toward the past, or suppression of the past. It is the charismatic's gift to make large numbers of people forget the past, forget themselves temporarily, and live vividly in the spell of the present" (p. 7). A baby has no past, and lives entirely in the present, which is why it casts a charismatic spell on us. Some thinkers call the work of art a specious present; others regard it as an eternal present. Whichever, its constant presentness contributes to its charisma, and makes it seems like a newborn baby, fresh and alive, however old and dead – historical – it may be.

76 Bernd Schmitt and Alex Simonson, *Marketing Aesthetics: The Strategies Management of Brands, Identity, and Image* (New York: Free Press, 1997). The strategies consist of using aesthetics, conceived as the ultimate marketing instrument – there's nothing about aesthetics that's obscure to them, as their precise analysis of the efficiency of color, line, and shape indicate – to create an image and identity for a brand, so that it becomes memorable. For an application of their concepts to art see my essay "Art Is Dead; Long Live Aesthetic Management," *Redeeming Art: Critical Reveries* (New York: Allworth Press and the School of Visual Arts, 2000), pp. 134–53. My point of departure is two paintings of Marilyn Monroe, one by de Kooning, one of the last artists, and Warhol, a postartist aesthetic manager. De Kooning's *Marilyn* was made in 1954, Warhol's *Gold Marilyn Monroe* in 1962, a time of transition from art to aesthetic management and marketing.

77 Alexandre Melo, "Guess Who's Coming to Dinner," *Parkett*, 44 (1995):105.

78 Rochelle Steiner, "En Route [An Interview with Rirkrit Tiravanija]," *Parkett*, 44 (1995):116.

79 Quoted in Cabanne, pp. 13–14.

80 Erich Fromm, *Man for Himself: An Inquiry into the Psychology of Ethics* (New York: Henry Holt, 1947), p. 67.

81 Ibid., p. 68.

82 Ibid., pp. 69–70.

83 Ibid., p. 70.

4: THE DECLINE OF THE CULT OF THE UNCONSCIOUS:
RUNNING ON EMPTY

84 Charles Baudelaire, "The Salon of 1846," *The Mirror of Art*, ed. Jonathan Mayne (Garden City, NY: Doubleday, 1956), p. 43.

85 Baudelaire, "On the Heroism of Modern Life," ibid., p. 129.

86 Baudelaire, "The Salon of 1859," ibid., p. 235.

87 Ibid.

88 Quoted in Henri Dorra, ed., *Symbolist Art Theories* (Berkeley: University of California Press, 1994), pp. 5–6.

89 Ibid., p. 239.

90 Baudelaire, "The Salon of 1846," p. 55.

91 Ibid., p. 44.

92 Ibid., pp. 44–45.

93 Ibid.

94 Quoted in Dorra, p. 4.

95 Ibid., p. 5.

96 Ibid.

97 Ibid., p. 55.

98 Baudelaire, "The Salon of 1859," p. 233.

99 Ibid., p. 242.

100 Quoted in Alexandra Lange, "Queens Modern," *New York Magazine*, June 17, 2002, p. 35.

101 André Breton, "The Art of the Insane: Freedom to Roam Abroad" (1948), *Surrealism and Painting* (New York: Harper & Row, 1977), p. 316.

102 George Frankl, *Civilisation, Utopia and Tragedy* (London: Open Gate Press, 1992), p. 169.

103 Ibid., p. 171.

104 Cabanne, pp. 13–14.

105 Roger L. Williams, *The Horror of Life* (Chicago and London: University of Chicago Press, 1980).

106 Janine Chasseguet-Smirgel, *Creativity and Perversion* (London: Free Association Books, 1985), p. 10.

107 Ibid., p. 11.

108 Ibid., p. 141.

109 Charles Baudelaire, "A Philosophy of Toys," *The Painter of Modern Life and Other Essays*, Jonathan Mayne, ed. (London: Phaidon, 1964), p. 199.

110 Quoted in Herschel B. Chipp, ed., *Theories of Modern Art* (Berkeley: University of California Press, 1968), pp. 83–84. Years later Pollock used the image of a hobby horse as a collage element in *The Wooden Horse*, 1948.

111 Baudelaire, p. 8.

112 *The Memoirs of Giorgio de Chirico* (New York: Da Capo Press, 1994), p. 13.

113 Ibid., p. 14.

114 Ibid., p. 65.

115 Quoted in John M. MacGregor, *The Discovery of the Art of the Insane* (Princeton: Princeton University Press, 1989), p. 296.

116 Ibid., p. 297.

117 Ibid., p. 300.

118 Ibid.

119 Ibid.

120 Ibid., p. 298.

121 Quoted in ibid., p. 297.

122 Caroline E. Meyer, "Read It – or Weep," *Washington Post National Weekly Edition*, June 3–9, 2002, p. 19.

123 James George Frazier, *The Golden Bough: A Study in Magic and Religion* (London: Macmillan, 1954), p. v.

124 Ibid., p. 1.

125 Quoted in *Parallel Visions: Modern Artists and Outsider Art*, eds. Maurice Tuchman and Carol S. Eliel (Los Angeles: Los Angeles County Museum of Art and Princeton: Princeton University Press, 1992; exhibition catalogue), p. 217.

126 Ibid., p. 224.

127 Quoted in ibid., p. 134.

128 Eva Forgács, "Toys Are Us: Toys and the Childlike in Recent Art," *Art Criticism*, 16/2 (Spring 2002):9.

129 Ibid., p. 8.

130 Ibid., p. 12.

131 Hanna Segal, *Dream, Phantasy and Art* (London and New York: Tavistock/Routledge, 1991), p. 95.

5: MIRROR, MIRROR ON THE WORLDLY WALL, WHY IS ART NO
LONGER THE TRUEST RELIGION OF ALL?: THE GOD THAT LOST
FAITH IN ITSELF

132 Albert J. Lubin, *Stranger on the Earth: A Psychological Biography of Vincent van Gogh* (New York: Henry Holt, 1987 [1972]), p. 113. All subsequent quotations from van Gogh are from this book.

133 Quoted in *Andy Warhol: A Retrospective* (New York: Museum of Modern Art, 1989), p. 459.

134 Chasseguet-Smirgel, p. 10.

135 Quoted in *Andy Warhol: A Retrospective*, p. 457.

136 Michael Wolff, "The Last Adman," *New York*, April 8, 2002, p. 24.

137 Langdon Thomas Jr., "Board Stiffed," *New York*, August 19, 2002, p. 15.

138 Richard Lambert, "Reasons to be Suspicious about Tyco," *Financial Times*, June 5, 2002, p. 13.

139 Quoted in Peter Plagens, "This Man Will Decide What Art Is," *Newsweek*, March 4, 2002, p. 55.

140 Mihaly Csikszentmihalyi, "The Dangers of Originality: Creativity and the Artistic Process," *Psychoanalytic Perspectives in Art*, ed. Mary Mathews Gedo (Hillsdale, NJ and London: Analytic Press), vol. 3, p. 214.

141 Daniel Bell, *The Cultural Contradictions of Capitalism* (New York: Basic Books, 1978), p. xxiv.

142 Dore Ashton, ed., *Picasso on Art: A Selection of His Views* (New York: Viking, 1972), p. 11.

143 John Ruskin, *Modern Painters* (Boston: Dana Estes & Co., 1902), vol. 5, p. 178.

144 Stephen Donadio, *Nietzsche, Henry James, and the Artistic Will* (New York: Oxford University Press, 1978), p. ix.

145 Ibid., p. 49.

146 Ibid., p. 61.

147 Ibid., p. 50.

148 Jacques Barzun, *The Use and Abuse of Art* (Princeton: Princeton University Press, 1973), p. 30.

149 Ibid., p. 33.

150 Ibid., p. 39.

151 Ibid., p. 38.

152 Ibid., p. 34.

153 Quoted ibid., pp. 35–36.

154 Quoted in Herschel B. Chipp, *Theories of Modern Art* (Berkeley: University of California Press, 1968), p. 79.

155 Quoted in ibid., pp. 89, 88.

156 Ibid., p. 66.

157 Ibid., pp. 83, 86.

158 Ibid., p. 83.

159 Barzun, p. 37.

160 Quoted in Rainer Funk, *Erich Fromm: The Courage to Be Human* (New York: Continuum, 1982), p. 62.

161 Ibid.

162 André Haynal, *Depression and Creativity* (New York: International Universities Press, 1985), p. 64.

163 Richard Huelsenbeck, "The Agony of the Artist," *Memoirs of a Dada Drummer* (New York: Viking, 1974), p. 177.

164 Haynal, p. 64.

165 Ibid., p. 149.

166 Huelsenbeck, p. 177.

167 Catrina Neiman, ed., *David Rabinowitch Sculptures 1963–70* (Bielefeld: Karl Kerber Verlag, 1987), p. 272.

168 Huelsenbeck, p. 178.

169 Ibid., p. 179.

POSTSCRIPT

170 Wolff, p. 24.
171 N'Gai Croal, "Battle for the Soul of Hip Hop," *Newsweek*, July 8, 2002, p. 19.
172 Richard Lacayo, "America's Best Artists and Entertainers," *Time Magazine*, July 9, 2001, p. 47.
173 Quoted in Michele Hannoosh, *Painting and the Journal of Eugène Delacroix* (Princeton: Princeton University Press, 1995), p. 27.
174 Ibid., p. 30.
175 Ibid., p. 41.
176 Ibid., p. 40.
177 Ibid., p. 41.
178 Quoted in Ursula Meyer, ed., *Conceptual Art* (New York: Dutton, 1972), p. x.
179 Ibid., p. xi.
180 Hans Eysenck, *Genius: The Natural History of Creativity* (Cambridge: Cambridge University Press, 1995), p. 69.
181 Quoted in Chipp, p. 287.
182 Segel, p. 90.
183 T. W. Adorno, *Aesthetic Theory* (London: Routledge & Kegan Paul, 1984), p. 429.
184 Breton, p. 348.
185 Zbigniew Herbert, *Still Life with a Bridle, Essays and Apocryphas* (Hopewell, NJ: Ecco Press, 1991), pp. 36–37.

INDEX

Aberbach, David, 196
Abstract art, 159, 165, 167, 172
Abstract Expressionism, 31, 51, 87, 90,
 101
Adorno, Theodor W., 32, 107, 186, 201
aesthetic emotion, 22, 24, 29
aesthetic experience, 2, 8–13, 18, 19, 21–26,
 28–32, 34–37, 40, 42, 44, 45, 50, 66, 67,
 69, 80, 83, 96, 102, 103, 127, 130–132,
 134, 137, 145, 146, 150, 158, 160, 161, 175,
 177, 180, 183, 185, 186, 190–192, 195, 196
aesthetic judgment, 19, 20, 23, 29
aesthetic object, 34, 80
aesthetic osmosis, 14, 22, 29
aesthetic pleasure, 34, 40, 44, 45, 187
Anderson, Laurie, 128
Anderson, Maxwell, 154
anomie, 168, 170
anti-aesthetic, 28, 177
anti-art, 23, 66, 173
Antes, Horst, 103
Appel, Karel, 103, 120
Apple, Billy, 69, 84
appropriation art, 160
Arikha, Avigdor, 183
Aristotle, 90
Arnheim, Rudolf, xiii, 50, 51, 57, 180,
 193
Arp, Jean, 68
art and money, 6, 8, 10, 14, 29, 74, 88,
 110, 111, 147, 149–155, 158, 159, 162, 175,
 177, 192

Art Brut, 122, 123
art of the insane, 103–106, 108, 111–114,
 120, 122, 125, 135–137, 198
assemblage, 66
automatism, 136
Aurier, G.-Albert, 162

Bach, Johann Sebastian, xiv
Bacon, Francis, 114
Baechler, Donald, 136
Balzac, Honoré, 180
Barr, Jr., Alfred H., 1, 5
Barthes, Roland, 57
Barzun, Jacques, 161, 162, 164, 200
Baselitz, Georg, 177
Basquiat, Jean-Michel, 108
Baudelaire, Charles, 12, 41, 55, 89–91, 96,
 97, 104, 118, 120, 124, 133, 134, 138, 197,
 198
beauty, 30–32, 34, 36–38, 45, 51, 69, 81, 89,
 158, 185, 187, 190, 191
Beckmann, Max, 55, 58, 146
Beethoven, Ludwig van, xiv
Bell, Daniel, 156, 199
Bellmer, Hans, 31
Benjamin, Walter, 92
Beert, Osias, 154
Bergson, Henri, 135
Berkeley, Busby, 176
Beuys, Joseph, 123, 128, 139
Bidlo, Mike, 141
Bierk, David, 183